EXHIBITIONISM

EXHIBITIONISM

*art in an
era of
intolerance*

**LYNNE
MUNSON**

chicago · ivan r dee

Library of Congress Cataloging-in-Publication Data:
Munson, Lynne, 1968–
 Exhibitionism : art in an era of intolerance / Lynne Munson.
 p. cm.
 Includes bibliographical references and index.
 ISBN 1-56663-399-0 (alk. paper)
 1. Art patronage—United States—History—20th century.
 2. Postmodernism—Influence. I. Title.
NX705.5U6 M86 2000
701'.03'0973—dc21 00-043107

To my trio

"Talking about art is almost useless."

—Paul Cézanne,

letter to Émile Bernard, 1904

"A good deal of twentieth-century art

has been pedagogical."

—Jacques Barzun,

"The Artist as Prophet and Jester," 2000

CONTENTS

ACKNOWLEDGMENTS

Among the notes I made while writing this book I find this comment: "If you spend any amount of time looking at paintings or talking to artists you quickly realize how far you are from art. Art is not merely another language, indecipherable to the nonlawyer or nonmechanic. It is another world of relationships—to objects, to ideas, to life's priorities. Nonartists can painstakingly describe works of art and even record every word an artist says. But, in the end, the only thing that can fully explain great art is the work itself."

During the three years I've spent on this project, the largest debt I acquired is to the dozens of artists who allowed me into the inspiring sanctuaries that are their studios. Many names stand out—Nicholas Carone, Stanley Lewis, Deborah Rosenthal, Temma Bell, Jake Berthot, Ruth Miller, Andrew Forge, Barbara Grossman, Alan Cote, Barbara Goodstein, Sylvia Plimack Mangold, David Wooddell, Lennart Anderson, Rebecca Howland—but, all told, dozens of artists spent hours trying to help me bridge the gap between my eyes and their work, and for that I am more grateful than they can know.

The Lynde and Harry Bradley Foundation believed in this book when it was merely the pipe dream of a would-be author. And the W. H. Brady, John M. Olin, and D & D foundations, along with an anonymous supporter, made it possible for me to do the extensive research my subject re-

quired. For these institutions' faith, and for their missions, I am grateful. W. H. Brady Foundation director Elizabeth Lurie deserves special thanks. She has been this work's keenest critic and my most unflagging supporter. Much thanks also goes to Christopher DeMuth, both for his insight and for allowing me to remain in the fold of the American Enterprise Institute even as I ventured far afield in pursuit of my goals.

I've tapped the talents and tested the patience of more librarians, archivists, and museum personnel than I have room to mention. I'd like to thank, en masse, the staffs of the New York Public Library, Brooklyn Public Library, and the fine arts library at Harvard University. Many people provided unique assistance: Stephen Polcari, formerly of the Archives of American Art; Abigail G. Smith, archivist of Harvard's Fogg Art Museum; Marjorie Ciarlante at the National Archives in Washington, D.C.; and Susan Scott, archivist of London's Courtauld Institute of Art. Karen Elias and Michael Faubion helped me navigate the circuitous bureaucracy of the National Endowment for the Arts, and Professor John Pultz of the University of Kansas was kind enough to lend me an important paper he wrote on the arts endowment's early years. Barbara Rauch, the niece of Henry Geldzahler, spent many hours on many days helping me sift through the treasure trove that is her uncle's archive.

At the book's formative stage Barbara Rose and Jed Perl, who write about art with uncommon insight, served as crucial sources of both historical knowledge and creative inspiration. My editor and publisher Ivan Dee propelled my work forward with his deep interest not only in my words but in my goal.

There are many longtime friends without whose caring guidance I may never have begun this work. They include Professor Olan Rand, who taught me the pleasures of looking at art, and Leslie Lenkowsky, who helped me realize that

my dual interests—art and politics—could be one and the same. Irving Kristol and Joseph Epstein are mentors who for years have guided and motivated me (and countless others) by their example. Irving gave this project an important boost when he published an early version of the chapter "Leveling the Museum" in the *Public Interest* in the spring of 1997. Special thanks go to Barbara Ledeen for being the kind of friend who not only listens but acts, and to Anne Neal for poring over my manuscript as only a dear friend would. Bruce Cole and Jerry Martin provided the kind of unflagging encouragement that usually comes only from family.

When I press further in my research or work to refine my writing it is in large part due to Lynne Cheney. She brought me to Washington, D.C., and gave me the opportunity to draw from her wisdom and her vigor, and to create my own path. It is in her image that I pursued this task.

I dedicated this book to the three people whose strength I rely on each day. My mother planted the seeds that created this book by teaching me that art and words are the most precious things we have, and by instilling in me the idea that no challenge is insurmountable (even a blank computer screen). It meant a great deal to me that she redoubled her always bountiful encouragement while I was at work on this book. I hope she knows that her pride in me is a reflection of mine in her.

Chris Clary is my co-explorer in the art world. Without his help I could not have gathered or understood half of what is written here. Chris's unspoken assurance that I could complete this book was a constant source of momentum. I have tried to imprint my work with his open-mindedness and his natural curiosity—since these are the same qualities that make Chris's art great.

You have to be a poet, not merely a writer, to express how a husband can make even the most trying moments in

one's life pure joy. In recent years Ed and I have mastered the science of helping each other produce our best work. And now that we've both written our books, we can go on.

Finally I must thank my little friend Eraser, who (perched atop my monitor) is the only one actually to have seen me through it all, though he didn't lift one delicate paw to help.

L. M.

Brooklyn, New York
May 2000

PREFACE: THE ART WARS

At the height of the elephant dung war of 1999, I received a call from the Creative Coalition, an arts advocacy group founded by Alec Baldwin, Susan Sarandon, and other actor-activists. The Coalition was desperate to fill a vacancy on a panel they were holding the next day to protest New York City Mayor Rudolph Giuliani's criticism of the Brooklyn Museum's now-infamous "Sensation" exhibition. The forum was already stacked with six staunch defenders of the show. The only panelist critical of "Sensation" was an official from a well-known Christian group who had just pulled out claiming illness. My caller had heard that I was a critic of the show and wanted to know: "Did I also want to censor the Madonna portrait?"—the work that had spurred opposition to the show.

I explained that I did think the exhibition was inappropriate—though not for the reasons that had dominated public debate. My gripe with "Sensation" was not that it contained art that was offensive to some, or of marginal quality in the view of many, but that there was no scholarly or civic rationale for an American public museum to host it. After all, none of the "Sensation" artists, whose average age was thirty-five, had been making art long enough for anyone to know whether their work would be worth including in a museum show in even ten years. If these young artists were Brook-

lynites, their home museum might justify the risk of showing them. But not one of the artists in "Sensation" lived, worked, or even was born in the United States, let alone in Brooklyn.

I was also suspicious of the motives reflected by the museum's marketing campaign, which included a mock health-alert warning that the exhibition could cause "vomiting, confusion, panic, euphoria and anxiety." Why did the museum go out of its way to hype "Sensation"'s shock potential and to fan the flames of controversy? And why had the museum's director so self-consciously placed his institution on the firing line? After all, no other American museum had been willing to take the show. The San Francisco Museum of Modern Art and the Museum of Fine Arts in Houston had both turned it down. Wasn't this more likely a case of bad stewardship than of censorship? I suggested that this was the kind of question that was being overshadowed by the fever-pitched uproar over "Sensation."

"You sound very informed," my caller remarked, adding that she would have to check with her superiors before extending an invitation (which I thought had already occurred). I hung up, e-mailed her my bio, and began juggling my schedule. She rang minutes later to say that she would not be needing me. The group had found a panelist better suited to their purposes, a second religious activist whose fiery opinions promised to incite the audience's ire. Clearly, the Coalition's goal was to produce fireworks, not discourse.

The art wars of the last decade have been driven less by reason than by rage. Their fury has made these controversies resemble military engagements more than intellectual arguments. A chronicle of the ongoing conflict includes the Battle at Tilted Arc, the Siege of Piss Christ, Mapplethorpe's Last Stand, The Finley Offensive, and the Great Dung War. Each skirmish has been sparked by art crafted to provoke the

public. Richard Serra's *Tilted Arc* sculpture bisected and deliberately obstructed pedestrian traffic in a busy Manhattan plaza. The fluid in Andres Serrano's infamous image would have been unidentifiable had the artist not gone out of his way to title the work *Piss Christ*. And if its pachyderm waste had not brought wrath down upon Chris Ofili's *Holy Virgin Mary*, the pornography that the artist collaged over and around the icon likely would have. To varying degrees, each of these artists acted like exhibitionists, calling attention to himself by baiting public sensibility.

These artists' critics and defenders have appropriated this exhibitionist strategy, framing every dispute in a way that is sure to generate much heat but little truth. The combatants take their positions each time along the same battle lines. On one side is arrayed the army of the offended, rallying around cries of blasphemy. Against them are amassed the troops of art advocacy, rousing to the charge of censorship. After a full-scale barrage—in the press, via direct mail, and even in the courts and on the Senate floor—the dust settles each time to reveal that the debate has not advanced. The art wars have accomplished nothing aside from bloating the coffers of the opposing armies and propelling the careers of the artists who started them. Least of all have they served the public, which has been left wondering what happened and why.

Exhibitionism will not rehash these controversies but reveal their root cause. The art wars erupted at the apex and throughout the waning days of what is widely referred to as the postmodern era. Postmodernism is a spinoff from deconstruction, a set of theories that dominated humanities scholarship throughout the eighties and nineties. Deconstruction posits that truth and objectivity are impossible and that our traditional understanding of knowledge is naive. According to this way of thinking, what we believe to be true—

about past events and historical figures long considered significant, or about the merit of treasured artistic and literary works—is actually a propagandistic illusion perpetuated by the powerful. Postmodernists would argue that Leonardo da Vinci's place in the history of art is less a result of qualitative judgment than of Eurocentric influence, both now and in the past. In this view the best art and the most useful scholarship should eschew the search for eternal truths to engage instead in an ongoing struggle for power.

The art wars have essentially been public protests against the effect of these postmodern ideas on art institutions. Postmodernism was accompanied by a culture of intolerance which took root inside and eventually engulfed many of the art world's most central institutions. It is a prejudice that has operated in reverse of the established stereotype, favoring the so-called "cutting edge" over the traditional, preferring political art at the expense of painting. In art funding agencies, museums, college art history departments, and even in artists' studios, this bias has placed narrow limits on what type of art it has been acceptable to fund, to exhibit, to study, and to make. Artists and art historians whose work is not sufficiently preoccupied with power or with any of the other designated concerns of postmodern theory have gone unrecognized.

Because its entire life span overlaps the postmodern period, the National Endowment for the Arts is an almost perfect prototype for understanding how institutions became beholden to this culture of intolerance. The agency had a promising start. When the NEA awarded its first full round of grants in 1967 it recognized painters and sculptors whose work spanned a wide spectrum of styles and approaches. Awardees included minimalists Donald Judd and Agnes Martin and maverick surrealists Edward Ruscha and H. C. Westermann. Even artists working to establish new mediums, like

the ceramicist Kenneth Price and the assemblage artist Richard Stankiewicz, were not overlooked. The only characteristics these artists shared were that each had demonstrated a steadfast commitment to their work and a potential for excellence. Although most of these grantees were scarcely known in 1967, many went on to rank among the most influential artists in America's history.

By 1995 the NEA's grantees were a different kind of lot. Over the decades the agency revised its Visual Arts Program in ways that diverted funds away from painters and sculptors and toward artists working in more trendy mediums, including video and performance art. Gradually what took hold was a commitment to pursuing the cutting edge, a preference reinforced by the fact that peer panels came to be dominated not by artists but by critics, curators, and art administrators who package and promote art movements for a living. By the mid-eighties it was almost impossible for an artist who was not working in the postmodern mode to receive an NEA grant. In 1995 the exclusion was virtually systematic, with nearly all of the fellowships going to artists whose work was intended primarily to serve as a social critique.

For decades this kind of intolerance—epitomized by the NEA but evident also in gallery rosters and among critics' selections—prevented scores of artists from finding an audience for their work. Worst hit were painters, since postmodernism targeted paint as the medium which, more than any other, reinforced the "hierarchies of the past." The careers of many important painters passed unnoticed, and in some cases whole communities of such artists remain relatively unknown. Among these is a group of painters who take their inspiration from a line of modernists including Paul Cézanne, Alberto Giacometti, and Hans Hofmann, each of whom placed a priority on working from life. Today these painters continue the project of using abstract principles to

understand the visible world. Most show their work in artist-run co-op galleries where buyers are infrequent and visits by critics even more rare. Even in this vacuum many of these painters have enjoyed long and prolific careers. And a few have had some success in striving for the goal they value most—producing work that shows signs of advancing the language of painting.

The culture of intolerance has sidelined not only artists but also some art historians. Harvard University provides a dramatic example in part because in 1874 it offered the first art history course in any English or American university. Harvard spent the next century turning out students with an encyclopedic knowledge of art and extensive firsthand exposure to art objects. So central to the graduate program was the collection of Harvard's Fogg Art Museum that art history students were said to be enrolled not at Harvard but "at the Fogg." Graduates included future directors of the National Gallery of Art and the Metropolitan Museum, and the founding director of the Museum of Modern Art. As postmodern theory swept the discipline in the early 1980s, much of Harvard's art history faculty all but divorced itself from the Fogg and even talked about selling off its collection. A tense relationship between faculty members who practiced object-oriented approaches to art and those advocating a new art history turned thuggish when a new faculty member prohibited his students from studying with a senior scholar, pushing him into early retirement. Since that time a series of faculty hirings and course changes has shifted Harvard's department further and further away from a direct focus on art.

The theory-driven art history that subverted Harvard's curriculum has altered art museums as well. Under the rubric of the "new museology," some art historians now advocate turning the traditional museum, dedicated to providing an

unfettered forum for learning through looking, into a new revisionist institution recommitted to the pursuit of altering visitors' beliefs. Although some museums have resisted this trend, where the new museology has been embraced its impact is evident inside the museum and out. In Cleveland, Baltimore, and elsewhere, museums have closed the original Greco-Roman style entrances that conveyed a sense of uplift and institutional authority by leading patrons up a grand staircase, across a colonnade, and through massive doors. Condemned as Eurocentric and elitist, many of these entrances have been replaced with inconspicuous ground-level doorways more akin to a strip mall than a treasure house. The new museology also has challenged the traditional museum's "master narrative," or the presentation of the history of art as a continuous evolution of artistic achievement proceeding from ancient Greece through the Renaissance and ending with modern America. The revisionist museum disrupts this arrangement by positioning non-Western collections at the front of the museum, along with the gift shop, café, and temporary exhibition space, making it possible, in the words of one art historian, "to visit the museum, see a show, go shopping, and eat, and never once be reminded of the heritage of Civilization."

A friend who hails from out West once told me that a fence will be stronger if you anchor it with a few deep posts rather than many shallow ones. *Exhibitionism* does not attempt to document the breadth of postmodernism's impact but rather to offer a few important examples of how deeply its intolerance has been felt. The stories here were chosen because they constitute substantial portions of the historical record which, because of postmodern intolerance, have either gone unnoticed or been misunderstood. By telling them, I hope to set the tone for a new art discourse which does not exploit the public square but instead fills it with facts.

EXHIBITIONISM

THE ENDOWMENT'S
EARLY PROMISE

The National Endowment for the Arts' first congressional critic was Representative H. R. Gross of Iowa. Gross came to Congress in 1948 and quickly earned a reputation as the House's "human stoplight," always ready to glow red at the idea of wasteful spending.[1] In his most infamous moment he took to the well of the House to question the use of taxpayer funds to pay for the gas fueling the eternal flame on John F. Kennedy's grave.

On the afternoon of September 15, 1965, when the bill that created the National Endowment for the Arts (NEA) was under debate on the House floor, Gross offered an amendment. On the list of art forms to be recognized by the proposed agency he inserted an anatomical description of belly dancing, complete with "jactitations and/or rhythmic contractions and coordinated relaxations of the serrati, obliques, and abdominis recti group of muscles—accompanied by rotary undulations, tilts, and turns."[2] Of course, if Gross's fictive performer had been costumed in chocolate sauce and bean sprouts (as a future NEA grantee would be), his prediction of the kinds of projects that would trouble the future

agency would have been nearly clairvoyant. Despite Gross's lampooning, the NEA's founding legislation passed the House and moved onto the Senate for consideration.

The only significant opposition it encountered there came from South Carolina Senator Strom Thurmond, who rose to make two points. Thurmond questioned the constitutional authority of the government to enter into the funding of the arts: "Nowhere within the grants of power to Congress . . . can there be found authority to sustain this proposal." Unable to ignite sufficient indignation among his colleagues to pursue this issue, Thurmond added: "Government subsidization of the arts will inevitably lead to the stifling of creativity and initiative. Government money will buy only mediocrity, and true, creative talent will not be properly recognized because it will not have official Government approval."[3] The legislation nonetheless passed, and Lyndon Johnson's Great Society was expanded to include the arts. Gross's and Thurmond's assertions certainly spanned the spectrum of diplomacy. But both members were expressing their doubts about the compatibility of government and art, and their fear of government's trivializing and mediocre effect. Today we have a thirty-five-year record of NEA grantmaking, a total investment of nearly four billion tax dollars, against which to judge these congressmen's expectations.

In an earlier incarnation, the NEA had been up and running a full year before these debates, and before President Johnson signed it into law on September 29, 1965. In August 1964 Congress had passed a bill providing for the establishment of a National Council for the Arts, assigning it a $50,000 budget. Roger Stevens, a Broadway theatre producer, was Johnson's special assistant for the arts and would eventually become the NEA's first chairman. He was assigned the task of working with the Council's twenty-four members to sketch out the budding Endowment's mission. The original Council

was a star-studded group which included actor Gregory Peck, violinist Isaac Stern, broadcaster David Brinkley, author Ralph Ellison, sculptor David Smith, and conductor Leonard Bernstein. Within a year author John Steinbeck, painter Richard Diebenkorn, and actors Charlton Heston and Sidney Poitier also joined the Council.

The Council's first annual report, dated 1964–1965, shows the group thrashing about to determine how broadly the NEA should cast its net. The state of almost every imaginable creative discipline was discussed. Most of the arts were characterized as being either in jeopardy or already on the brink of collapse, including such seemingly unlikely areas as film and fashion. One resolution calls for forming a Council subcommittee to study the problem of the "training of those Americans whose desire it is to expand the frontiers of achievement in motion pictures," a concern deemed "urgent as present activity toward this end is insufficient." A resolution on fashion was likely spearheaded by Council member Eleanor Lambert, a publicist famed for starting the now ubiquitous "best dressed" lists. The report calls for a "committee to study and recommend means for elevating public understanding of fashion design."[4] The Council seemed to be leaning toward a generous and unwieldy definition of what counted as art.

The group paid keener attention to the form of funding that would best serve the arts. With scarcely an appropriation to its name, the Council declared its intent to build an Endowment which placed its highest priority on supporting individual artists. In a lengthy statement on "The Creative Artist," the Council expressed its desire to provide "grants which will release the artist for creative activity."[5] Clearly, institutional support would also be a large part of the new Endowment's mission. But the Council intended its investment in individual excellence to act as a beacon guiding the rest

of the NEA's activities. And in no area was the importance
of the individual artist stressed more than in the visual arts.

On March 24, 1966, Council member and Museum of
Modern Art director René d'Harnoncourt convened an advi-
sory panel to set the priorities for the Endowment's Visual
Arts Program. The committee was composed of the directors
of the nation's most prominent museums of American art:
Lloyd Goodrich of New York's Whitney Museum of Ameri-
can Art; Martin Friedman of Minneapolis's Walker Art Cen-
ter; Mitchell Wilder of the Amon Carter Museum in Fort
Worth, Texas; and David Scott of the National Collection of
Fine Arts, which eventually became the Smithsonian's Na-
tional Museum of American Art. These museum men might
be expected to put forth a set of recommendations that would
guide Endowment funds into museum coffers. They did not.

Instead they recommended that the chief priority of the
program be to provide "direct assistance to the creative artist."
And that another high priority be the "recognition of excel-
lence in artistic achievement."[6] The advisers didn't find it suf-
ficient merely to reemphasize the Council's intent to award
grants to individuals; rather they stressed quite emphatically
the need to deliver support only to artists of proven merit,
whose seriousness and accomplishment was recognized by
other visual artists. Their advice was to be discriminating and
to avoid falling into the trap of funding anyone and every-
one who claimed to be an artist. This is a principle that
Henry Geldzahler, the first director of the Endowment's Vi-
sual Arts Program, fully embraced.

Geldzahler had built a career on knowing artists and
evaluating their work. In 1960 he was the first person ever
hired by the Metropolitan Museum of Art to scout contem-
porary art for its collection. Met director James Rorimer
drafted Geldzahler out of Harvard's graduate fine arts pro-
gram (just as he was beginning a dissertation on the sculp-

ture of Henri Matisse), gave him a $5,000-a-year curatorial assistant post, and told him to "take [his] salary and learn." In what Geldzahler described as "continuing my graduate school education," he spent nearly all his time searching out artists and logging time in their studios.[7] After visiting a studio he would often ask the artist whether there was "anybody else in the building," or if the artist had any friends whose work he could see. Geldzahler would travel around the country, announce he was with the Met, and elbow his way into studios. He found out years later that during an early trip to Chicago the artists he called on had never heard of him and doubted his Met credentials. As he made the rounds of their studios, artists passed word that Geldzahler "seems perfectly harmless, be nice to him."[8] By the time he was named to the NEA post, Geldzahler was known quite widely as someone who would not be sold on an artist's public reputation. He had spent enough time among artists to learn how to judge their work as they did.

By the late sixties a proliferation of trendy, commercialized, and increasingly politicized art was beginning to edge many serious artists out of the market. Andy Warhol had become an art star, provoking a popular redefinition of what it meant to be an artist. Many artists, particularly those who had begun making art when it was inconceivable that it could make them rich and famous, did not fit the new image and were finding it increasingly difficult to live off the sale of their work. Geldzahler was determined to design a program that would put money directly into the hands of the most deserving artists. As he explained in a memo years later:

> The important art of a period is not necessarily tied to the marketplace, and it is the obligation of a society to invest in its own future by identifying, as best it can, those artists who are saying things and seeing things in

luminous and resonant ways, and providing these artists with a modicum of support.[9]

In 1966 the new Endowment awarded a handful of grants in each of its program areas. Under Geldzahler's direction, the Visual Arts Program spent the bulk of its funds in two ways. It provided $38,000 to support American artists' participation in the Venice Biennial, an international exhibition of contemporary art.[10] And it launched a small pilot fellowship program, awarding $7,500 grants to fifteen artists who were also teachers, so that they could take a year off and concentrate on making art. Some of the artists who received those initial grants were affiliated with the New York Studio School, including two painters whose work will be discussed in a later chapter, Leland Bell and Nicholas Carone.[11]

As the Endowment geared up for its first fully funded year of grantmaking in 1967, Geldzahler worked to design a fellowship program and a grantmaking process in which both the art world and the taxpaying public would have confidence. He appreciated the link between the Endowment's mission to help artists and its responsibility to the public. In a memo written early in his tenure as director of the Visual Arts Program, Geldzahler argued that "the basic building block of culture is the artist . . . everything else—museums, opera companies, dance, theater and all their attendant institutions follow naturally as does the audience—the American people—for whom the NEA is by statute responsible."[12] Geldzahler had the political acumen (his next job would be New York City Commissioner of Cultural Affairs) to realize that a government agency could not survive an anything-goes arts policy.

Geldzahler's solution was to focus individual grants on artists of proven merit. Grants would go to "painters and sculptors in recognition of past contributions," artists who

had worked long and hard enough to prove their seriousness and earn the respect of their peers.[13] Geldzahler set a minimum requirement of twenty-five years of age, but the first group of grantees averaged forty-three years.[14] Although Geldzahler was certainly aware of emerging art forms—performance art, conceptual art, and the like—he chose to restrict NEA funding to painters and sculptors. He didn't position the Endowment on the cutting edge, roaming the ramparts and trying to fertilize artistic seedlings. His fellowships were investments in the most serious artists to help ensure that their work would come to fruition, and to increase their potential to influence others. As Geldzahler explained, it was a function of quality over quantity:

> Ideally the state of the arts is furthered, and the [NEA] looks better in retrospect, if you can manage to land heavily on the best men available and truly help them rather than attempt to cover the waterfront. Fairness in art is not nearly so interesting as quality.[15]

The number of grants needn't be large, because Geldzahler hoped to target the cream of the crop. Originally the d'Harnoncourt committee had recommended grants of $10,000 to fifty artists each year. For 1967 the Council approved a plan for sixty grants of $5,000 each. After managing the program for a few years, Geldzahler became convinced that it would be more effective to award a greater sum of money, $10,000 each year for three years, to fewer artists, only the very best. But that proposal was never enacted.

Far more important to Geldzahler than the number or amount of fellowship awards was the rigor of the process by which recipients were chosen. The only significant factor in determining which artists would receive grants was the quality of their work. In order to concentrate the support so keenly on the best artists, Geldzahler needed to set up a se-

lection process informed by serious artists and others who, like himself, looked at art as artists did.

Geldzahler did not want a group of yes-men to affirm his own choices. As he said of the painter Robert Mother-well, who served on one of the program's first panels in 1967: "We don't agree very much on picture by picture and artist by artist, but we both respect each other enough as human-ists and honest people so that we're able to come to not so much compromises as a meeting of minds."[16] The early pan-els never took votes because the idea was not to fund only those artists which each and every panelist found agreeable. Geldzahler was not seeking a consensus. According to sculp-tor and panelist Richard Hunt, Geldzahler wanted to make choices based on "what other artists were saying about other artists."[17] He trusted that if you assembled those with the most intimate knowledge of the serious art world, they would know who the best artists were, even if their work was known only to one panelist. After all, in 1967 one could not apply to the NEA for a grant. There were no applications, no artist statements, no slides for panels to review and debate. The entire system relied on the pool of information, and wisdom, that each panelist brought to the process.

Indeed, a good measure of the distinction that accom-panied receiving an NEA grant in those early years rested on the widespread knowledge that the people choosing the grantees were among the most informed and discriminating people in the art world. In a memo to NEA Chairman Roger Stevens, Geldzahler explained: "Decisions [on grants] must be made by a small and highly professional panel that makes suggestions based on their intimate knowledge of the field."[18] The goal, according to one panelist, was to compile a list of grantees that drew on "the informed opinions of the con-sensus of the serious art world."[19] There was no balance to

strike, no quota to fill. The only coverage Geldzahler strove for was to find artists working in different regions of the country so that the grants would be meaningful "on a local level as well as on a national level."[20]

In the fall of 1966 panels were convened in the East (New York City), Midwest (Chicago), and West (Los Angeles), to recommend artists for fellowships.[21] The following year concentrated only on the South and Southwest. The best documented of the three panels is the one that met first, in New York City. It convened at 11 a.m. on September 11, 1966, in Geldzahler's apartment at 112 West 81st Street. There were three panelists: Robert Motherwell, a painter and writer on art who was one of the early pioneers of abstract expressionism; Barbara Rose, an art historian and critic who, as a contributor to *ArtForum* magazine, was an authority on minimalist painting and sculpture; and George Segal, a young figurative sculptor who was quickly gaining respect as an early pop artist. Geldzahler had directed each panelist to bring along a list of worthy candidates, from which an omnibus list of 75 artists was compiled for discussion.[22] (A listing of the artists considered by each of the three panels, 179 painters and sculptors in all, appears in Appendix A.)

Segal and Rose both looked back and recalled, with some surprise, how easy it was to choose grantees. "We had remarkably little disagreement about who was a good artist and who wasn't," Segal remembered.[23] This is all the more impressive because, at the time the panel met, the idea that anything could be art was on the rise. Painting had been declared dead, and the very notion of quality was under attack as old and oppressive. But Geldzahler did not choose panelists who would use the panel to add momentum to the trend of the moment. To these panelists it was not enough just to make anything and call it art. They could see the dif-

ference, and they did not mind saying so. "You knew who was a serious person and who was a frivolous person," said Rose.

Geldzahler's panelists came from different stylistic communities within the art world, but they had one thing in common: they took the idea of quality seriously. "I think our generation—I include the abstract people, the pop people, the realist people—believes very strongly in the idea of quality," Segal said. Rose added, "We shared an absolute commitment to elitism in terms of quality." In addition to this bedrock belief, the panelists shared the attitude that serving on a government panel deserved an added level of seriousness. "No one would have dreamed of giving a grant to any kind of ephemeral art, because it was about permanence," said Rose. "It was about betting on people whose work had a chance of lasting."

The East Coast panel finished its work in just six hours. In the end, approximately half the grantees came from the East Coast panel list, and a quarter each from the Midwest and West Coast panels. On November 22, 1966, Geldzahler submitted the final list and summed up the panels' goals simply: "The two criteria were artistic excellence and need. In each case we feel both criteria were met."[24]

Many of the grantees first learned the news when they saw the list in the newspaper. Others received joyous calls from friends or dealers. All were shocked. Like most grantees, painter Robert Goodnough still reflects on the "pleasant surprise" with great pride.[25] Alfred Leslie says that getting an NEA grant "compares to getting an Academy Award. It makes you feel good."[26]

The grant list was greeted with immediate applause from both artists and the press. Early in the NEA's development, *ArtNews* editor Thomas Hess had expressed skepticism about the agency, warning that "the government is bound to make

IN PAINTING:

Lennart Anderson
Brooklyn, NY

Robert Beauchamp
Provincetown, MA

Billy Al Bengston
Venice, CA

George Cohen
Evanston, IL

Rollin Crampton
Woodstock, NY

Gene Davis
Washington, DC

William Geis
Stinson Beach, CA

Sam Gilliam
Washington, DC

Robert Goodnough
New York, NY

Stephen Greene
Valley Cottage, NY

Julius Hatofski
San Francisco, CA

Robert Hout
New York, NY

Will Insley
Oberlin, OH

Bill Ivey
Seattle, WA

Al Leslie
New York, NY

Agnes Martin
New York, NY

John McLaughlin
Los Angeles, CA

George McNeil
Brooklyn, NY

Neil Meitzler
Seattle, WA

Clark Murray
Los Angeles, CA

Ray Parker
New York, NY

Charles Pollock
East Lansing, MI

Richard Pousette-Dart
Suffern, NY

Ralph Rosenborg
New York, NY

Edward J. Ruscha
Los Angeles, CA

Ludwig Sander
New York, NY

Leon Polk Smith
New York, NY

Theodoros Stamos
New York, NY

Myron Stout
Provincetown, MA

Tony Vevers
Lafayette, IN

Bruce West
Mount Angel, OR

Phil Wilbern
Detroit, MI

Neil Williams
New York, NY

Jack Youngerman
New York, NY

IN PAINTING AND SCULPTURE:

Charles Biederman
Redwing, MN

Jean Follett
St. Paul, MN

Robert Mangold
New York, NY

Richard Randell
Sacramento, CA

IN SCULPTURE:

Wallace Berman
Topanga, CA

David Black
Columbus, OH

Ronald Bladen
New York, NY

Nassos Daphnis
New York, NY

Mark di Suvero
New York, NY

Dale Eldred
Kansas City, MO

Dan Flavin
Cold Spring, NY

Joe Goto
Providence, RI

Donald Judd
New York, NY

Gary Kuehn
Somerville, NJ

Alvin Light
San Francisco, CA

Edwin Mieczkowski
Cleveland, OH

Gary Molitor
San Francisco, CA

Robert Morris
New York, NY

Manuel Neri
Benicia, CA

Kenneth Price
Los Angeles, CA

Tony Smith
South Orange, NJ

Richard Stankiewicz
Huntington, MA

George Sugarman
New York, NY

Steven Urry
Chicago, IL

David Weinrib
New York, NY

H. C. Westermann
Brookfield Center, CT

mistakes as it dips a toe into the hot waters where artists are at work."[27] When the grants were announced, Hess declared that "all reservations were groundless," calling the awards "the best list of grants that we have ever seen in the field."[28] Hilton Kramer, then the chief art critic at the *New York Times*, remembers reading the names as the list came off the wire and thinking that "both on the basis of the quality of the artists' work and their financial situations it was an excellent list."[29] A letter from the director of the gallery representing painter George McNeil reflected both the excitement surrounding the list and the tenor of the times: "I'm closing the gallery which I'm a little sad about—but that grant to McNeil was really good news—and the whole list was really brilliant."[30]

Many of the 1967 grantees produced work that is now so widely celebrated that it is difficult to believe that at the time they could scarcely find an audience for their work. According to Rose, in 1967 Agnes Martin was "completely unknown and selling nothing," and Donald Judd was just getting noticed. Robert Mangold recalls the grant coming "at a time when it was really needed—my work wasn't selling."[31] Edward Ruscha, who in 1967 had just switched from painting to making photo books, remembers having "no art income to speak of."[32]

Today these artists' works are textbook examples in their areas of endeavor. Judd removed sculpture from the pedestal, minimalized its vocabulary, and argued that art need not reference anything outside itself. In his impeccable rows of boxes—constructed of aluminum, copper, plexiglass, plywood, or steel—Judd showed himself, in the words of one critic, to be "a master of scale and detail, for whom the thickness of a sheet of metal or the placement of screws were of paramount importance."[33] For nearly forty years Martin has studied the pressure of the pencil line across the field of a reduced

palette, creating some of the most elegant and sophisticated examples of late abstract expressionist painting. Mangold continues to conduct what many consider to be the most rigorous and thoroughgoing experiments with the formal potential of shaped canvases. And Ruscha, one of America's native-born surrealists, was among the first painters to use text effectively as visual language. Any history of twentieth-century art would be notably incomplete if it failed to discuss these artists and many other 1967 NEA grantees.

One of the earliest of the abstract expressionists, Richard Pousette-Dart worked from the early 1940s until his death in 1992 to integrate symbolic imagery into the language of abstract painting. The work of painters Gene Davis and Sam Gilliam marks the crest and the culmination of the Washington Color School movement. These painters were the first to explore the possibilities of plastic, or acrylic, paint which could soak and blend inside the fabric of a canvas. Pioneering abstract sculptor Tony Smith used modular, geometric volumes to create monumental shelterlike structures, betraying the sculptor's early career as an architect. Robert Morris's NEA grant coincided with his shift away from hard-edged minimalist sculptures and toward more fluid constructions made from draped and piled felt and other formless materials. In these pieces, and in a number of essays he wrote, Morris laid the groundwork for environmental and installation art by showing how the process of sculpting could move outside the studio.

These artists would come to rank among the best in their generation. But in 1967 most were unknown, except to the people Geldzahler put on his panels. Panelist Barbara Rose—who was married at the time to artist Frank Stella, and whose entire personal and professional existence has been lived among artists—is exactly the kind of person who would have known that Judd and Martin were doing important work. The

same can be said of West Coast panelist Walter Hopps, who directed the hip Ferus Gallery in Los Angeles and therefore knew Ruscha. To the informed eyes of people like Rose and Hopps, artists of this caliber stand out, even in their developmental stages.

In a sense, the clearest evidence of the panels' intimate knowledge of the art world, and the rigor of their judgment, is that the grants list is solid all the way through. It is impressive to recognize the standouts but even more difficult to identify dozens of other less obvious but equally worthy candidates for support. The high standard set by these early panels in essence took the gamble out of the grantmaking process. The panels were not guessing and placing bets on artists whom they hoped might pan out. Under Geldzahler's leadership, the NEA funded only visual artists who already had demonstrated some success in achieving serious artistic goals.

A good example was the painter and sculptor Ronald Bladen, who was forty-nine when he received his NEA grant. After nearly two decades of making abstract expressionist paintings, Bladen was just beginning to exhibit the towering geometric sculptures that signaled the beginning of the minimalist aesthetic. Bladen's forms were reductive but not inanimate, in part because they embraced meaning. His work was of great interest to his peers, including fellow grantee Donald Judd. It continues to have a strong influence on sculptors working today, most notably the late minimalist Richard Serra, whose recent *Torqued Ellipses* are essentially updates of a Bladen form.

Grants went also to important second-generation abstract expressionist sculptors, including George Sugarman, whose massive and wildly painted aluminum reliefs were ushering in a new emphasis on decorative concerns. The panels chose artists using new materials, like the junk that assemblage

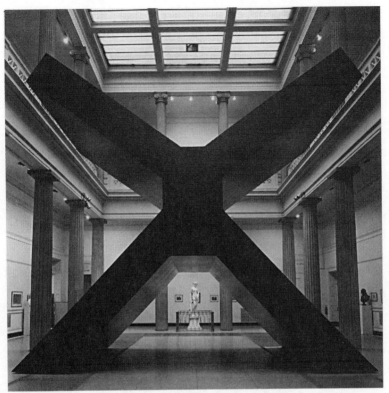

Ronald Bladen, *The X*, 1967, painted plywood, nuts, and bolts, installation. Courtesy of the Corcoran Gallery of Art, Washington, D.C.

sculptors George Cohen, Jean Follett, and Richard Stankiewicz turned into art. Grantee Gary Kuehn was bringing attention to the behavior of materials and the physical relationship between artist and medium in a series of sculptures of bent and bound mattress-sized fiberglass casts. The West Coast panel made sure that grants went to the best representatives of various contingents of an emerging Bay Area art crowd, including the painter Billy Al Bengston and sculptors Alvin Light and Kenneth Price, who was one of few fine artists doing important work in ceramics. The selections

of the Midwest panel spanned that region's stylistic diversity, with support going to Chicago's "Monster Roster" artists, including George Cohen and H. C. Westermann, whose work drew on their experiences as servicemen in World War II, and artists whose interests were purely formal, such as abstract expressionist sculptors Dale Eldred, Joseph Goto, and Steven Urry.

Support went to painters of all kinds. Grantees Will Insley, Myron Stout, and Jack Youngerman were exploring the potential of a new, postpainterly (or hard-edged) approach to abstraction. What Ray Parker called his "simple paintings"[34]— square canvases occupied by stacked strokes of vibrant color— were merging an interest in pure color with a new yearning for geometry. Painters Robert Beauchamp, Robert Goodnough, and Ralph Rosenborg were working and reworking the disputed terrain between abstraction and representation. Grants also went to a thoughtful, if not entirely thorough, selection of representational artists, including Lennart Anderson, a painter of still lifes and allegorical scenes.

Stylistically the 1967 grantees had little in common. What they shared was their approach to being artists. All were "serious committed artists," observes sculptor Richard Hunt, who served on the Midwest panel and eventually became a member of the National Council for the Arts. Today it is common for an artist whose career fails to take off to choose another line of work. But in 1967 no one became an artist expecting to be able to live off his or her work. The experience of painter and grantee Stephen Greene speaks for many: "Out of the forty-nine years I have shown, there may have been two in which I could live off my work. But I've always had quite a few people who have been interested in it."[35] The few artists who did make money were considered lucky.

Grantee Alvin Light was once described as a sculptor "who view[ed] art as a way of life rather than a career."[36]

The kinds of artists who received the early NEA grants didn't choose artmaking as a professional path. It may sound unusual today, but they made art because they were compelled to do it, and even the best of them expected to work their entire lives without public acknowledgment. Their task was clear: to strive for the highest possible standard of excellence in their work and to hold their peers to the same standard. In his obituary, painter and grantee Neil Williams was memorialized as an "'artist's artist' who was admired by his peers but not well known to the general public."[37] This is the reputation most of these artists held. Dubbed "underrated" by the press but influential among throngs of students and select peers, they comprised the core of the serious art world.

"Nobody on this list sold out, bought in, became a commercial artist, or dropped out. If they are not dead they are still working," observes Barbara Rose. For years Lennart Anderson has divided his time between teaching at Brooklyn College and painting in a studio in his Brooklyn home. When George Sugarman died in 1999 he was eighty-seven and still making sculptures in his fourth-floor walk-up studio on Bond Street in New York City. In 1993 grantee Dale Eldred died while trying to save his sculptures from damage when flood waters overtook his Kansas City studio. He had taught for thirty-three years in the Sculpture Department at the Kansas City Art Institute. Just in the last three years Anderson, Goodnough, Leslie, Price, and sculptor Manuel Neri have had one-man shows of new work. Recent works by the best-known grantees—di Suvero, Gilliam, Mangold, Martin, Ruscha, and Smith—are routinely on prominent display at museums and galleries around the world.

Of course, the lists that Geldzahler's 1967 panels compiled were not perfect. Their picks reflected some blind spots that existed in the art world at the time. Although many

women were considered for grants, only two made the final list, Agnes Martin and Jean Follett. One panelist now expresses regret that sculptor Eva Hesse was overlooked. The list was also fairly light on representational painters. Again, many were considered—Philip Pearlstein, Sidney Tillim, Nell Blaine, Milton Resnick, Vija Celmins—but just a handful made the cut.

Still, if there was one hallmark in addition to the overall seriousness of the 1967 grantees, it was the stylistic diversity of the group. Art historian Irving Sandler, who served on a panel the following year, observes that "the heads of the NEA seemed to make sure that no single artist and no single tendency would control these panels." He names off "Judd, Leslie, Anderson," pointing out that "right there you have three entirely different aesthetic positions."[38] Richard Hunt makes the same point, juxtaposing three other grantees: "The difference between Dan Flavin and his fluorescent bulbs, Dale Eldred who was working at that time a lot with earth works, or Stankiewicz working with junk [proves that] there wasn't an interest in making a statement through these grants about the ascendancy of a particular style. It was more about recognizing talent in need." Even though some panelists were more familiar with some communities of artists than others, no one was gunning for a particular style of work or for a particular constituency—just for the best artists. The 1967 grant list is a story of consistent quality but contrasting styles.

Indeed, it is probably only as part of a search, as Hunt says, to find "talent in need" that artists as stylistically opposed as Leon Polk Smith and H. C. Westermann would appear on the same list. When Smith received his grant he had been working for more than twenty-five years on synthesizing his observations of Mondrian's work with his desire to make paintings built from geometric, shaped fields of saturated color. (See Plate 1.) Smith's work influenced many

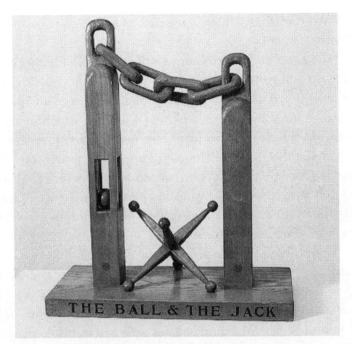

H. C. Westermann, *The Ball & The Jack*, 1965, ash wood, 28-1/4" x 24-1/2" x 11". Collection of Robert Lehrman, Washington, D.C.

artists, particularly Ellsworth Kelly (who became more famous but whose accomplishment falls far short of Smith's). By contrast, Westermann was an eccentric, known for his seemlessly crafted objects, many of which employed imagery from his World War II service on a ship that came under kamikaze attack. Westermann also made representations of common objects, which he loaded up with multiple meanings. Is *The Ball & The Jack* a simple homage to a child's game, or does the dangling chain reference the "ball and chain" of marriage? As the viewer ponders the mixed message, he also cannot help but wonder how Westermann managed to carve the entire work from a single, unseparated piece of wood. Where Smith's paintings were steeped in art his-

tory, Westermann's objects merged a magician's sensibility with an artist's eye.

The grant to Westermann confirms that Geldzahler's decision to fund only painters and sculptors did not exclude unconventional artists. If artists were serious, it made no difference what subject they took up (if any) or which medium they used. Flavin was working with neon lights, Eldred with reflected and refracted light. Bengston used spray paint, and Ruscha painted words. Cohen's assemblages included mirrors and doll parts. No matter what materials an artist used, what was important was that he engaged the materials in a way that was visually significant.

When they are asked how they spent the money, most of the early grantees give a twofold response: rent and paint. A few remember special purchases. Anderson put a skylight in his studio. Sam Gilliam was able to build a studio onto his house. Robert Mangold and his wife Sylvia, also a painter, had just had a child, so they bought a rocking chair and the household's first television set. For most grantees the support just made it easier for them to continue working. For a few artists the grant came at a particularly significant time.

Sculptor Mark di Suvero's first New York show had received rave reviews. In 1960 di Suvero's assemblage sculptures were mostly human-scale pieces constructed from joined pieces of wood or metal. But by the mid-sixties his work was starting to change, to become larger and more difficult to construct. Di Suvero faced another challenge: to continue working after a debilitating elevator accident nearly took his life. In the spring of 1965 di Suvero wrote to Geldzahler, who was not yet then at the NEA: "Crushed by a machine, I use machine parts now (or try to—this is the first time and perhaps I'll just scrap it). The big piece is done (18 or 20 feet high, it has a swing and is a tension structure)."[39]

As the world now knows, di Suvero did not "scrap" his

interest in industrial sculpture, in part because his grant helped him to push his work further. In 1970 he wrote to the NEA explaining the significance of his 1967 grant: "I bought a crane. It cost me $4,200 and then another $1,500 to get her running. With the crane as my paintbrush, I was able to do what every normal modern sculptor has dreamed of: to use industrial scale and size in sculpture."[40] Panelist Barbara Rose says that di Suvero "could not possibly have gone on to the next step in his work without that crane, and he could not have bought it any other way. And we all knew that." History will likely consider di Suvero one of America's most important postwar sculptors.

For Alfred Leslie the NEA grant was almost literally a lifesaver. In the mid-sixties Leslie was a well-known abstract painter and a leading figure among the de Kooning faction of the abstract expressionists. But in 1962 he lost interest in abstraction and began working on a series of large grisaille portraits. As one of the first New York School painters to introduce overt realism into his work, Leslie was considered a maverick. And he did more than just paint. He made films, took photographs, and published a magazine. He was the serious art world's answer to Andy Warhol, an artist willing to pursue any creative activity that might push his work further. Or, as Leslie puts it, he was intent to "become a victim to all these octopussarian impulses and trust in my intuition, let them take me over and lead me someplace fruitful."[41]

Leslie's early work sold so well that he probably would not have been considered sufficiently needy for an NEA grant. His name does not appear on any of the panels' lists of grant candidates. But six days after the last NEA panel met in 1966, the building that housed Leslie's studio burned to the ground. Everything was lost, including many grisaille paintings that were about to go on view at the Whitney Museum. Leslie was devastated: "My entire life's work as an artist was in a

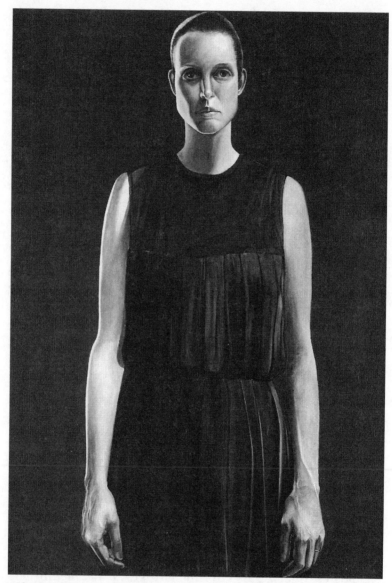

Alfred Leslie, *Lisa Bigelow*, 1964–1966, synthetic polymer on linen, 108" x 72". Courtesy of Indiana University Art Museum, Bloomington, Indiana.

shambles and I was left with my five-year-old son, no savings, no insurance, many acquaintances and a few good friends."[42] Leslie remembers: "Henry called me and said that I was going to be given the money, and it was marvelous." Geldzahler knew that an important artist, at a key time in his development, was in danger of having to stop working. And that was the sort of thing Geldzahler believed these grants were designed to prevent.

Geldzahler designed a number of programs, in addition to the individual fellowships, that were meant to get support into the hands of important, accomplished artists. The Museum Purchase Plan provided $10,000 matching grants to museums that bought work from living American artists. Most of the funds went to university and local museums, particularly those located some distance from where contemporary art was readily seen: Oberlin College Museum in Ohio, the Des Moines Art Center in Iowa, the Brooks Memorial Art Museum in Tennessee. In 1968 fifteen museums bought work from more than eighty artists, including Robert Irwin, Karl Knaths, Jim Dine, Jack Beal, George Segal, Ilya Bolotowsky, and many artists on the 1967 NEA fellowships list. Museums had new and exceptional art to display, and hundreds of thousands of dollars were, as Geldzahler put it, "pumped into the artists' economy."[43]

Geldzahler also envisioned programs to commission work directly from artists. Two proposals, for a Drawing Project and a Program of Portfolios of Authorized Prints, were designed to put art into circulation and to provide support for accomplished artists. Geldzahler hoped that each year the NEA could commission approximately fifty artists to create original drawings and prints. Editions of the prints and reproductions of the drawings would then be provided at a nominal cost to high schools, community colleges, and libraries. Geldzahler thought students would benefit from seeing original work, "a tangible and vital link to the creative

world of the artist."[44] But he also wanted to help the artists: "By commissioning artists to create these works," Geldzahler explained, "we put money directly in their hands [and] encourage and reward quality in the field."[45] Like the individual fellowships, Geldzahler thought of these programs as "important ways of stimulating and rewarding excellence."[46]

In the spring of 1969 Roger Stevens's term as NEA chairman expired. A newly elected President Richard Nixon chose not to reappoint him (in part because Stevens had worked for Democrat Adlai Stevenson in his two bids against the Eisenhower-Nixon ticket[47]). Geldzahler left too, citing his close working relationship with Stevens. Immediately upon their departure, both the NEA in general and the Visual Arts Program in particular changed in nearly every respect.

Nixon likely saw the same political potential in the NEA that Johnson had. Neither president enjoyed a rapport with cultural elites, a fact which may have worried both. After all, Johnson stepped into a presidency whose previous occupant had been portrayed as the most sophisticated president in history. In contrast, Johnson was described by the press as "aloof and ill at ease when dealing with members of the artistic and intellectual community."[48] And Nixon's impoverished upbringing had helped to instill in him a now-infamous cultural insecurity and a distaste for "Ivy Leaguers" and others from whom he felt apart. Both presidents had something to prove. Johnson did it by founding the NEA, Nixon by allowing it to be reinvented.

Each president also had advisers who believed strongly in the political benefit of federal arts funding. Immediately upon Johnson's swearing in as president, historian and adviser Arthur Schlesinger, Jr., a member of the Kennedy team, impressed upon Johnson the electoral importance of the arts. Schlesinger argued unabashedly that federal arts dollars equaled votes because arts funding "can strengthen the connections between the Administration and the intellectual and

artistic community—something not to be dismissed when victory or defeat next fall will probably depend on who carries New York, Pennsylvania, California, Illinois, and Michigan."[49] Nixon received similar advice. In the fall of 1969 his adviser and former campaign aide Charles McWhorter sent a memo to the White House recommending a "dramatic increase" in the NEA's budget. "At a time when it is probably impossible to satisfy all of our critics on Vietnam," McWhorter suggested that a rise in federal arts funding "would provide an opportunity to demonstrate the President's deep personal concern with improving the quality of living here at home, and his determination to present a better image of America abroad."[50] Whether either Johnson or Nixon bought their advisers' arguments, both presidents followed their advice.

When Nixon took office in 1969 the NEA's budget was $8.5 million. He immediately asked Congress to double that budget by 1971. Congress complied, giving the Endowment $16.4 million. In 1972 the budget nearly doubled again, rising to $31.5 million. By the time Nixon left office in 1974 the NEA's budget (at the president's behest) had multiplied eight-

Figure 1: How NEA Appropriations Grew

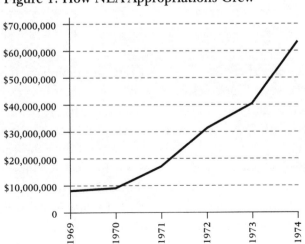

fold, from just over $8 million to more than $64 million (Figure 1).

During the Nixon administration the NEA's budget increased more rapidly than at any other time in the agency's history. But the agency's administrative budget was skyrocketing even faster than its grants budget (Appendix B). In the early 1970s the NEA's bureaucracy started mushrooming in size and cost, and the trend continues today (Figure 2).

Figure 2: The Rise of the NEA Bureaucracy
Administrative Budget as a Percentage of Total Budget

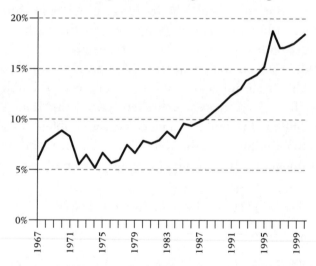

In 1967 the NEA gave away 16 grant dollars for every dollar it spent on administration. By 1983 that ratio had dropped to 10 grant dollars for each administrative dollar. By 1996 the NEA was 400 percent less efficient than it was in 1967, giving out only 4 dollars in grant funds for each administrative dollar spent. According to Alice Goldfarb Marquis, whose 1995 book *Art Lessons* overviews the NEA's history, "In 1966 only 28 people had staffed the offices full time; ten years later, there were 130 full time, assisted by some 70 'floaters' and a smaller number of freelance consultants." The

chairman's staff alone numbered 17.[51] Nixon's NEA was well on its way to becoming a well-fed bureaucracy.

The president also recommended that the Endowment adopt a more populist approach to its mission. In a Special Message to Congress in 1969 Nixon observed: "The full richness of this nation's cultural life need not be the province of relatively few citizens centered in a few cities . . . the diverse culture of every region and community should be explored." Nixon argued that the federal government had "an obligation to help broaden the base of our cultural legacy [and] to make its diversity and insight more readily accessible to millions of people everywhere."[52] Nixon wanted the NEA to increase and diversify the audience for art. Nancy Hanks, whom the president nominated for two terms as NEA chairman, shared Nixon's populist goals but took his thinking one step further.

When Hanks was nominated to become chairman of the Endowment, she was a little-known Rockefeller Republican. She was chosen at least in part because the White House wished to appoint women to visible government posts. Hanks viewed art as a broad, egalitarian project. She was uncomfortable with qualitative discussions about art and was once quoted as saying: "You've got to have a lot of 'bests.' If we go for just one, nobody would stand for it." Her way of discussing art made it sound more like a cause than an intellectual undertaking. In her 1983 obituary, Hanks was touted as someone that "nobody could call an elitist."[53] The Hanks definition of art was whatever artists were choosing to do. And she took it as her responsibility to support their work, unconditionally. Unlike the previous chairman and his staff, Nancy Hanks was not a stickler for quality.

Under Roger Stevens the NEA had functioned like an elite private foundation, parceling out grants strictly on grounds of merit. The early Endowment operated on the assumption that if you help ensure that the best artists have

the resources they need to make great art, everyone will benefit. Most of its programs focused on aiding individual artists. Even most of the NEA's institutional grants at that time were actually thinly veiled efforts to get more support out to individual artists. A few grants were made for programs aimed at reaching new audiences. In 1967 three museums received grants totaling $150,000 to design and implement education programs for teachers and community leaders. A handful of grants appeared to skirt the issue of standards, including one for a contemporary Appalachian arts and crafts exhibit and another to a photographer who was documenting the plight of Puerto Rican immigrants living in New York City tenements. But by and large the early NEA, and Geldzahler's Visual Arts Program in particular, was a model of elitism, aimed at seeking out and supporting America's best artists. With Hanks at the helm and the NEA funded to the hilt, a new philosophy quickly took over, one which valued pluralism above excellence.

The Endowment's new priorities were laid out in a three-point mission approved by the National Council in 1971:[54]

1) *Availability of the Arts:* To encourage broad dissemination of the arts of the highest quality across the country.

2) *Cultural Resources Development:* To assist our major arts institutions to improve artistic and administrative standards and to provide greater public service.

3) *Advancement of Our Cultural Legacy:* To provide support that encourages creativity among our most gifted artists and advances the quality of life of our Nation.

Individual artists were now the Endowment's lowest priority, behind outreach and institutional support. The institutional emphasis quickly gave rise to a cadre of arts lobbyists who worked tirelessly on behalf of the NEA's expansion. They

would shape NEA budgets for years to come. The new stress on "dissemination" also was, in part, shaped by Hanks's desire to grow the agency at any cost. In the visual arts Hanks was willing to embrace any art form which could serve as an excuse for asking Congress for additional funding. Of Hanks starting a Folk Arts Program in 1975, Alan Jabbour of the American Folk Center remarked: "She had no idea what the hell she was getting into. She just sensed that it would play well on Capitol Hill."[55]

Hanks also lassoed funding for a series of outreach efforts. These attempts to bring art to the masses met with uneven success, largely due to the Endowment's top-down approach. In a 1970 memo to Hanks titled "The Wichita Story with a Footnote on St. Louis for Light Reading When in Europe," Hanks's new director of visual arts, Brian O'Doherty, recounted site visits to two outreach efforts. The first report concerned a public sculpture project in Kansas. In commemoration of Wichita's second century as a city, its citizens were hosting a sculpture competition. Plans had been made and funds already collected when the NEA recommended that Wichita enlist the Endowment's assistance. Community leaders submitted a grant application and soon found themselves on the receiving end of a lot of advice. "We finally got them off the competition idea," O'Doherty wrote, "and immediately had to soothe suspicions." The NEA organized a seven-person panel and charged it with choosing a sculptor. The people of Wichita felt underrepresented after being allotted only three seats on the panel. They became further upset when two of the NEA's panelists (a New York art critic and an art historian from the University of California at Berkeley) complained to a local newspaper. According to O'Doherty, letters to the newspaper argued: "Forget the National Endowment and let's go it alone." O'Doherty reported that the selection of abstract sculptor James Rosati was, in

the opinion of Wichita citizens, "stuffed down their throats," and "they don't heartily admire what he does."[56]

Next, O'Doherty reported on an effort to find a candidate in St. Louis for the Inner City Mural Program. Hanks started the short-lived mural program as an effort to use art to help "inner city residents ... express their community's ideas, concerns, and pride."[57] O'Doherty recounted "the unique experience (for me) of driving around the Waste Land (ghetto) with a black lawyer from the Mayor's office." He observed with dismay that "they've got the inevitable Wall of Dignity (Martin Luther King, Malcolm X, Cassius Clay, James Baldwin, etc.)." O'Doherty thought the prospects for inspiring a community effort were bleak because "the ghetto itself is more depressing than most. The faces looking out didn't even hate—[they] simply had been wiped blank. I don't think we're going to have sudden success in fostering local pride and dignity." Snapping back into form, O'Doherty told Hanks "if you're reading this in Venice" (where she would be on vacation), remember that "if the Rothko show is still on at Pesaro, don't miss it."[58]

The Endowment's new dissemination and outreach priorities did much more than just expand the agency's budget. Under Nancy Hanks the NEA began embracing the idea that the art it funded should encourage some sort of good in the world, that art's virtue resided not in its aesthetic quality but in its ability to effect social change. There is no evidence that Hanks understood this idea in anything but the most altruistic terms. Still, the Nixon-Hanks push for the democratization of the arts coincided with a shift in thinking among many in the art world who had decided that artistic standards were old hat and needed to be replaced with goals deemed more relevant to contemporary concerns. And it wasn't long before the organization of the Endowment's Visual Arts Program began to reflect this way of thinking.

2

BUREAUCRATIC ART

Before becoming director of the NEA's Visual Arts Program, Brian O'Doherty's career had been uneven. During short stints as an art critic for the *New York Times* and *Newsweek*, some of O'Doherty's artistic assessments were so wildly off the mark that they were later cited, with irony, in articles about the artists. Two prominent examples include O'Doherty's blasting of pop art pioneer Roy Lichtenstein as "one of the worst artists in America," and his calling the work of abstract painter Frank Stella "valueless as art."[1] O'Doherty says he left both critic jobs because he "wasn't much interested in writing for the little old lady in Topeka."[2]

He also made art before going to the NEA, and to this day he still works. Over the years O'Doherty's artwork has taken different forms, always keeping pace with the trend of the moment. In 1962 O'Doherty made a portrait of Marcel Duchamp by hooking this father of conceptual art up to an electro-cardiograph and presenting the readout as documentation. He staged a "happening" in 1967 where performers in white body stockings and featureless silver masks repeatedly asked, "Why don't you open the door?" and responded,

"There's nobody there." O'Doherty made a political-artistic statement in 1972, changing his name (as an artist) to Patrick Ireland, out of solidarity with the citizens of his homeland, and pledging to keep the name until British forces vacated Northern Ireland. This name change was accompanied by a performance in which O'Doherty was painted orange from the head down and green from the feet up to produce a symbolic blending of the colors associated with Ireland's warring Protestants and Catholics.[3] In a seventies interlude with gender construction, O'Doherty adopted the identity Mary Josephson, under which name he published art criticism and photographed himself in drag.

As colorful as O'Doherty's work has been, he is better known for a series of essays he published in *ArtForum* magazine in 1976, when he was already at the NEA. In these essays O'Doherty called for a new kind of artmaking that would break out of the "white cube" of the traditional gallery space, which he dismissed as elitist and ideological. According to O'Doherty, the "white cube" was guilty of giving off "negative vibrations" which imply that art is "difficult." He argued that such an elevated, pristine environment was inherently at odds with the new art's emphasis on the real.[4] Not only did the "white cube" have to go, O'Doherty declared, but so did the notion of serious artmaking—replaced by unfiltered, untempered experience. In keeping with the "painting is dead" ethos of the sixties and seventies, O'Doherty wrote:

> The picture plane, like an exclusive country club, keeps reality out and for good reason. Snobbishness is, after all, a form of purity, prejudice a way of being consistent. Reality does not conform to the rules of etiquette, subscribe to exclusive values, or wear a tie; it has a vulgar set of relations and is frequently seen slumming among the senses with other antithetical arts.[5]

O'Doherty's recommended metaphor for this new age was "to ejaculate over the space on entering a gallery."[6] He further suggested that "a perfect avant-garde act would be to invite an audience and shoot it."[7]

O'Doherty arrived at the Endowment in May 1969 and spent the next twenty-seven years directing first the Visual Arts and then the Media Arts programs. He proved effective (probably even more so than Geldzahler) at turning his ideas into grant programs. The founding director of the Menil Collection, Walter Hopps, who served on the West Coast fellowships panel in 1967 and on many later panels, said of O'Doherty:

> In my lifetime, and I was born when Herbert Hoover was president, I haven't seen anyone as effective vis-à-vis centralized power with respect to the manipulation of public money since (former Chicago mayor) Richard J. Daley controlled the Democratic machine.[8]

One of the first changes O'Doherty made was to shift funding away from exactly the artists who had comprised the core of Geldzahler's program: painters and sculptors. O'Doherty argued that important artists were no longer interested in painting and sculpture because they recognized that these media were suffering from "historical exhaustion." More significant work was being done in "mixed categories," which O'Doherty defined as including "performance, post-Minimal, video, [and] tuning the environment." In O'Doherty's view, artists preferred these areas to painting and sculpture because they could "present more temporary situations involving an inspection of consciousness."[9] It was hardly news that in the late sixties and early seventies many artists were beginning to stretch the definition of art to include almost any activity. Geldzahler knew this as well as O'Doherty. But Geldzahler took a measured approach, directing funding only

toward endeavors of proven merit. This was too confining for O'Doherty, who took the proliferation of new mediums as license to open up the Endowment to every known art trend— not in addition to, but at the expense of, supporting painting and sculpture.

In 1971 and 1972 the NEA gave no fellowships to painters or sculptors, but grants were introduced for photographers and, in 1973, for craftsmen. In 1974 printmakers and video, performance, and conceptual artists also began receiving grants. Some of these art forms had long been considered low arts. Historically both photography and printmaking have been seen as too technical to be high arts. Geldzahler once argued that "painters [make] prints of consistently greater clarity and carrying power than professional print-makers."[10] The decision to award fellowships to craftsmen was the clearest indication that the NEA was expanding its definition of art to include even casual creative activity. Indeed, perhaps because of Hanks's constant push for more funding, the NEA went further than just offering fellowships in these new categories. An array of programs was designed that would help to professionalize and increase the standing of these newly elevated art forms. O'Doherty explained:

> To the fellowship program, photography added exhibition aid in 1973, assistance to publications in 1975, and a state and regional survey program in 1976. Crafts fellowships were joined in 1975 by a separate crafts workshop program, by exhibition aid in 1974, and by an apprenticeship program in 1975.[11]

A fellowships category was added even for art critics. The Visual Arts Program was now investing most of its funds outside the artist's studio.

Throughout the 1970s the NEA spent more money fueling the expansion of the art world than it did helping

individual artists. Four programs—Services to the Field, Short-Term Activities, Visual Arts in the Performing Arts, and Workshops/Alternative Spaces—were established to help build new visual arts institutions. The description of the Visual Arts Program in the NEA's 1976 annual report boasts of "an expansion over the course of ten years from two funding programs to sixteen."[12] As with the booming numbers of fellowship grants, the focus of institutional grantmaking was on quantity, not quality. In 1977 nearly half the applicants in the Workshops/Alternative Spaces program received grants. In 1969, for the first time, the number of grant dollars in the Visual Arts Program going to institutions surpassed the number going to individuals. Institutions would maintain the upper hand until 1982.

Still, the NEA grants to individual artists remained influential, particularly because the Endowment was now in the business of funding the so-called "cutting edge." In order to pursue this new goal, the NEA had to reverse course on its policy regarding the level of achievement required of its grantees. Under Geldzahler, fellowships had gone primarily to artists who already had demonstrated some level of achievement. After 1970 grant-seekers no longer needed to demonstrate significant accomplishment because the National Council "agreed to stress fellowships for future work, rather than awards for past achievement."[13] Accomplishment was now a liability for an NEA applicant. Being a novice had become a virtue.

This weakened standard for awardees, together with the increases in funding, encouraged a freewheeling approach toward grantmaking. Instead of painstakingly whittling down a list of candidates to only the best and brightest, the visual arts panels were now handing out hundreds of grants. By 1978 the NEA was awarding fellowships to art critics, artists specializing in drawing, conceptual artists, craftsmen, envi-

ronmental artists, painters, performance artists, photographers, printmakers, sculptors, and video artists. The fellowship program that Geldzahler had once feared would be insufficiently selective at 60 grants was, between 1974 and 1986, awarding an average of 300 grants per year. In 1980 alone, 531 artists received fellowships totaling over $3 million, ten times the amount spent on fellowships in 1967.

Where Geldzahler had carved out an important role for the NEA at a safe distance from experimentation, the NEA was now leaning into trends, coaxing them along with massive amounts of funding. Throughout the 1970s organizational changes to the fellowships program made it even easier for cutting-edge artists to get NEA fellowships. In 1974 fellowships were earmarked specifically for video artists, and in 1976 separate panels were convened in the video and conceptual/performance art categories. These and other changes had the effect of providing a set-aside for experimental art forms. Not only could video, conceptual, and performance artists now avoid direct competition for grants with painters and sculptors, but separate pots of money assured them a certain level of funds regardless of the comparative quality of their applications.

As the NEA was disbursing exponentially more visual arts fellowships than it ever had before, a profile was emerging of the typical grantee. Most fellowship recipients—in all categories—were making work that tended toward the provocative in one way or another. O'Doherty describes applicants for the Endowment's first photography grants, in 1971: "Most of the applicants were young, freelance photographers; most of the projects centered in documentary studies of specific groups or communities: gypsies, Chinese-Americans, mobile home owners, rodeo circuit riders."[14] Some projects seemed oddly amorphous, like video artist Agnes Denes's 1974 fellowship "to continue my open-ended philosophical inves-

tigations in theoretical aesthetics." Other projects appeared trivial, like a $3,000 grant in 1974 to video artist John Margolies to collect "contemporary commercial television collage tapes." Many applicants described projects that did not even sound art-related. John Cloonan's grant was for "comprehensive research on the dreams of the blind" while Andrew Menard's $3,000 grant went to publish his conversations with "political scientists and others."[15]

A few NEA officials were becoming worried that grants like these might spark public controversy over the Endowment. The NEA already had caught flak in 1970 for a $500 subgrant to a poet who used the money to produce a one-word poem which read: "LIGHGHT." Michael Straight, the NEA's deputy chairman, was worried about more than just public controversy. Straight thought that the Visual Arts Program in general—and its fellowship awards in particular—were having a destructive effect on the visual arts themselves.

In 1972, after sitting in on a series of panels convened to select that year's fellowship awardees, Straight wrote to Chairman Hanks: "I believe that [the fellowship program] harms rather than helps the artists. I believe further that it will harm the NEA." Straight had two criticisms of the panels: their members did not represent a sufficient diversity of artistic style and approach, and their decisions were not based on any shared understanding of aesthetic standards. Straight concluded that the program was "misguided in principle and probably unworkable in practice." He was particularly concerned about an excessive number of grants going to video and conceptual artists in light of the substantially greater number of applicants in more traditional categories. "If large numbers of painters and sculptors were rejected in order to fund these grants," Straight asked, "don't they have a legitimate complaint?" Of the grants for experimental art, Straight said: "I'm not prepared to defend them in public."[16]

O'Doherty and his staff responded to Straight's concerns by packaging potentially controversial grants in ways that would divert the attention of critics. In a memorandum summarizing the program's new approach, the Visual Arts Program staff reasoned that if the Endowment stopped asking artists to describe their projects in their grant applications, the NEA's files would be rid of potentially embarrassing paperwork. The memorandum suggested that asking for such material was unfair:

> In asking artists to provide [a] written description of the activities they propose, an injustice occurs in two respects: First, the artist may not have the ability to accurately describe his activity (he is not necessarily adept at writing); secondly, no matter how well expressed, some visual projects may sound unimportant or even silly to laymen.[17]

In 1973, grant application guidelines had directed artists to include a "brief but specific" project description that would "spell out concrete details [of] all essential elements of the proposal."[18] In 1974 those instructions were replaced with a warning: "The description should not include elaborate statements of your aesthetics or philosophy."[19] The 1975 application guidelines did away with project descriptions altogether. Where the application form provided a blank for a "Description of Proposed Activity," a preprinted statement appeared in large type: "Should a grant result from your application, grant funds will be used to advance your career in a fashion consistent with your previous performance as shown by your slides and other supportive material." Because some artists still tried to include project descriptions on their application form, in 1977 a clearer instruction was appended to the preprinted statement: "No project description neces-

sary."[20] By 1983 the "Description of Proposed Activity" blank, and its prewritten statement, had been deleted altogether.

Removing the project description from the grant application was deceptive because the Endowment was continuing to ask for project descriptions, but now only as an attachment to the formal application. In this format, the program pointed out, "Should a situation reoccur where an artist has described a project which presents funding difficulties . . . the Endowment will be in a better position to deal with the application since the description will be separate from the official forms which are referenced in the grant letter." In other words, since any controversial materials would now appear as a separate attachment, no one would notice if they disappeared. And since such attachments would not be mentioned in the application, no one would think to ask for them anyway.

In addition to these procedural sleights of hand, the Visual Arts Program was now also masking potentially scandalous applications. Michael Straight had worried about a grant to James Pomeroy, who requested support in 1975 for a project involving "drip[ping] ink from Hayley, Idaho to Cody, Wyoming." A Visual Arts Program memorandum reported how the grant was handled: "It was decided that the grant letter would stipulate that funds were being provided solely for Item B of his application. In this way the Endowment is not in a vulnerable position."[21] Item B of Pomeroy's application stated his desire, in addition to his proposed project, to buy materials to continue his previous work. Ironically, funding only half of Pomeroy's plans resulted in an increase, not a decrease, in the size of his grant. Pomeroy had requested $3,000 but he received $4,000 from the NEA.

A Visual Arts Program memorandum described how other applications were "handled." Richard Harder explained in his

NEA-2 (Rev) OMB-128-R0001

Visual Arts

INDIVIDUAL GRANT APPLICATION
NATIONAL ENDOWMENT FOR THE ARTS
WASHINGTON, D. C. 20506

NAME (Last, first, middle initial) | U. S. CITIZENSHIP
☐ YES ☐ NO VISA NO.

PROFESSIONAL NAME OR PSEUDONYM | PROFESSIONAL FIELD OR DISCIPLINE

PRESENT MAILING ADDRESS | SOCIAL SECURITY NUMBER | SEX | DEPENDENTS

PHONE NO. AC | BIRTH DATE | PLACE OF BIRTH

PERMANENT MAILING ADDRESS | PERIOD FOR WHICH GRANT SUPPORT IS REQUESTED
STARTING ___ MONTH ___ DAY ___ YEAR
ENDING ___ MONTH ___ DAY . ___ YEAR

PHONE NO. AC

DESCRIPTION OF PROPOSED ACTIVITY

"Should a grant result from your application, grant funds will be used to advance your career in a fashion consistent with your previous performance as shown by your slides and other supportive material."

AMOUNT REQUESTED FROM NEA $_____ ALLOCATED AS FOLLOWS: $_____ TIME $_____ TRAVEL $_____ MATERIALS

CAREER SUMMARY OR BACKGROUND

(IF ADDITIONAL SPACE IS REQUIRED, USE SUPPLEMENTAL SHEETS AND STAPLE TO THE APPLICATION.)
CONTINUED ON REVERSE SIDE

Individual Grant Application, National Endowment for the Arts, Visual Arts Program, Fiscal Years 1975 and 1976.

1975 application that he made process-related sculptures in which he would "construct and destroy a monumental sculpture within a day's time." He offered the example of a piece he made by cutting holes in sandbags and letting the sand

pour out. The Visual Arts Program cited Harder's application as epitomizing "the kind of problems created by a written narrative." In order "to place the Endowment in a stronger defensive position," the program suggested that Harder's "grant letter be modified to place the emphasis on Mr. Harder's slides rather than his proposal." Harder got off easy in comparison to Darryl Sapien, who was awarded $4,000 for his plan to "perpetrate a coup d'état of sorts on the San Francisco art oligarchy [by] seizing vacant spaces within the city and transforming them into creatively functional performance sites."[22] Sapien was required to "re-work his application into a form which more accurately and less aggressively describes his activity." Sapien went on to win another $20,000 NEA grant in 1991.

Bonnie Sherk also was awarded a grant in 1975, but only after filing a new, more appropriate, application. Sherk's project, described in the fullest terms in her original application, involved shutting herself into a cement-floored studio with a few friends and numerous animals (a sow named Pigme, two ring-necked doves, a woolly monkey, etc.). Together they would engage in "building and maintaining nests." The artist specifically requested money for a "motorbike with a large sidecar" to help the group venture outside the studio.[23] Sherk was asked to "better describe her conceptual project involving nature and animals" in a new application. She received a $4,000 grant.

Throughout the late seventies and eighties the NEA's budget continued to rise while, paradoxically, the ever more numerous fellowships began focusing even more narrowly on experimental art. In 1977 the directorship of the Visual Arts Program passed from O'Doherty to James Melchert, an artist and professor at the University of California at Berkeley. In the NEA's 1979 annual report, Melchert sketched out his view of the types of artists who made successful fellowship appli-

cants. Melchert called the "most important group" of artists that the NEA funded "investigators," or "people involved in radical research into the nature of art." Another type of artist "to which we pay much attention," according to Melchert, were the "innovators" or artists involved in "taking a familiar form and re-examining it in a highly individual way."

Melchert dubbed the largest and least successful group of applicants "followers," who were "usually competent artists working within a tradition . . . but without submitting it to any radical revisions." These artists, according to Melchert, produced "competent compositions, but ones which we have seen so often that they are practically visual clichés." No doubt some of the "follower" artists Melchert had in mind were of the unrigorous, Sunday-painter variety. But Melchert's statement dismissed more artists than just the nostalgic painter. It excluded any artist who conceived of his task, even in part, as learning from and building on the art of the past. Of applications from "followers," Melchert stated flatly: "We do not believe it is our job to support this kind of artistic activity."[24] In short, if you don't think painting is dead, don't bother applying for an NEA fellowship.

The kind of artist the NEA was seeking to support was typified by those receiving fellowships in a newly established category: Building Arts. In the Endowment's 1980 annual report, Melchert described an ideal Building Arts grantee: "A sculptor in New Mexico, for example, designed his own hydroelectric system to tap a stream on his property and then built his house around it. Considering the increasing scarcity of energy sources and materials, such demonstrations of alternatives are timely and worth encouraging."[25] In 1980 and 1981 alone the Endowment spent more than $250,000 on Building Arts projects.

Of course, the NEA had been moving away from supporting serious painting or sculpture for years. In 1976 painter

Philip Pearlstein sat on a fellowships panel and noticed, after viewing applicants' slides for a full day,

> that nearly all the slides we had looked at were of installations of things scattered through rooms, some with sound; some were only sound on tape. . . . We were not shown many paintings that had four sides, and few sculptures that had a single axis. Nothing shown was representational; very few works were traditional in any way.[26]

When Pearlstein mentioned this to an NEA staffer he was told that two panelists had been asked to review the applications the previous day and to remove from the competition any artist deemed "uninteresting." Pearlstein recalls: "So then I spent an hour going through the slides that had been culled, and put back in the running about one hundred artists—traditional abstractionists as well as representational artists." Years later Pearlstein cited his NEA panel service as an example of "censorship on stylistic grounds," where artists working outside the strictures of postmodern academic taste were cast off, regardless of the quality of their work.

Historically art thought of as academic—literally, derived from the art academy—has been lightweight, ultra-conservative work, epitomized by the nude nymph paintings that graced the walls of the late-nineteenth-century French Salon at the expense of Cézanne, Seurat, and other members of the rising modern avant-garde. But the American art world of the 1970s and 1980s put a new spin on the idea of "academic" art. Postmodernism ushered in an establishment academicism which celebrated the contrary for its own sake. Suddenly, being shocking or offensive or just anti-art was the safest approach an artist could take. Painting figures, landscapes, or even just painting at all placed an artist on the margins of establishment taste.

The NEA panels began reflecting this theory-driven ap-

proach to art in part because the number of artists serving on panels was declining. In 1975 only fifteen of the forty-nine visual arts panelists were artists. Just one artist sat on most panels. During a twelve-year stretch, from 1975 to 1987, artists only twice constituted the majority of Visual Arts Program panelists. The NEA's "peer panels," as they were increasingly being referred to, were now dominated by nonartists. The prominence of nonartists significantly altered the tenor of panel deliberations. Many artists naturally were hesitant to disagree with influential curators or critics who served on panels. After all, there was little incentive for an artist to defend a worthy application if it meant crossing swords with someone in a position to take it out on the defender's own work. Other more subtle differences had even greater influence on the panels' decisions.

Sculptor Richard Hunt, who served on the Midwest panel in 1967, sat on a fellowships panel again in 1975. Its eleven members included six artists. Hunt was surprised to find that the atmosphere had become argumentative, almost combative, and that the focus of discussion had shifted. He remembers that in 1975 "there was more advocacy for particular points of view," with panel discussion driven less by an interest in individual artists than by a desire to advocate certain kinds of art and oppose others. Hunt recalls: "People on the panel who were curators and directors of museums were quick to recognize people they had an interest in or had done something with." Because many curators' own careers were wedded to particular trends, they used the opportunity of serving on the panel to promote artists representing those trends. "Two curators might come to a panel," Hunt recalls, "prepared to support certain ideas." And they came ready in ways that artists did not, Hunt recalls: "They have files in their offices about artists. I know artists I like, but I don't have files." The panels had become tug-of-wars, won by who-

ever pulled most aggressively for his interests. In the words of another panelist, "zealousness had replaced quality."

That zealousness was fueled by another new influence on the NEA panels, that of the repeat panelist. Even as the Endowment's funds were helping expand exponentially the number of people working as artists and art professionals, the agency's own visual arts panels recycled the same panelists time and again. Between 1972 and 1990, sixty-four panelists served two years in a row and eighteen panelists served three consecutive years. The greatest overlap occurred between 1981 and 1986, when 24 percent of panelists, on average, served two consecutive years. Thirty-two percent of the panelists sitting in judgment on applications in 1986 had done so in 1985.

Among the "regulars" serving on Richard Hunt's 1975 panel were Marcia Tucker and David Ross, two rising stars among a new generation of activist-minded curators and museum administrators. Tucker and Ross began their career during the Vietnam era and, like their peers in academe, they considered themselves intellectual activists who saw their work as an extension of their personal politics. In 1977 Tucker founded the New Museum of Contemporary Art, a New York City gallery-museum hybrid dedicated to advocating political art. According to Tucker, whom the *New York Times* called the "high priestess of trendiness," she started the New Museum "to see what happens when you don't look at everything through white male eyes."[27] Ross, who was an early proponent of video art, became director of the Whitney Museum and led it through its most controversial years. The climax of Ross's tenure was the universally derided 1993 biennial exhibition of American art which strove to relocate art permanently into the realm of politics.

Tucker served on NEA panels three years straight, from 1973 to 1975, and then again in 1980 and 1982. Ross sat on

panels in 1975, 1976, and 1980. Kathy Halbreich, another activist-minded curator who eventually became director of Minneapolis's Walker Art Center, served every year from 1982 to 1987. Another panel regular was art historian and critic Rosalind Krauss, who championed the notion that photography had replaced painting as the ultimate art medium. Krauss served on panels in 1981, 1982, and 1984.

This reuse of panelists led to a fair share of favoritism. Tucker was awarded an individual grant in 1977, and her New Museum received grants for six straight years from 1978 to 1983. The Long Beach Museum of Art, which Ross helped make into a showcase for most types of postmodern art, began receiving NEA grants when Ross joined the staff in 1974. Long Beach continued to receive grants for the next five years. *October,* an art-theoretical journal co-founded by Krauss, received NEA grants for fifteen consecutive years, from 1979 to 1993.

But simple favoritism does not fully explain the bias in the NEA's grantmaking during this period. More than just awarding grants to one another, influential nonartist panelists were also pushing the NEA decisions toward embracing a postmodern academic view of art. The artists and even more so the institutions that reflected this view were not simply bestowed grants, they were placed almost permanently on the government dole. Among the favorites were various alternative art spaces, which would lead the NEA into controversy in later years.

The NEA began funding the Franklin Furnace in New York City in 1977, just a year after it was founded. The Furnace's performance-art space and its archive received thirty-three grants over twenty years, an NEA investment of more than $600,000 in all. Director Martha Wilson told the *New York Times* that Furnace performers generally "use nudity,

religious imagery, bodily fluids, and references to sex and violence—all the stuff that's supposed to be wrong" and which offends "guys in three-piece suits."[28] The Furnace became a source of controversy in 1990 when porn-star-turned-performance-artist Annie Sprinkle performed an act which included a "public cervix announcement," wherein the audience was invited to view Sprinkle's cervix through a speculum. Controversy reignited in 1992 after the Furnace submitted a videotape of performance artist Scarlet O in a grant application to the Endowment. Scarlet O was shown dressed as a man, then a woman, then disrobed and asking audience members to rub him/her with lotion.

Another performance space that became a thorn in the Endowment's side was the Kitchen, also in New York City, which received twenty-five NEA grants over eighteen years. In the late eighties the Kitchen came to be identified with one of its regular performers, Karen Finley. It was there that Finley premiered "We Keep Our Victims Ready," a performance-art piece in which she railed, as one critic put it, against "males, museums that don't show art made by women, child and wife abusers, males, Jesse Helms, the Roman Catholic Church, males, religious zealots, Nazis and males."[29] What Finley said in the performance didn't become nearly as infamous as what she did: smear her body with melted chocolate, onto which she sprinkled candy, alfalfa sprouts (standing in for sperm), and Christmas tinsel.

The NEA funded many other similar institutions that never reached the same level of notoriety as the Franklin Furnace and the Kitchen. Artemisia Gallery, a woman-only art space in Chicago, opened its doors in 1973, began receiving NEA funds in 1975, and received eighteen awards over the next fifteen years. One performance at Artemisia in the seventies involved three leather-clad men bursting into the

gallery, throwing a woman to the floor, and committing an apparent rape. As it turned out, the victim was a performance artist, her art piece an attempt to raise consciousness about women's vulnerability.[30] Creative Time, which organizes public art projects in New York, was awarded twenty-nine NEA grants over nineteen years, totaling almost $800,000. Another frequent sponsor of Finley's work, Creative Time commissioned the performance artist in 1998 to create 1-900-ALL-KAREN, described by the *Washington Post* as a "pay-per-call phone line devoted to a daily changing recorded screed on such subjects as sex, her Supreme Court case, and, as she warns, 'whatever the hell I feel like talking about.' "[31] Exit Art, a nonprofit gallery which has received eleven NEA grants, was founded by artist Papo Colo, who in 1977 ran down New York City's West Side Highway with fifty-one pieces of lumber tied to his legs, arms, and back. Eventually Colo collapsed, but not before explaining that his performance illustrated Puerto Rico's uncertainty toward statehood.[32] Colo also received a $15,000 NEA fellowship in 1983.

The NEA's early and continued support of postmodern academic art led the agency, by the early nineties, into an almost constant state of controversy. Two artists in particular came to symbolize the Endowment's problems: Robert Mapplethorpe and Andres Serrano. Each was a photographer whose work appeared in shows underwritten by the NEA. A Serrano photograph of a crucifix submerged in urine, and a portfolio of Mapplethorpe photographs showing violent sexual acts, elicited widespread criticism, from the floor of the United States Senate to the op-ed pages of even the smallest newspapers. NEA supporters trying to protect the fellowships program pointed out that the controversial grants had actually gone to institutions showing the photographers' work, not the artists themselves. But both artists had in fact

received individual NEA grants in the past. The Endowment awarded Mapplethorpe $15,000 in 1984 at a time when his work consisted mostly of portraits and dramatic photos of flowers. Serrano's grant came in 1986 when he had just begun using bodily fluids—blood, semen, urine—in his work. His infamous *Piss Christ* was made just a year after receiving his NEA grant.

The dispute over the Endowment was marked by the outspoken opportunism of its critics and defenders—one side crying blasphemy, the other claiming censorship. A serious discussion about the NEA was surely needed. In budgets, programs, and personnel the agency had mushroomed far beyond its original conception, and in its grants to individual visual artists it had moved away from what was once a solidly conceived program backed by public confidence. But by the time the Mapplethorpe/Serrano controversy hit in 1989, the Endowment was so wedded to the mission of fueling the so-called cutting edge that pulling back from that goal came to be seen by the agency as tantamount to unconditional creative surrender. The NEA's leadership, under all White Houses, had refused to defend either the agency or the art it funded. Instead successive NEA chairmen recited the mantras of censorship and artistic freedom even while maintaining a panel system that discriminated against artists outside the postmodern art establishment.

The most thoughtful contributions to the NEA debate came from the only visual artists to serve on the NEA's National Council in the eighties or nineties. Abstract painter Helen Frankenthaler was a Council member from 1984 to 1992. Midway through her tenure she wrote an article in the *New York Times* referring to the Endowment as a "mediocre art enterprise."[33] Frankenthaler was finding panel recommendations to be of "increasingly dubious quality" and asked

whether the NEA, "once a helping hand, [was] now beginning to spawn an arts monster?" She blamed the panel system for failing "in its job of 'quality sifting'":

> Despite the deserved grants, I see more and more non-deserving recipients. I feel there was a time when I experienced loftier minds, relatively unloaded with politics, fashion and chic. They encouraged the endurance of a great tradition and protected important development in the arts. I recall spirited, productive discussions and arguments.

Frankenthaler questioned the wisdom of the agency's preoccupation with the cutting edge: "Do we lose art along the way, in the guise of endorsing experimentation?"

Painter William Bailey asked similar questions when he took over Frankenthaler's Council seat in 1992. Bailey's criticism was aimed squarely at the panel system. He thought the panels' recommendations reflected a tendency of individuals in any decision-making group (but particularly pernicious when applied to art) to allow compromise to rule the day. Instead of funding the best artists, Bailey suspected the panels were settling on "the most agreeable person to satisfy all the people on the panel, and that's not usually the best person in the applicant pool." He also was concerned about the considerable influence of nonartists. "The dynamics of a panel," Bailey pointed out, "usually means that the strongest and most persuasive individual gets his or her way."[34] This was more likely to be someone who wrote criticism or conceived exhibitions, not someone who spent his days alone in a studio. Bailey called on the Visual Arts Program to have a "major American artist" on every panel it convened, someone whom critics and curators couldn't intimidate and who would add some "wisdom" to the decision-making process.[35]

Still, Bailey's most repeated criticism dealt with the nar-

rowness of the Visual Arts Program's definition of contemporary art. He found the panels driven by "a kind of clubby assumption that [panelists] know what's going on in contemporary art," even though their recommendations revealed that they had only a blinkered view. Because the panels lacked "artistic diversity," they applied a "lock-step notion" of the cutting edge, Bailey concluded. As a result, the bulk of the Visual Arts Program's grants went to individuals, museums, and artists' forums that created and supported the "official art of our time," in Bailey's words.[36] Postmodern academic art had become Government Art.

This bias only worsened when the Endowment began hiring onto its staff exactly the art bureaucrats who—during repeated panel service—had led the NEA down the path toward support of postmodern academic art. In 1994 one of the panelists with the most service in the eighties and early nineties became director of the Visual Arts Program. Jennifer Dowley served on twelve NEA panels over a fourteen-year period. Before being hired by the Endowment she ran the Headlands Center for the Arts, which offers residencies for artists and interdisciplinary public programs in Sausalito, California. When Dowley assumed the directorship of the Visual Arts Program in 1994 she was a seasoned veteran of the NEA's panels, well aware of how incestuous the review process had become. In 1987 and 1990 she had even sat on three separate NEA panels that awarded grants to Headlands. After Dowley went to the NEA, Headlands continued to receive grants, including two awards in 1995 and grants in 1996 and 1997.

Dowley's resumé makes a stark contrast with that of Henry Geldzahler, the Visual Arts Program's first director. Geldzahler's relationship with artists was firsthand and based on time spent in studios; Dowley knows artists from the once-removed vantage point of an arts administrator. Where Geld-

zahler's keen "eye" was the result of extensive academic train-
ing in connoisseurship, Dowley's resumé lists graduate courses
in "personnel administration, fundraising, and problem solv-
ing." Where Geldzahler rather infamously had struggled with
even the most basic administrative tasks, Dowley is a bu-
reaucrat with thirty years' experience working in the art-sup-
port institutions that make up the extended art world. Dowley
oversaw the final round of fellowship grants before Congress
in 1996 cut off the NEA's funding of individual visual artists.

The 1995 awards reflected the biases the program had
developed in the thirty years since its founding. Fifty-eight
grants were given in three categories: other genres, painting,
and works on paper. ("Other genres" is a catchall category
for artists who work in nontraditional mediums, including
performance and video.) Because an almost equal number of
grants was awarded in each category, applicants working in
more popular mediums, such as painting, were far less likely
to receive a grant than performance or video artists. In 1995,
each of the 2,577 applicants in the painting category stood
less than a 1 percent chance of receiving a fellowship. Any
of the 375 "other genres" applicants was six times more likely
to receive a grant than any painter. Many of the 1995 grantees
were also NEA "regulars." For almost a third of the awardees,
this was at least their second Endowment grant. For five
grantees it was their third. For one performance artist in the
"other genres" category, this 1995 fellowship was his third
NEA grant in as many years.

East Coasters, and New Yorkers in particular, fared bet-
ter than artists elsewhere. Almost half the awards went to
New York artists, and 60 percent of all fellowships went to
the East Coast. Five grants were to Midwestern artists, and
two went to artists working in the South. By contrast, the
NEA's first panel in 1967 had awarded nearly a quarter of the
grants to artists in the Midwest, and in 1969 all the grants

went to artists in the South and the West. In the Endowment's final year of awarding visual arts grants to individuals, the artist with the best chance of receiving an award was a nonpainter from New York City.

Only 40 percent of the panelists sitting on visual arts panels in 1995 were artists. The painting fellowships panel was chaired by a curator, Terrie Sultan of Washington, D.C.'s Corcoran Gallery of Art. Before working at the Corcoran, Sultan was director of public affairs for the New Museum of Contemporary Art. By most panelists' accounts it was Sultan's voice, along with that of artist David Diao, that prevailed on the panel. Diao is a conceptual painter whose work often comments on art history. In 1996 Diao showed *Plots Available*, described by the *New York Times* as "a diagram made to scale showing plots still available in Green River Cemetery in Long Island in the vicinity of such celebrity artists as Jackson Pollock, Ad Reinhardt and Stuart Davis."[37] Diao is a three-time NEA grant recipient who says he has "received every grant practically."[38]

When asked about the panel, Diao immediately recalled: "One thing that was really clear was that some people are just more conservative than others." Diao explained how he evaluates art:

> I'm not impressed by craft or skill. I'm more impressed by ideas and something that's driven more by conceptual issues. So already that's a problem for a lot of people. For them art is still predicated on some kind of know-how at the level of material or craft. . . . For me it's always the culture that generates ideas, not individuals.

Painter Sylvia Plimack Mangold also served on Diao's panel. She received a $3,000 NEA grant in 1974, and her husband Robert was one of the Endowment's 1967 grant recip-

ients. Mangold paints landscapes, but her real subject is a classically modernist one, as one critic puts it: "chart[ing] the tension between the depiction and the depicted, between the flatness of one and the other's three-dimensionality."[39] Mangold spends most days painting trees and the space around and inside them. Her view of art is greatly divergent from Diao's:

> I don't categorize things, but I don't think that images have to be constantly in reaction to other images. I think people have experiences in life that don't always have to do with being on top of the moment but are just relevant in terms of life. I just look for work that I respond to. . . . I am impressed by craft and skill. Ideas come out of making work.[40]

It's not surprising that Diao and Mangold disagreed. What is significant is how they clashed, and how Diao's view won out.

Another member of the panel, abstract painter Denzil Hurley, recalls that certain panelists "became spokesmen for particular types of work."[41] Mangold remembers that it seemed as though "people were there with an agenda." Instead of debating the merits of individual applicants' work, some panelists were using the artwork to conduct a debate on the validity of different ways of working. Mangold saw that the "fights were not about good art and bad art" but about "people promoting something"—one type of art over another. Eventually the discussion deteriorated into a verbal shoving match. At one point, as Mangold was attempting to articulate the merits of a particular painter's application, Diao responded: "I can't believe you fall for that kind of sentimentality." "That's not a discussion," Mangold felt. Instead of arguing applications on their merits, Diao would "make the person who doesn't agree with him seem backward, re-

actionary, or in the past." Because Sultan, the panel's chairman, allowed the conversation to move in this direction, Mangold concluded that "curators and critics have a persuasiveness that is about persuading, not seeing." In this context Mangold found it impossible to represent effectively her opinion about many of the applications in which she had the most confidence. The purpose of the 1995 panel was not to assess applications fairly and objectively, one by one, but to reward all the grants to whichever side won the larger war of ideas. And to the winner went the spoils.

Of the final list of grantees, Sultan admits: "There were many people that showed up on that list that I had organized into exhibitions. You know, quite a few of them. So, obviously, you know, I had some vested interest in them because I presented them [at the Corcoran], I'd written about them."[42] Indeed, Sultan had shown four of the NEA grantees within the last four years and also gave a grantee an exhibition in 1997. Diao was also glad that he "got some of the people whose work I am supportive of grants."

In 1995 grants of $20,000 each went to fifty-eight persons (Appendix C), a total expenditure of $1,160,000. The grantees' work runs the gamut in terms of processes, materials, and subject matter. Yet only a handful of grants went to artists primarily concerned with formal aesthetic issues. By far most grantees make art to make a point about something else, most often politics. A few produce work that gives equal weight to their critical message and to their aesthetic interests. But for most, the pursuit of social critique engulfs their entire process. And some seem almost to base their work on the notion of treating aesthetic concerns as below contempt.

Most of the grantees at the formal end of the spectrum were painters, including Linda Stark, whose paintings are better described as additive sculptures. Each of her small,

pop-color canvases takes as its subject the potential of paint. Stark weaves and twists ribbons of paint she repeatedly lays down in a process which can take months, much of it spent in drying time. (See Plate 2.) Sometimes she pours paint onto panels, shifting and rotating them to manipulate the paint's flow. One critic calls Stark's process "shamelessly sumptuous," her final pieces "talismans of infectious dedication."[43] Her project is narrow in scope but, aside from a few whimsical references, exhibits little concern with the world outside painting.

Megan Marlatt paints the food you cook at home—burgers sizzling on the grill, pasta steaming in a colander—trying to tread what she calls the "fine line between appetizing and gross."[44] (See Plate 3.) She will paint a pizza by baking the pie and then throwing it onto her studio floor. Her titles suggest a love-hate relationship with her subject—Dysfunctional Teapot, Domestic Turmoil—but these paintings really aren't trying to convey a message. Marlatt says she is trying to provoke in viewers "a sensuous impulse," not an "intellectual experience." When Marlatt tries to describe her work she explains: "I really believe in paint." Her real goal in each painting is to explore the unique language of whichever medium she has chosen. She uses gouache, fresco, oil, wax, egg tempera, matching each with subject matter that furthers her study.

Grantee Rebecca Howland paints flowers, a significant departure from her earlier work. In the 1980s Howland made political art, much of which took up environmental issues. In 1985 she showed Toxicological Table, a dinner table set with plates displaying scenes of environmental disaster instead of china patterns, and drumlike drinking glasses labeled "toxic." A "lung cancer ashtray" and time-bomb-themed napkins rested on a tablecloth described by one critic as "a glorious pattern of tumbling barrels and sick rivers."[45] Howland

attributes the anger in her early work to immaturity. The flowers she focuses on now are "wildflowers and weeds that grow wild in New York City."[46] (See Plate 4.) She describes her project as examining the "theme of survival on a very humble scale as well as exploring the pleasure of paint, of gesture, of color." The pleasure of her project is reflected in the titles of her work, including *Crazy Muscle, Porcelain Berry,* and *Queen Anne's Flesh.*

A similar sense of pleasure—in both craft and engagement with subject—can be detected in the work of a few grantees using more unconventional materials. Hongtu Zhang, who grew up in China, uses a range of materials—soy sauce, rice, MSG, corn kernels, cheap lipstick—to create versions of the Mao Zedong portraits that were ever-present in his childhood. Zhang couples the iconic image with these informal materials to convey his ambivalent attitude toward Zedong, "transferring this psychological feeling," Zhang says, "to a physical form."[47]

Nancy Chunn spent her grant period obsessing over the *New York Times.* Every day of 1996 Chunn subjected the people and events gracing the *Times's* front page to a barrage of ink stamps and pastel doodles. (See Plate 5.) Sometimes her commentary involved political critique. An article about the relationship between the government and Native Americans is overlaid with a welcome mat and retitled "Don't Trust the White Man." 1996 Republican presidential nominee Bob Dole is dubbed "Bob Bland," while Chunn advises "Hold Your Nose and Vote" atop an article discussing Clinton's reelection effort. Most of Chunn's illuminations express universal sentiments. A series of articles pertaining to the crash of TWA flight 800 are covered with blue fields occupied by angels, candles, and question marks.

A few grantees whose work features overt social messages were able to calibrate the frequency of their critiques

to the same pitch as their aesthetic interests. While they made sure to tell viewers what they thought, these artists didn't allow their opinions to overwhelm their project. All of Malinda Beeman's work departs from a desire to persuade her viewers. Beeman's *Tree Wall, Winter* memorializes a wooded Rocky Mountain pass near where she once lived. (See Plate 6.) When the area was cleared for a housing development, Beeman was spurred to depict what she saw as a "violent act upon something which was pure."[48] In her installation one remaining deer, made of a taxidermist's mold wrapped in Aspen bark, tries to camouflage itself in an arcade of trees set against a blue, snowy backdrop. The deer is accompanied by ceramic chainsaws, pushing through tree knots. An intersecting, undulating floor pattern is modeled on snowy tire tracks, which Beeman found both ominous and "kind of beautiful." Indeed, it's the beauty Beeman teases even from subjects she finds disturbing that enlivens her work. She uses patterns set to a "sort of music" for each project, while her nearly compulsive dedication to craft brings the other elements into place. She defends her commitment to beauty and craft: "I'm unabashedly interested in beauty, which is still a relevant way to have a voice in the arts." She adds, "I don't think that work has to be ugly or crude or violent looking" in order to make a point.

Lisa Corinne Davis makes collages which carry the message that people should be seen as individuals, not stereotypes. In *Essential Traits #8* Davis layered uneven rows of portrait photos, each one xeroxed and worn. (See Plate 7.) Over most of the faces she penciled outlines of continents and countries, assigning to their bearers what, at first glance, would seem unlikely places of origin. An image of a white woman is overlapped with an outline of Africa while a picture of Italy crosses a black man's face. Davis's work is political, but it has visual interest that extends beyond its

message. Each collage first presents itself as an abstraction, only soon to disassemble into a series of delicate components. The whole image maintains its presence while, as Davis describes, "more information is revealed that isolates these forms away from the broader groupings and towards an individual character."[49] Even after we know the point she is making, Davis gives us reason to keep on looking.

That can't be said of some of the NEA's other 1995 grantees. While many have perfected the art of attention-grabbing, most keep it for only as long as it takes to make their point. These artists don't engage their medium; they use it to create clever and visually amusing packages for their opinions. Lawrence Gipe says he sees painting "as a veneer, as a sheen on top of a story."[50] At first glance Gipe's artfully lit images with bold type resemble the inspirational posters often seen on office walls. But Gipe isn't trying to uplift. His work comments on "how male power has been misused in the past" by illustrating "capitalism run amok." Gipe says history is a "tool" he uses "for [his] own agenda," which is to question American ideals. In the early nineties Gipe's work critiqued America's notion of progress during the industrial age. A monotype from his *Themes for a fin de siecle* series shows an ominous industrial landscape where dark profiles of smokestacks frame a steel mill aflame in production. This grim panorama is underlined by the word "PRIDE." (See Plate 8.) In another image five charging, steam-heaving locomotives appear above the banner "ACQUISITION." In the year after receiving his NEA grant, Gipe made work that collaged images of industry with profiles of George Washington and Abraham Lincoln. Gipe presents a version of American history which, in the words of one critic, is made entirely "of failed promises and shattered utopian dreams."[51]

In comparison to Gipe's work, Ken Aptekar's paintings take longer to view, but only because there is more text to

read. All of Aptekar's paintings take the same form. After painstakingly copying select details from famous paintings, he overlays them with glass into which he sandblasts a text which is intended, most often, to convert his painted image into a critique of contemporary American society. Aptekar's *Heavy Equipment* is based on a 1633 double portrait that Rembrandt painted of a wealthy Dutch couple. (See Plate 9.) Aptekar shows only the figures' torsos in order to focus attention on their lavish dress. On the painting's glass cover are snippets from *New York Times* wedding announcements, including: "partner in the New York law firm of," "and is keeping her name professionally," and "Yale University and an MBA from." Aptekar also makes work that comments on what he sees as the fetishism of art history. Another Rembrandt is the backdrop for *Originally There Was a Child*, the text for which reads: "Originally there was a child playing on the floor. X-rays have revealed that the artist took the child out while the painting was still wet. Recently, a thief stole the painting from a museum. Now nobody can see it." Aptekar describes his relationship to painting as "ambivalent," because, while he enjoys working with paint, he feels it necessary to represent painting as something that "has been the exclusive domain of privilege" and of "Christian white men."[52]

The works of several 1995 grantees reflect visual interest, but only as an afterthought. For these artists, visual considerations do not play a significant role in defining their work; they fall in line behind a critique. Typically these artists substitute cleverness for visual interest. Maureen Connor's work comments on what she sees to be the ways in which society controls women. Her work often has involved clothing. In the early nineties Connor showed a series of pieces featuring black net body stockings stretched in various ways— between the pegs of a bottle rack, weighed down with coins in one foot and made long and thin, stretched wide with

metal pincers to resemble an animal skin. She was making a point about the natural impossibility of fitting into the ideal female form. Connor's 1995 NEA grant supported her work on a video installation entitled *Narrow Escape.* The piece consists of three video monitors inside an antique armoire, each running a tape that begins by showing the same platter of food being eaten by unseen people. In her final grant report to the NEA, Connor described what follows:

> The center monitor dissolves to a woman trying, unsuccessfully to fit into a dress. Next, the same woman, and several others, all quite slim, try to enter a party through a door that is way too narrow. After they manage to squeeze through they discover that the chairs at the party are, like the door, too small for even the slimmest among them to sit comfortably. Next, when they try to use them to play a game of musical chairs they realize that not only are they impossible to sit in, they are too weak to support them as well.[53]

The irony of the piece, as Connor sees it, is the fact that because "no one is slim enough to keep their chair intact, there is no winner in this game."

Grantee William Pope.L describes himself as an "activist-performance artist" who is "suspicious of things that make sense."[54] In addition to his 1995 visual arts grant, Pope.L received fellowships in 1993 and 1994 from the NEA's theatre program. Pope.L's performances are premeditated and carefully staged. Usually they incorporate an element of endurance and involve deteriorating objects, most often food. In 1991 Pope.L performed a piece at the Franklin Furnace by sitting almost naked in the front window and covering himself in mayonnaise. He says he used mayonnaise because "the longer it remains, the more transparent it becomes. Not to mention the smell. I was interested in doing something futile. For me,

William Pope.L, *ATM Piece*, February 26, 1997, performance.
Photograph by Catherine McGann.

mayonnaise is a bogus whiteness."[55] In 1996 Pope.L staged
Sweet Desire, a performance in which he was buried in the
ground chest-high with a bowl of vanilla ice cream in front
of him. He remained buried for four hours in ninety-eight-
degree heat in an effort, as one newspaper reported, "to rep-
resent people who are limited by disabilities, race or poverty."[56]

 In February 1997 Pope.L staged *ATM Piece* across the
street from New York City's Grand Central Station. He in-
tended the piece to be about "the forgotten street person,"
in particular the panhandlers who open doors for people as
they enter ATM vestibules. Pope.L outfitted himself in work-
boots and shorts overlaid with a hula-style skirt fashioned
from dollar bills. Instead of asking for money as a panhan-
dler might, Pope.L planned to turn the tables by offering
ATM visitors dollars from his skirt. To make an additional
point about the relationship of individuals to institutions (in

this case, the Chase Bank), he tied his wrist to the door with a twelve-foot length of Italian sausage. Within minutes a crowd formed and the police were bearing down. In order to quiet the crowd, Pope.L started giving away the hundred dollars or so in his skirt. Soon, Pope.L recalls, people were "pulling at the skirt and ripping the money off and running down the street."[57] Pope.L remains undeterred: "My skirt is cleaned and pressed (in the closet) ready for another assault on culture for the proper fee."[58]

Connor and Pope.L are political artists, but because their work is clever it requires some study in order to realize its full intent. Viewers must decode some visual clues in order to decipher what the artists are trying to say. Other grantees are less nuanced. In the year Matthew Lawrence received his NEA grant he showed a woodcut entitled *Bring Me the Head of Vanilla Ice*. A critic described the piece:

> "I am a gay communist, handle my hammer and tickle my sickle brother," reads the text that travels around the perimeter of a circular woodcut centering on a small dancing figure and surmounted by the generic image of a politician. . . . If the viewer stands back, the visage of the much maligned rapper emerges from the tangle of images.[59]

Another piece by Lawrence in the same exhibition showed a fat man wielding a knife and was entitled *Spring Break Rwanda*.

Grantee Annie West is part of the two-person art collective "Girl Germs," which in 1995 showed *Filthy Mouth*, a ceramic wall piece one critic described as a "face whose open mouth is filled with individual bar soaps."[60] In 1990 West surreptitiously replaced the toilet paper in the bathrooms of Chicago's Art Institute, City Hall, and the Mercantile Ex-

change with rolls bearing critiques of those institutions. What West called the "disposable graffiti" at the Mercantile Exchange included pictures of pigs and comments including: "85% of traders have never seen a real pig" and "Swine have a keen sense of smell and can run fast."[61]

Daniel J. Martinez's best-known work was his contribution to the Whitney Museum's 1993 biennial. Martinez redesigned the metal lapel tag given to each museum visitor so that it read, in whole or in part: "I Can't Imagine Ever Wanting to Be White." Martinez's application for his 1995 NEA grant (his second) included slides of *The Castle Is Burning,* a site-specific piece commissioned by Cornell University. When Martinez visited campus to scout a location for his piece, he decided that Cornell students had "a little too much privilege" and were "a little too comfortable." He dedicated himself to confronting what he imagined the students' attitude to be: "We are the sons and daughters of the rich and famous and we are the inheritors of the positions of power that will run this country next."[62]

Martinez constructed a massive walled structure which obstructed travel through a main campus quadrangle. A crew of twenty-five took two weeks to assemble it. Eight-foot-high walls were covered in tar and placed in an asterisk pattern. The arrangement prevented anyone walking near the piece from seeing others until they were upon them, an effect Martinez hoped would make quad-dwellers "feel like rats in an experiment." Each wall was topped with a quotation spelled out in three-foot-high letters cut from Styrofoam and painted red. The quotes were meant to mimic the odes to learning etched above the entrances to nearby classroom buildings. One was a line from the movie *Rollerball*: "No player must be greater than the game itself." Another quote was a slight misquotation from the ancient Greek philosopher Diogenes:

Daniel J. Martinez, *The Castle Is Burning*, 1993–1994, mixed media installation. Courtesy of the artist.

"In a rich man's house the only place to spit is in his face." Not long after *The Castle Is Burning* was completed, the campus newspaper dubbed it a "monstrosity" and students began attacking the piece, removing letters, spray-painting walls, eventually knocking down panels. In response, radical students seized the university's administration building. Martinez, who has said he "would have been a terrorist"[63] if he were not an artist, considers his Cornell piece "extraordinarily successful."

The work of some 1995 NEA grantees is altogether devoid of aesthetic interest. They give viewers nothing to look at, choosing to make art out of opinions and unfiltered experience. Along with her 1995 grant application, video artist Margaret Stratton submitted "Kiss the Boys and Make Them Die," a work which uncharitably recounts her mother's and grandmother's relationships with men and then segues into a lengthy feminist diatribe (visual descriptions appear in parentheses):

This is a video about women (Stratton's mother in her casket). This is a video about process (woman taking off

her bra), about how women are not about culmination, but about process (people toasting wineglasses). We are not the climax, we are the foreplay. . . . This is a video about lesbianism, desire, seduction, letting go.

Stratton applied her NEA funds to her next project, a video critiquing religious belief systems, originally titled "Holy Dirt."

In her grant application, "other genres" awardee Joseley Carvalho described her art solely in terms of its political import:

> From 1991 to 1993 my work has dealt with issues of the violence of wars. . . . I intend with this new phase to create an awareness that exploitation of children in the labor force is a violent act. . . . The NEA funds will support my research, which includes my travels to the Northeast of Brazil and the Southwest of U.S. to interview and visually document the children's experience.[64]

Carvalho mentioned nothing in her application about her visual strategy for rendering her subject. Most of the work she produced while on her fellowship appeared only abroad, including a video documentary of a "permanent public work I made for a subway station in São Paulo, Brazil."[65]

Ulysses Jenkins is another three-time NEA grant winner, having received awards in 1980, 1983, and 1995. His 1980 grant application included seven slides of a performance titled "Just Another Rendering of the Same Problem." In the slides Jenkins is shown in jeans and a blue shirt sitting at a table with various objects, including an instruction manual, a television set, and a dildo in a wooden box. Jenkins stands and removes his shirt, revealing sequined pasties in the shape of Superman shields. He takes off his jeans and, in silver lamé boxer shorts, pulls a gun and aims it, point blank, at the dildo.

DANNY TISDALE
AN ARTIST FOR A CHANGE IN NEW YORK CITY

Danny Tisdale, postcard for "Danny Tisdale: An Artist for a Change in New York City," Lombard/Freid Fine Arts, September 7–October 5, 1996. Courtesy of the artist.

In 1995 Jenkins used his NEA fellowship award, and an additional grant from the California Arts Council, to produce "Find A Hap-e-meal," a compact disc featuring songs that Jenkins says are "urban stories that are related to welfare reform."[66] Jenkins wrote all the lyrics for the CD, including these verses from a song called "Emergency":

No more . . . health care
No more . . . food stamps
And welfare too-o-o-o-o
The government goes on strike
What ya going to do
It's a call/it's a call
For human rights!!

Performance artist Danny Tisdale says that "without the NEA I wouldn't be where I am."[67] Indeed, Tisdale's 1995 grant enabled him to launch "Danny Tisdale: An Artist for a Change in New York City," a conceptual performance piece that involved a real candidacy for political office. Comparing himself to former Nicaraguan dictator Daniel Ortega and Czech Republic President Václav Havel, Tisdale adopted an artist-as-politician identity and in 1997 sought a seat representing Harlem on New York's City Council. His platform was based on "creatively [sic] problem-solving through the arts."[68] Tisdale promised to "promote environment-friendly art materials," to "encourage the diversity and tolerances of all," and to support "policies in the best interest of the arts community."[69] The NEA grant enabled Tisdale to set up a campaign headquarters both in Harlem and at a Soho gallery space. Although he lost in 1997, Tisdale looks forward to another run in 2001.

History has not yet had a chance to make an objective assessment of the NEA's 1995 grantees as it has their 1967 counterparts. But some generalizations may already be offered. The most striking contrast between the two groups is the stylistic narrowness of the art the NEA sponsored in 1995 in comparison to that of 1967. The vast majority of 1995 grantees are working within the confines of postmodern academicism, making work that sublimates aesthetic concerns to the demands of a social critique. In 1967 grants went to

artists working in a wide range of styles, including second-generation abstract expressionist painters, budding minimalist sculptors, artists reintegrating the figure into painting, and assemblage sculptors making art from junk. The majority of 1967 grants would have gone *only* to artists working in one of those areas if the NEA's first panelists had gone about their task as their successors would.

A less obvious but perhaps deeper division between the two groups is the starkly contrasting view each holds of what it means to be an artist. The difference is evident even in descriptions of how the artists used their NEA grants. When asked how they benefited from their grant, most of the 1967 awardees will discuss the work they were making at the time, putting it in the context of a transition they were going through or an artistic goal they were striving to meet. Few say the award had a direct impact on their work. Those who do, like Al Leslie (whose studio burned down just before he received the grant), attribute the effect to fortuitous timing. Certainly none credit the NEA grant with influencing their desire to remain an artist. Most remember their grant period fondly as a time when they could put aside some of their financial worries and concentrate more intently on their artistic development.

By contrast, many of the 1995 grantees portray the NEA award in make-or-break terms. Some even claim that the grant was what kept them from giving up as an artist. One grantee says that the grant came at a time when she was "wonder[ing] how I could justify the time, and money, and the continued attention to my artwork."[70] Some of this rhetoric may be no more than overdramatic gratitude. Still, a sufficient number of 1995 grantees made similar observations to suggest that at least some would no longer be artists if art were not paying so well. Indeed, one 1995 grantee has already left artmaking for an Internet career.

When asked about the grant's impact on their work, most 1995 awardees do not talk about how the grant helped their art, but how it enhanced their "career." Many grantees filed final reports with the NEA that amount to little more than a laundry list of the exhibitions and the publicity they attribute to their grant. One awardee's report begins: "Upon receiving the NEA grant I was featured in the local newspaper."[71] The artist then explains how that publicity led to a solo exhibition, which received positive reviews, and to another exhibition, which was reviewed in the *Los Angeles Times* and elsewhere. Not a single comment is included about what kind of aesthetic progress may have accompanied the grant. Most 1995 grantees seem to equate artistic progress with career advancement, not creative development.

There is no denying the fact that what is commonly referred to as the "art world" today is much larger and considerably different from what constituted the artists' community in the late 1960s. The history of the NEA's own Visual Arts Program reflects most of these changes. Still, many fundamental principles about artists remain the same. In 1995 as in 1967 there are artists making important, serious work who deserve any kind of support they can find. And, regardless of the mushrooming numbers of people who call themselves artists, there are still very few who are working on a level that earns them the title *artist*. What differs across the decades is how thorough the National Endowment for the Arts had become by 1995 at excluding precisely the caliber of artist it had rewarded in 1967. And how dimly the agency had come to be viewed by everyone but its dependents.

THE PERSISTENCE OF PAINTING

Stanley Lewis handles the canvas like a coach does a clipboard. His paint-stained hands jab at the surface so aggressively that you expect a finger to plunge right into the impasto. "This is what I think I'm really good at," says Lewis.[1] The painting is of a landscape, but the section Lewis points to would be unrecognizable in isolation. Strands of color intertwine and mix to form a mound. Zigzags of paint overlap without being random. A discrete form emerges, singular and complex, which instinctively seems to know its role in the painting. It's a tree from Lewis's backyard. He has drawn and painted it thousands of times. "The day goes on and I find rhythms in the trees that are really invented, like different connections," Lewis explains. "You invent the colors all the time because the trees don't have a distinct color." This is how most painters talk about space, color, and the way paint acts.

There are many artists working today who want to be known as painters, not artists. Some even carry business cards with the designation "fine art painter." They argue that the term *artist* has been co-opted by people who consider art-

making a mere act of self-expression. Art historian Barbara Rose explains: "'Artist' means 'I'm an artist because I say I'm an artist.' Being a 'painter' means 'I have certain kinds of skills and a relationship to a tradition.'"[2] The French-born artist Balthus, who at age ninety-two is often called the greatest living painter, draws the distinction even more starkly: "I'm considering myself as a craftsman. I don't want to be an artist. I have a horror of the word."[3] Painters stress practices—including drawing from life and studying past art—that the most celebrated art of the last three decades has devalued.

Painting with "painting" priorities has not driven artmaking in America for more than forty years, since the original abstract expressionists dominated the scene. Many art movements since then have defined themselves, at least in part, in opposition to the building blocks of traditional painting. Art historian Edward Lucie-Smith observed that the close of the abstract expressionist period was signaled in the early sixties when painters Morris Louis and Kenneth Noland produced color-field works in which brushstrokes disappeared and "all pretense at composition [was] abandoned."[4] Already, pop artists were substituting the language of the cartoon and the grocery-store shelf for considered subject matter. In the late sixties minimalists took a hundred-plus-year debate over space and boiled it down to the unemotive geometry of the interval. And just when seventies conceptual artists had retired the very idea of producing an art object at all, political artists revived it in the eighties if only to intrude upon it with an identity politics bent on erasing any notion of artmaking as a detached project, independent of social concerns. Throughout the nineties the work of radically unskilled "outsider" artists (Sunday painters, children, the incarcerated, the insane) was elevated to the status of fine art. These successive waves of aesthetic deconstruction had the effect of dis-

tancing artmaking from any honest relationship with the practices or standards of painting.

It is worth noting that many of the artists participating in these projects used paint to make their point. Throughout the eighties the intentionally awkward "bad" figure painting of the neo-expressionists made a nefarious bid to lay claim to the grand tradition of narrative oil painting. These artists wanted to co-opt painting's high art status without engaging in painting practices. Even some of today's most celebrated postmodern work is made, at least in part, with paint. Sue Williams's pieces consist of painted segments of the human body or sometimes animals, rendered in a graphic style and distributed across a canvas as evenly as a wallpaper design. The core of Nicole Eisenman's installations are drawings or paintings, sometimes applied directly to the wall, which most often depict people engaged in sex or other suggestive activities. So prevalent has paint become in the current scene that some observers have been wondering out loud and in print about whether painting is making a comeback.

But there is a difference between painting and just using paint. Today artists often work with paint not in order to explore the potential of the medium but to evoke an ironic effect. In part, Williams and Eisenman use paint to participate in a feminist critique of traditional painting. They are demonstrating that they have figured out how to use paint in ways that sublimate what they consider a patriarchal medium to a contemporary feminist message. Today if you see painting in the galleries that show contemporary artists, most often it is "painting" of this sort.

Some painters, including many who enjoy significant reputations, still paint in an unironic, forthright manner. Many of them began showing their work in the sixties or seventies and are at least one generation removed from the current scene. Abstractionist Brice Marden paints large, thin surfaces

occupied by weightless webs of solid color. Chuck Close uses a sometimes fanciful array of painted elements to produce portraits with an aggressive frontal effect. Some artists working in other mediums are equally forthright in their use of materials. Sculptor Richard Serra balances massive slabs (more recently curls) of industrial steel as if they were playing cards. The stylistic differences and range of interests these artists encompass is great, but their approach to making art is similar.

These artists manufacture large, dramatic, and often beautiful statements about the process and materials of art-making. Each is a strict formalist engaged in a narrow, limited project which puts maximum value on completeness and elegance. Many painters who have resisted this approach call it safe, even "Republican." And though some would take issue with the stereotype, what artists see in Republican art is art that is closed to all but the most incremental innovation and unworried about the challenge of moving the project of painting forward.

The goal of serious artists has been the same for centuries. It is to explore the potential of the current visual language and, when it is spent, to create a new one. Although we have been conscious of it only since the advent of modernism, this aim has shaped the very outline of art history. In the early fourteenth century the Florentine painter Giotto, in his Arena Chapel fresco cycle, delivered painting into the Renaissance by making medieval icons and portraits of ordinary people breathe and act human for the first time in the history of painting. Michelangelo's Sistine ceiling unfolds as one artist's struggle to bring painting out of the awkward end stages of the early Renaissance, exclaim the High Renaissance, and then wade into the surreal reaches of mannerism. Of course, these examples benefit from the clarity of historical distance.

But the twentieth century too has clearly seen innovation. Pablo Picasso and Willem de Kooning each pushed his work through three distinct phases of accomplishment. This is how artists conduct their investigations. A new visual language does not emerge often. Some argue that it has not happened since the end of the nineteenth century when Paul Cézanne combined perception with a self-conscious interest in the structure of painting to launch the project that would become known as modern art. It is not important, indeed not possible, that breakthroughs be made often. What is crucial is that the process that leads to such innovations be kept alive so that, when possible, progress can be made. Most of the painters who have been trying to advance the project of painting in recent decades have done so in near anonymity. Ironically, this discouraging situation took root in the early 1960s, when American painting was just coming down off a high.

At the time, the large, heroic canvases of the abstract expressionists had captured the public imagination for more than a decade. Jackson Pollock's drip paintings became the group's trademark after *Life* magazine ran a feature article on the painter in 1949 asking: "Jackson Pollock—Is He the Greatest Living Painter in the United States?" But the popular attention given to Pollock has obscured the actual diversity of interests among the abstract expressionists—which included considerable exploration of both figuration and abstraction.

Yet as abstract expressionism evolved and *Nation* magazine art critic Clement Greenberg's voice became prominent, the movement's public aims narrowed. Greenberg argued that the goal of modernism was to strip painting down to its core: the textureless, rectangular canvas. This reduction also involved deleting any hint of imagery. A painting on canvas was no longer allowed even in part to be a window onto the

world, as it had been for centuries and in a multitude of cultures. By the early 1960s abstract expressionism had petered out into the brushless, paint-soaked canvases of the color-field painters. While Greenberg had managed to gain considerable notoriety for Morris Louis, Kenneth Noland, and other color-field painters, where painting could go next was unclear. It looked as though Greenberg's exhortations literally had driven paint into the canvas, never to emerge again.

This was making it easy to believe what critics were starting to argue—that "painting was dead." Some people were no doubt skeptical of the notion that painting, a project that had challenged men for millennia, had culminated in their time. But to many it seemed exciting. This was the early sixties when lambasting tradition and bringing down institutions was just coming into vogue. Campus radicals were calling on universities and other cultural institutions to "free" knowledge from the constraints of tradition. And when applied to the art world, the radical call to "question authority" meant attacking painting.

This assault on painting was enhanced by the fact that, perhaps for the first time in the history of American art, the public was watching. Greenberg had made the abstract expressionists big news. He intended this publicity to help his artists in their campaign to triumph over their European counterparts. In Paris, then considered the capital of the art world, artists enjoyed royal, semi-divine status. The best American equivalent is celebrity, and Greenberg made sure that a select few of his artists became well known. During his short-lived career, Pollock's work appeared not just in art magazines but in *Time, Vogue,* and *Harper's Bazaar.* In a sense, Greenberg took the kinds of decisions and assessments artists make amongst themselves and dragged them out onto a public stage. He used public interest to bolster his own argu-

ments, thereby making both the individual artist's and an art movement's "marketability" a plus.

At the same time that Greenberg's color-field painters were garnering attention, pop art hit the scene. The earliest pop art was, in part, a philosophical reaction against image-free painting. George Segal, who in the fifties began making figurative sculptures, plaster-cast from life, had "giant reservations about shutting out the validity of observation of the real world."[5] Segal felt that the first generation of pop artists— Claes Oldenburg, Roy Lichtenstein, Jim Dine—were reacting to Greenberg's "pronouncement" to "exclud[e] any kind of figuration." Of course, within a few years most pop art would devolve into a simplistic mimicry of the commercial culture.

Still, given a choice between what increasingly was being seen as academic abstraction and the seemingly new and all-accessible work of the pop artists, it is little wonder that pop won out. Where art previously had separated out "avant-garde and kitsch," as Greenberg's important 1939 essay had argued, now the avant-garde had *become* kitsch. But it was more than that. As Lucie-Smith has reported: "When the first retrospective of Andy Warhol's work was held, in Philadelphia in 1965, the crush at the private view was so great that some of the exhibits had to be removed, for fear of damage. It was clearly the artist himself, and not his products, whom the visitors wished to see."[6] An art star had emerged and delivered art into a realm in which painting did not have the tools to compete.

New Republic art critic Jed Perl has observed that because Warhol and the Duchampian project "did in some sense win we have lost a lot of the history of the other side."[7] The "other side" includes artists whose work reflects a belief that Greenberg drove the project of painting off course. Green-

berg argued that his New York School painters had triumphed over their European counterparts and inherited the mantle of painting. In a biography of Greenberg, Florence Rubenstein points to a 1984 painting by Mark Tansey which, in its exaggeration, captures the essence of the critic's perspective. The School of Paris is shown as a military brigade, some on horseback, donning festooned helmets and high boots. General Picasso (in a fur coat) steps forward to surrender to Greenberg, whose Pollock-led New York School troops resemble American GIs.

Where Greenberg saw a break with the European tradition as crucial to America's own artistic progress, many American artists wished to continue both working from life and building on the work of the past. It is this group of mostly representational painters, ignored by Greenberg and invisible to most of the critics and historians of the postmodern period, whose history has gone largely undocumented. There are, of course, innumerable artists who continued to paint even after painting was declared dead. To tell each of their stories is impossible. What follows is an attempt to sketch the portrait of a single community of painters who, for decades, has found ways to continue exploring the project of perceptual painting, or painting from life.

Like the early abstract expressionists, this is a diverse group about whom few generalizations can be made. Their primary dedication is not to a process, medium, or theory but to exploring the relationship between the reality of the visible world and the demands of painting. Their inspiration is simple, as one painter explained: "The reason I paint is because I want to paint what I see."[8] They make every attempt to distance their personal identity and opinions from their work. The "meaning" of their work is the visual activity it provides. They emphasize pictorial values, but they share no characteristic style. Many explain their method as using

abstract principles to understand the visible world. They are all engaged in a dialogue with the art of the past and feel both its weight and the freedom of its lessons on their task. When interviewed, most every painter insists on being in his studio. Barely five minutes pass before pencil, paper, and canvases of all ages are ushered out for reference. Answers to questions are just as likely to take the form of sketches as sentences.

For more than three decades the institution that has been most central to this community of artists is the New York Studio School. The school was founded in 1964 on the basis of an idea put forward by painter Mercedes Matter. The previous year Matter had published an article in *ArtNews* arguing that the proliferation of art schools throughout the fifties and early sixties had diluted the essence of art instruction. Novelty and the "promiscuity of experimenting" were being substituted for artistic development, Matter charged, and the fundamentals of painting were going untaught. Art schools were training students how to be successful in the art scene without ever becoming artists: "Instead of an Eakins as president of an academy, we have public-relations experts throughout."[9] The Studio School was dedicated to reviving the studio-based atelier tradition.

The school got off the ground with the pooled resources of students and the proceeds from an auction of drawings donated by the incoming faculty, among them the painters Charles Cajori, Nicholas Carone, Philip Guston, and George McNeil. Many of the faculty had studied with painter Hans Hofmann, who ran two schools, one on 8th Street and another in Provincetown, Massachusetts. Hofmann taught many of the abstract expressionists, but his thinking about the roots of abstraction and, by extension, the goal of modern art, ran counter to Greenberg's. Hofmann saw abstraction and representation as two sides of a coin: observing nature begat ab-

stract forms. The two depended on each other. Central to Hofmann's teaching was drawing from the still life or nude.

To this day the Studio School teaches the importance of drawing and working in the studio. It is an emphasis taken from both Hofmann and the modernist painter and sculptor Alberto Giacometti, who claimed, in a line often quoted by Matter, that "it is only drawing that counts . . . if one could master drawing a little, all the rest would become possible."[10] Drawing is stressed throughout the year, but particularly during two-week "Drawing Marathon" sessions—the artistic equivalent of foreign-language immersion—which open each academic session.[11] The standard curriculum consists of two four-hour working sessions each day, with students encouraged to stay at the studios and work into the night. The Studio School tries to remove artmaking from the imperatives of the outside world and teach students the skills and rigor required for the solitary, lifelong process of discovering and articulating an individual artist's means of expression.

The Studio School has always stressed accomplishment in the studio over the pursuit of popular success. A description of the school appearing in its literature explains: "It is a school based on the maxim: 'Ambition for the work, not ambition for the career.'" While this creed has helped many artists to focus on their most important task, it also casts a virtuous light over this community's greatest hardship: its struggle to find an audience for its work. Since the earliest days of abstract expressionism, serious representational painting has found itself on the margins of art world interest.

In the fifties and early sixties a handful of galleries was dedicated at least in part to showing painters who worked from life. The Hansa Gallery in New York was a cooperative, or artist-run, gallery founded in 1952 by a group of young artists, many of whom had emerged from Hofmann's Provincetown Art School. Hansa's director was Richard Bellamy, a

budding young dealer who would come to play a crucial role in supporting many of the most important artists of the fifties and sixties. Hansa founders included artists as stylistically different as representational painter Wolf Kahn and assemblage artist and "happenings" originator Allan Kaprow. To a certain degree these artists came together to form an alliance based on a shared desire, according to art historian Martica Sawin, "to outflank rather than imitate" the senior abstract expressionists.[12] Hansa was the place to see serious alternatives to the prevailing trend.

Strategy aside, what the variety of Hansa's exhibitions demonstrated was the enormous breadth of interests appreciated by the serious, unprejudiced eye. These artists saw keenly inside one another's vastly dissimilar work. The painter and critic Fairfield Porter, whose own landscape and interior paintings remain important to painters today, wrote of assemblage artist Richard Stankiewicz's Hansa show:

> Stankiewicz uses the mud of this civilization. . . . He takes apart old refrigerators and wrecks of cars, broken beds and stoves, using the irreducible pieces from which meaning has disappeared; but because they once had meaning they have retained a mystery and an emotion that their inventors would not have thought of.[13]

In the seven years it existed, Hansa's groundbreaking shows included George Segal's earliest sculptures, Alfred Leslie's avant-garde films, and the debut exhibition of the meticulous figure compositions of Leland Bell. The vast majority of artists affiliated with Hansa, including all the ones named above, went on either to teach or to lecture at the Studio School.

A few other New York galleries showed serious observation-based painting in the fifties, including the Tanager Gallery, another artists' co-op. Tanager gave Iceland-born painter Louisa Matthiasdottir (wife of Leland Bell) one of

her earliest New York shows. The commercial Zabriskie Gallery also showed a number of representational painters, including Robert De Niro, Sr. (father of the actor), and Paul Georges. Virginia Zabriskie gave Bell two shows after Hansa shut its doors in 1959. But it wasn't until 1962, with the founding of the Robert Schoelkopf Gallery, that painters who worked from life found a home fully dedicated to supporting their project.

Robert Schoelkopf had come to art indirectly. In his senior year as a romance literature major at Yale, Schoelkopf sailed to Europe in the hope of studying Spanish poetry. Aboard ship he met Yale art historian John Spencer, who convinced Schoelkopf to go on with him to Italy where he would acquaint him with the riches of Florentine art. According to Schoelkopf's wife Jane, "he got to Florence and never left," if not in body at least in soul. Although he had bought a drawing from painter William Bailey while both were students at Yale, Schoelkopf had never shown any particular interest in art. He had never even bothered to visit the Yale Art Gallery. But when Schoelkopf returned home from Florence he was set on becoming an art dealer. After a four-year stint running a gallery jointly with Virginia Zabriskie, Schoelkopf struck off on his own.

The Robert Schoelkopf Gallery was the first gallery in decades to devote itself significantly to showing perceptual painting. A wide range of styles and interests comprised the gallery's lot. The gallery's intellectual center revolved around a cohort of three painters: Bell, Matthiasdottir, and Gabriel Laderman. Matthiasdottir's self-portraits, still lifes, and Icelandic landscapes are built from solid forms carved out of pure color. Laderman's narrative paintings situate figures in tense psychological relationships both with each other and with the space around them. Bailey joined the gallery in 1968, though his style of painting was more reductive than many

of the gallery's other artists. All of Schoelkopf's painters were dedicated (as Laderman later wrote of Matthiasdottir) to "a lifetime of looking at nature and of studying art."[14] Many of the gallery's artists were intensely interested in a particular group of early French modern painters. It was a circle of artists brought together as a result of a fight over the course of modern art that had taken place in Paris fifty years earlier.

At the beginning of the twentieth century Pablo Picasso, Henri Matisse, and André Derain were the leading figures of the School of Paris, a group of artists whose individual pursuits of modern questions were grounded in a dedication to working from observation and learning from the art of the past, including non-Western art. In 1907 Picasso, with Georges Braque, began experimenting with a less experiential and more intellectualized method of artmaking. Cubism, as it would eventually be called, was an exploration of the potential of narrowed space that involved using a simplified palette, limited subject matter, and elements of collage. Although the cubists kept one foot in reality (most of their works were still lifes and portraits), their work opened a door to the notion of a reductivist, conceptual project, driven primarily by the desire to illustrate a theory or idea.

Not all of the painters associated with the School of Paris were persuaded to pursue cubism. Early on, Fernand Léger had been attracted to the cubist technique of showing fragments or sometimes all sides of objects. He thought the approach had the potential to depict modern man's view of the world "through the door of the railroad car or the automobile windshield."[15] But in the end Léger's fascination with the challenges provided by the visible world drew him away from the increasingly formulaic cubists. (Picasso and Braque both returned to working from observation in their later years.) Matisse took a passing interest in later cubism,

only to turn quickly back to his lifelong exploration of the resonance between color and drawing. Many artists, including Raoul Dufy and Giacometti, resisted the new trend entirely. They did not believe that the original modern project which had been launched by Cézanne was yet completed. These painters were still inspired by Cézanne's challenge to explore painting through the process of trying to reveal the underlying structures of nature. They admired Cézanne's modesty before nature and were put off by the cubist idea of inserting themselves intellectually between nature and art.

Many of these artists were following the lead of André Derain, an ardent critic of cubism. Derain called cubism "the most revolting thing there is,"[16] causing a significant rupture between himself and Picasso. Indeed Picasso considered the split so offensive a breach that he even leveled false charges of Nazi collaboration against Derain, hoping, according to one account, that the painter would be punished and his approach to painting discredited.[17] The cubists, of course, eventually went on to achieve far greater fame than many of their detractors. Still, the stand by Derain and others had demarcated a clear boundary between their project—working from life and continuing a dialogue with past art—and other conceptually inspired ways of working.

This project found its way to America. A main conduit was Jean Hélion, who had been a student of Léger's. Even though during the early part of his career Hélion had allied himself with a group of painters who considered themselves adamant abstractionists,[18] he had always worked from life. Later he recalled struggling as a young artist to paint an abstract composition of Ile de France, only to look out the window of his studio and see that "a tree was waving its very thin boughs and my picture contained only vast flat areas."[19] Hélion spent much of the thirties living in America, commuting between studios in Virginia and New York, where his

work was shown regularly until the mid-forties. He returned to France to fight in World War II and spent nearly two years in a German prison camp. When he escaped and returned to America, he found himself filled with "fantastic joy" and dedicated to working figuratively in order to "tackle the problem of man . . . and see what was wrong with them that the world could come to such a bad end."[20]

Hélion painted everyday activities: people reading newspapers, sipping coffee, riding bikes, visiting a flea market. Often he juxtaposed many incompatible events, producing a surreal effect. In just one panel from his *Dragon Street Triptych* of 1967 a man, who stands in front of an embracing couple, plays an accordion while another descends into a manhole as a blind man approaches. Hélion's still lifes were simple arrangements which often included scores of battleship-rigid baguettes, seed-mouthed pumpkin sections, and unfurling umbrellas. He gave all objects equal weight, each form a tense negotiation between the freedom of pure color and the demands of a black outline. After returning to his Paris studio in 1946, and until the end of his life, Hélion invited young American artists to visit. He provided them with introductions to the modern masters—Balthus, Constantin Brancusi, Giacometti, Wassily Kandinsky—whose lessons they learned and carried back to the states. One young artist who took advantage of this opportunity was Leland Bell. Bell met Hélion in New York in 1944 when the young artist, looking for a building superintendent's position, saw Hélion's name on a list of tenants and took the job. It took a number of weeks for Bell to approach him, Hélion recalls:

> I came down the stairway and found a man with his broom. He was not sweeping anything away. He looked at me and said, "Mr. Hélion, in 1935 you have written," and then he quoted ten lines of me. "What do you mean

exactly?" Then I started talking and I realized I was talking to my janitor and I said, "Who are you?" And he said, "I am a New York painter."[21]

Bell never attended art school. He spent his life trying to learn from artists' work and, when possible, from master painters themselves. In the early 1940s, when he was still a newcomer in New York, Bell saw a group of paintings by Piet Mondrian which, according to one account, "so moved" him that he "went and knocked on the door of the Dutchman's East Side apartment."[22] When Bell traveled to Hélion's Paris studio in 1951 the Frenchman offered to introduce the young artist to Balthus. Bell capitalized on the opportunity, visiting Balthus's studio many times. He did the same with Giacometti.

Bell had what he once described as "a love affair" with drawing from other artists' work.[23] But he was not nostalgic. Bell's dialogue with the past was less like a student receiving instruction from a teacher than as a colleague in a lively exchange with peers. To Bell, great paintings of any age were as alive when he studied them as when they first were made. Bell and Hélion had followed similar paths. Bell also had started out as an abstractionist, inspired by the rhythm and forms in the work of French surrealist Jean Arp. He would soon learn to use abstraction as Hélion had, as a device for understanding the visible. Hélion explained: "I could build a man with the structure of abstraction, use abstraction to discern what a man was, not to make him into an abstraction. Use [abstraction] as a tool to discover the amplitude of a man."[24]

Bell came to be known for his self-portraits and figure compositions. Everything in a Bell painting—from human features and fabric folds to the light in the corner of a room—is a form, drawn in both line and color. Light on an arm is

shown not through modeling or shading but by painting the exposed side coral and the underside brown. A young woman's dress in a Bell painting gives the appearance of being orange even though some of the forms defining it are brown or dark blue. Like Hélion, Bell used a solid black outline to surround each form and set it in motion with the rest of the composition. Some of the situations that most interested him involved humans reacting to the activities of animals—a butterfly or bird near the dinner table, a cat delivering its catch to a waking couple's bedside. If Bell found a particular composition intriguing, he would paint dozens of versions, often working on them simultaneously.

The Robert Schoelkopf Gallery was the first to bring any sustained attention not only to Bell's work but to an entire lot of perceptual painters. Their solo shows at Schoelkopf earned these young Americans their first reviews. In 1968 *New York Times* art critic Hilton Kramer had already praised Bell's seriousness, observing that he was a painter who studied the museum and was "acutely conscious of great pictorial quality."[25] Kramer wrote that a 1976 show of Louisa Matthiasdottir's work proved that "the art of 'painting' is alive and well." Her "pure pictorial distillations of a visual experience" demonstrated that the painter was "the real thing."[26] In 1975 the *New Republic* found that William Bailey's work "dares to invite comparison with the likes of Titian and Ingres."[27] Even more than calling attention to the work of individual painters, Schoelkopf shows helped expand the vocabulary for talking about painting which had for so long been focused on abstraction. The gallery did a group show of "Nine Realists" in 1964 which helped reintroduce the word "realism" into critical debate. When the Whitney Museum put on an exhibition of works by "22 Realists" in 1970, both Gabriel Laderman and Bailey were included.

Art was not simply sold at the Schoelkopf Gallery; it was

debated and discussed. Bailey, Bell, and Laderman were teachers. Each enjoyed a considerable following among young painters who, along with their elders, comprised the packed crowd at most of the openings. When Jed Perl visited Schoelkopf in the late sixties and early seventies, he was reminded of Clement Greenberg's observation that a real gallery is "a place where art goes on and is not just shown and sold."[28] In those days the Schoelkopf Gallery was the "definition of a great gallery . . . a place where you go, you argue, you get excited, you get angry," Perl recalls. Robert Schoelkopf was like a professor with an open-door policy, allowing artists to browse the contents of his office, notoriously packed with books, articles, and stacks of canvases. Teachers who brought their classes could ask to see anything in the gallery's holdings. And if a student or a group of painters wanted to buy a gallery artist's work, Schoelkopf allowed them to purchase it from the artist directly, without having to pay a commission to the gallery.

Exciting as this environment was, many of the artists' works did not sell. Jane Schoelkopf remembers that during the gallery's early days, "so few people came in you didn't need to keep the lights on all the time."[29] For a time the Schoelkopfs lived in the front of the gallery and would flip on the lights once or twice a day when someone stopped by. She says her husband wasn't "idealistic" and never considered supporting these artists' efforts as "doing something great for the world." Schoelkopf was just running the gallery the only way that seemed logical to him, "showing people because you really thought they were good painters, not because they were going to sell." She feels certain that "some of those people stayed with the gallery because there wasn't any other place to go." But also because Schoelkopf stood by them.

Although few of Bell's works sold, Schoelkopf gave the painter a one-man show every other year for more than

twenty-five years. Laderman, another tough sell, showed his work at the gallery eight times. Some of Schoelkopf's artists found buyers more readily. Matthiasdottir always sold well, as did Bailey, whose first show at the gallery in 1968 sold out except for one painting. That painting was purchased by Mrs. John D. Rockefeller III, who saw it when she visited the gallery to see some early modernist work. Indeed, Bailey's work was so popular that there was always a waiting list to buy paintings the artist had not yet produced.[30] Bailey's considerable success frustrated some of the gallery's less popular artists. But the balance Schoelkopf struck among his painters was crucial to maintaining the gallery's mission. Popular artists' sales enabled the gallery to support the rest of its stable. The proceeds from the sale of early American modernists such as Joseph Stella and sculptor Elie Nadelman, and the photographs of Walker Evans, also bolstered the operation.

Schoelkopf made it possible for these painters to explore the possibilities of their individual projects, which each managed to bring to fruition while at the gallery. In 1986 Laderman showed *The House of Death and Life,* a six-scene narrative painting of over seven by thirteen feet depicting various stages of violence and its aftermath. Perl, writing in the *New Criterion,* dubbed the work "America's first original response to Balthus."[31] Matthiasdottir's most successful show came in 1989 when the *New York Times* praised her paintings and pastels for being "without guile, steady in their gaze, bracing in their austerity."[32] A year later, in Bell's final show at the gallery (Bell and Schoelkopf both died in 1991), he displayed the most complete and fully realized versions of the two figure compositions he had been working on for decades—*Butterfly Group* and *Morning.*

Bell went on to enjoy a museum retrospective at the Phillips Collection in Washington, D.C. A review of the show insisted that "when the history of painting in America over

the last hundred years comes to be properly written, the avant-garde of the last two decades will be understood as consisting of a few powerful and unfashionable artists," among them, Bell.[33] Yet, aside from an uncharacteristic early self-portrait at the Smithsonian's Hirshhorn Museum, precious few museums own Bell's work today. The same can be said of Matthiasdottir and Laderman, neither of whom have enjoyed a major museum show.[34] Today Laderman shows at the Tatischeff Gallery where his work appears alongside that of less challenging painters.

Still, in comparison to the generation of representational painters that followed, Schoelkopf's artists had it easy. They enjoyed the benefit of thoughtful and serious teachers, a supportive gallery, and sporadic but flattering reviews. Perceptual painters who came of age after the rise of postmodern art around 1970 faced an art world which in many ways no longer recognized what they were doing. Too young to fit into the Schoelkopf roster, they lacked even an institution around which to form a community. So, in the spirit of the age, they built their own.

In the early sixties a group of young painters ran an informal drawing workshop below an African dance school on 14th Street. Four nights a week artists could draw from a live model. According to painter Barbara Grossman, who joined the group in 1965: "Everyone took turns running a night. Thursday night was all one pose and Wednesday night was five, ten, or twenty [poses] an hour. . . . You paid two dollars and you drew."[35] Many of the artists who started the workshop had attended the art school at Cooper Union. Stylistically the group was diverse, but it was held together by its participants' interest in working from life. As Grossman recalls, "If you were an abstract painter, you weren't there."[36]

In early 1969 four painters who had attended the 14th Street drawing workshop launched the Alliance of Figurative

Artists (AFA).[37] Larry Faden, Howard Kalish, Anthony Siani, and Sam Thurston wanted a forum for painters and sculptors that would "attempt to dispel the sense of isolation so often felt by representational artists" and "create for figurative art a viable New York scene."[38] The response was tremendous. Artists had already been meeting informally in their studios, a tradition they wanted to continue. More than two hundred artists crammed into the studio of painter Alfred Leslie on East Broadway for the first meeting on February 14, 1969. A number of older artists, including Bell, Laderman, and Paul Georges, spoke out at the gathering and factions quickly arose, mostly dividing painters who worked in a loose, painterly manner from tight realists—groups colloquially referred to as the "guts" and the "heads."[39] Yet, according to sculptor Richard Miller, AFA participants shared a clear sense of purpose: "Everyone realized that it was sort of the beginning of something unplanned and unsponsored and really growing out of a common interest that these artists had" to share ideas and to show their work to others.

The AFA tried to meet every Friday evening. There were three basic meeting formats. One was the individual speaker. An artist would, as Miller explained,

> simply go up there and [tell] us, man to man you might say, exactly how he felt about his own development and how he got interested in art. How he proceeded, his struggles, and so on, just as they happened. Just as he would to another understanding artist rather than as he would maybe to a magazine writer or somebody like that.

Other meetings had a theme, such as narrative painting or landscape painting, which a panel of artists would discuss. And there was "Show Your Work Night," when admission to

the meeting required bringing a painting, drawing, or piece of sculpture. This was also a way of making sure that no critics or dealers sneaked in since AFA participation was limited to working artists.

The discussion was lively and aggressive, sometimes degenerating into shouting. Some invited speakers—including portraitist Chuck Close and art historian Robert Rosenblum—were "showered with abuse" after their presentations.[40] During a panel on sculpture, the moderator cut off panelist Harvey Citron after apparently becoming bored with the sculptor's discussion of anatomy. After the moderator told Citron to "shut up or stop," the audience protested. Miller recalls that a vote was taken "to see whether Harvey would be permitted to talk at such length about anatomy. The vote went in Harvey's favor, and he was allowed to continue." The rough-and-tumble atmosphere at these artist-run meetings often produced debates punctuated by strange and sometimes violent intrusions. Larry Faden remembers a heated exchange between two painters which ended when one pulled a knife from his boot. During a tense discussion at the AFA's inaugural meeting, painter Jack Silberman was attacked by a dog as he stood up to speak. Miller recalls another incident:

> The painters Paul Georges and Sidney Tillim got into somewhat of a violent argument based partly on the fact that they felt they were in opposite camps; that is, Georges is of the "loose" or brushy painting school, and Tillim is of the tighter school. . . . There was a commotion at the back door of the room. A poor bum had come in off the street and was stealing something. . . . When he was overtaken and apprehended by quite a number of the young artists, it was discovered that this poor bum had stolen nothing more than Sidney Tillim's battered hat. So that sort of ended that argument. That was that.

Despite the fireworks, the benefit of these painters' discussions was obvious. The AFA was a place where the problems and aspirations of perceptual artists were talked about and taken seriously. It gave artists an opportunity to test their ideas on their peers and mentors. Perhaps most important, the AFA's existence gave these artists (even those who chose not to participate) a sense of being part of a community of painters working—if in very divergent ways—on the project of painting from life.

In the AFA's second year its gatherings became more formalized. Meetings were moved to the Educational Alliance, a Jewish community center on the lower east side of Manhattan, which provided meeting space, coffee, and mailing services. A nominal attendance fee was charged. Although meetings were as open as ever, the divisions among the older generation of artists had come to dominate discussions. Younger painters like Grossman "could see that these older guys like Laderman, Leslie, Georges, were having their own battle for power." Grossman and her peers "did not want to follow the 'older' painters, some of whom were former teachers; we wanted a place of our own." AFA founder Sam Thurston agreed: "We felt we were ready to get on the stage. . . . We were young and going to be ourselves."[41]

After all, the younger artists had needs much different from their elders. Unlike the previous generation of perceptual artists, they had no commercial galleries committed to showing their work. As the sixties came to a close, postmodern art was beginning to grab the attention of the art world. The project of painting from life shared nothing with the conceptual roots of postmodernism. When the representational artists of the previous generation did battle with the abstract expressionists at least it was on the same field, in the arena of serious painting. The differences between abstract and representational painters were mostly matters of

style and method, not of fundamental purpose. Postmodernism was taking art into an entirely different arena, one that did not just sideline but invalidate the idea of painting for its own sake, no matter the style.

In the turn of a generation, the goal of perceptual painters had changed from fighting for popular attention to surviving at all. These young artists could not afford to spend time arguing with painters from other stylistic camps or even picking fights amongst themselves. They were concentrated on figuring out how to pursue their own projects and to find a public for their work. And they began by reviving the idea of the cooperative gallery. In 1969 four co-ops opened downtown: Bowery, First Street, Prince Street, and Green Mountain galleries.[42] Each of these spaces was dedicated to showing the work of young representational artists. The co-ops were alternatives to commercial representation, but they were not launched begrudgingly. The painters who started them considered themselves radicals dedicated to reestablishing the legitimacy of figurative painting.

The four artists who had emerged from the 14th Street drawing group to start the AFA were also founding members of the Bowery Gallery, which has always been considered the most selective of the co-ops. Its members hoped to achieve nothing short of a revolution in painting. Gallery member Norman Turner recalls viewing the Bowery early on as "a center for the return of representational art. The atmosphere was one of idealism, collegiality, heated debate, and artistic ferment."[43] In a group photo taken at the time of the Bowery's opening, the members, assembled atop a pile of rubbish in front of their gallery, look with serious faces and swaggered poses straight into the camera. "In 1969 we felt we were part of the art world," recalls Sam Thurston, "we were its new members." Barbara Grossman, also a Bowery founder, recalls, "Some thought we would change the art world."[44]

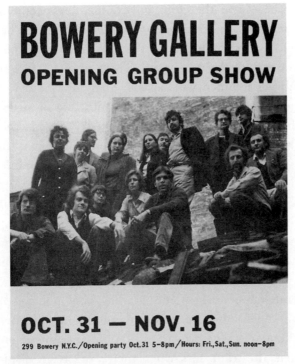

The Bowery Gallery's original members as shown on a poster announcing the gallery's inaugural exhibition, October 31–November 16, 1969.

In the beginning the Bowery could not afford to be too choosy about who could participate. The early membership, according to Grossman, was composed "partly out of who was there, who had money to contribute, who could climb a ladder and bang nails." She recalls a painter whose work many of the gallery artists found unconvincing but who was allowed to join anyway because her husband might prove useful—he was an electrician. In the Bowery's first few years, membership dues ran ten dollars per month. The gallery "opened on Halloween, 1969, in the atmosphere of Bowery bums, broken glass, urine, and used clothing shops," Grossman re-

members. Despite the grim environment, expectations ran high—and they appeared well warranted. Exhibition openings were held on Friday nights so that AFA members could stop by on the way to their meetings. These events, Miller recalls, "were always jammed with artists, many of whom were very well known. . . . It had all the glitter of a big uptown gallery when in fact the space, if one looked at it carefully, was somewhat shabby." Thurston remembers thinking at the time: "There seemed to be a movement. It looked hopeful."[45]

All four of the figurative co-ops are still operating. The Bowery, Prince Street, and Blue Mountain galleries (changed from Green Mountain in 1980) share a divided loft space at 121 Wooster Street in Soho.[46] Today's Bowery operates in much the same elbow-grease fashion it did thirty years ago. Gallery management and maintenance duties—from collecting membership dues, painting walls, and pouring refreshments at openings—are parceled out to members. Bowery artists send out their own exhibition announcements and often man the front desk when their work is on display. The gallery has no employees; its annual budget runs around $35,000, up from $4,000 in 1977. Today the Bowery has thirty-five members, more than twice the number it had in 1969. This limits artists to one show every three years. Burgeoning membership is partly a result of the need to keep pace with New York City rent, which, along with the rest of the gallery's expenses, has to be covered by the $85 monthly membership dues. But the Bowery's long membership rolls are mostly due to another reason—a glut.

The original purpose of the figurative artist co-ops was to introduce young talent and new ideas onto a scene dominated by an orthodox view of abstraction and a rising postmodernism. Once that introduction was made it was expected that commercial galleries would take over and the co-ops could close, their utility no longer needed. This is what hap-

pened in the fifties when Hansa and the other 10th Street co-ops ran their course and closed their doors. In the late sixties and early seventies the Bowery artists had the same expectations. When the gallery opened, its press announcement explained that the Bowery would be showing art before it "goes from downtown to uptown," in other words, from where the artists make it to where commercial galleries sell it. But the Bowery never fulfilled its mission. The artists did most everything right. They were clear and articulate in their purpose and energetic in their approach. According to Thurston, "We saw no reason to be worried about a bleak future."[47] But when the Bowery's artists earned their stripes among their peers and it came time for them to move into commercial galleries, the opportunities were not there. What they had not planned for was how thoroughly the values and standards of the art world would change under postmodernism—and how that change would affect the way their work was viewed.

Not only had the art world become acclimated to seeing these painters' work—indeed, most all serious painting—as a foreign and irrelevant project, but this bias was given added momentum by the influx of money that flooded the rising postmodern art market throughout the eighties. This infusion contributed to a change in the way most galleries viewed their mission. Dealers became less interested in supporting artists' goals and more involved in creating and marketing "artists." Long gone, Perl has observed, was "the art dealer who is committed to the life of forms," typified by Schoelkopf or Betty Parsons, who showed the early abstract expressionists.[48] Painter Nicholas Carone recalls that in the fifties "artists made the artists. It was not the critic or the collector or the museum people. The people listened to the artists, who they were talking about, who they were following, who they were influenced by, and then the dealers

went to that artist."[49] By the end of the eighties, *Time* magazine art critic Robert Hughes would fault the art world for sinking to "the manufacture of art-related glamour."[50] The painters at the Bowery and other co-ops were passed over.

Bowery artists no longer expect that they will be plucked by a commercial gallery and made famous. Instead they are concentrated, as they always have been, on their individual efforts to explore painting from life. Today the Bowery functions less as the rallying point it was originally intended to be, and more as ground zero in the effort to maintain the project of perceptual painting. In an essay commemorating a twenty-fifth anniversary show for Bowery artists, Grossman observed, "Exhibiting in a co-op enables artists to pursue the work they believe in and stay the course."[51] Thurston explains that the Bowery was founded because "we wanted to fulfill ourselves in our styles." More than two decades later, he concludes: "We got a lot of good art done."[52]

Unfortunately it's work that few people outside the perceptual painting community have seen. Every so often a Bowery show gets a brief notice in the popular art press. Jed Perl is the only critic who writes consistently about the project of perceptual painting.[53] Perl is a painter's critic who sees the kinds of things in paintings that painters do. Sometimes he writes on topics that few aside from painters and studied connoisseurs would likely appreciate—like explaining the relationship between seeing and time.[54] Many of the most celebrated critics and artists value Perl's opinions, even while admitting never to have seen much of the work he discusses. Robert Hughes says he has "the highest respect for [Perl's] judgment."[55] Neo-expressionist artist David Salle (whose work Perl dismisses as "bad painting without the quotation marks"[56]) says that he has "always wanted to know what Jed Perl likes."[57]

Not unlike the artists he favors, Perl is ambivalent to-

ward popular success. On the grounds that they get too much press already, he refuses lucrative offers to write articles about postmodern art stars. Meanwhile he writes lengthy critiques of relatively unknown artists, sometimes making the case that one of their paintings is a masterpiece. Perl is the only person ever to have written about many of the Bowery's artists. He is so close to the perceptual project that his criticism often also functions as advice. Some Bowery artists find that years later they continue to consider issues Perl raised with regard to their work.

One of the artists whom Perl has written about consistently is Stanley Lewis. My interview with Lewis was the first he had ever given—it was the first time he had ever been asked. Lewis paints the landscape, most often his backyard. Sometimes he makes drawings of his studio, which is the first floor of his home. He paints four or five hours each day and teaches three days a week. Lewis's "first real teacher" was Leland Bell.[58] As a student at the Yale Art School Lewis gravitated to Bell, whom he saw as "a figure painter coming out of the great tradition of figures." Bell introduced him to the work of Derain, expanded his understanding of Giacometti, and convinced Lewis to travel to Paris to meet Hélion.

Lewis's paintings look nothing like his teacher's, but his work does reflect one of Bell's lessons about perception: "When you sit down to paint someone or something, then you begin to see it. Until then you don't really see it."[59] Lewis's eyes are glued to his source. "I get my excitement from just looking at things," he explains. "That's what makes me want to paint." Every decision Lewis makes somehow is tied to what he sees:

I can't draw with a pencil when there's leaves on the trees because . . . I can't make a pencil drawing feel like

Stanley Lewis, *DC Backyard*, 1997, pencil on paper, 39" x 30".
Courtesy of the artist.

summer [unless] it's a grey day like today. If the sun
comes out I couldn't draw. And then in the fall, I use
pen and ink because the black tends to have something
to do with the bright fall day.

If the season changes before Lewis completes a painting, the
painting doesn't get finished. He is not willing to guess away
from his subject. For Lewis, the experience of sitting in front
of his source is as integral to making a painting as the process
of applying the paint itself. He once offered this revealing
explanation of another painter's work:

> The long, stubborn involvement with this subject cre-
> ated . . . a kind of coalition between the artist's technique
> and the forces of nature. Without the conscious impo-
> sition of an art idea, an unexpected aspect of the sub-

ject, the spaces between the branches, could be more fully revealed. Thus, his subject is helping to paint itself. The irony is that this kind of unity cannot be achieved anywhere but in front of this particular tree at a particular season.[60]

Of course, this is also how Lewis works. When he paints his backyard, the vantage point pivots and the medium varies with the season, but the cast of characters differs little. (See Plate 10.) A deep sprawling lawn is occupied by a metal chair and redwood picnic table. At right, the profile of a canopied porch overlaps the back of a metal-sided home. A slain tree trunk and a spray of weeds lay before a tall holly tree, the last defense against an unwieldy stand of elms. A long shed camps among distant trees.

In 1990 Perl wrote a devastating review of a Lewis show. He called the painter's work "hollow all the way through" and used Lewis to point to a tendency he had noticed among those in the "serious crowd" to fall prey to "insularity and underdog self-consciousness."[61] Lewis remembers being angry when he first read the review. But, even though the tenor of Perl's attack still bothers him, Lewis now agrees with the substance of his criticism: "I think that [Perl] really cared for me and thought I was a good artist, and he thought I was really going on the wrong track, and I think he was right." For years Lewis had been rushing too quickly through paintings. Recently he has begun working more slowly, allowing observations and brushstrokes to accumulate and come to a resolution. It is a way of working that concentrates on the multitude of parts that make up a painting more than the completeness of the whole.

Lewis is a bit of a cult figure. The opening receptions for his Bowery shows are so crowded that, even if it's freezing outside, inside the gallery the human heat turns the space

into a sauna. Among the attendees are flocks of students, many of them alumni of Lewis's decades of teaching. David Wooddell, who studied with Lewis, observes that his power as a teacher comes from the way he "conveys a deep conviction in painting." Lewis teaches young painters to situate their task in the context of a long tradition. This "takes a burden off," explains Wooddell, because "you realize that there's always been a reason to do this, and there still is one." Wooddell, who is thirty-three, shows at 55 Mercer, another co-operative gallery, and is gratified when Lewis comes to his openings and congratulates him on his work: "For him to say something is more meaningful than a gallery."[62] Though it is not uncommon for Bowery artists to collect one another's work, Lewis is one of the most avidly collected among his peers. The homes of at least a half-dozen Bowery artists prominently display a Lewis painting or drawing. One Bowery artist admits that she hoards anything that Lewis works on, from completed paintings to random scribbles. Lewis seems to be the Bowery's unspoken but agreed-upon best bet for moving the language of painting at least an increment forward.

Temma Bell, who also shows at the Bowery, is the daughter of Leland Bell and Louisa Matthiasdottir. Ever since she can remember, art has been part of her everyday life: "My father was always painting. My mother was always painting. Everybody was always painting. And then you would eat and do other things, but, basically, life was painting."[63] Family and painting were compatible interests. That tradition lives on in the Catskills farmhouse where Bell and her family live today. Works by Hélion, Derain, and Léger hang throughout the home, not glassed-in but casually, as though they could be taken down and referred to at any time. Bell's seven-year-old daughter entertains herself by grabbing a small painting by her grandmother, propping it up in a rocking chair, and drawing from it in crayon.

Bell's studio looks out the back of the house across a vast expanse of land. She has the same no-nonsense approach to painting as her mother, who once described her creative process as, "one puts the food on the table and one paints it."[64] Bell paints what she knows—the faces of her four daughters, local landscapes, objects from her kitchen. It's a familiarity she translates with the force of gravity. Sifting through past work, she dates paintings often by referencing her daughters' ages when she painted them. Perl wrote of a landscape painting in Bell's most recent show that "the hand of a master is evident in the unfurling rhythms of her brush."[65]

The Bowery's Barbara Goodstein makes what she calls "sculpture you can see through" by applying thin strokes of plaster to painted wood boards.[66] The method uses a sculptural medium, in the unit of painting, to depict the complex force of drawing. Goodstein's sources are almost anything she finds visually interesting: the three graces at Pompeii, a fourteenth-century fresco of Christ's Resurrection, the rooftop view from a Manhattan apartment building. Her figure pieces capture both physicality and psychology in a few spare strokes. The figure in *Woman Washing*, modeled on one of Cézanne's bathers, stands slightly askew. (See Plate 11.) Her hips push out and shoulders lean back as she reaches out to scrub the length of her arm. Soap drips from her wrist. The everyday nature of the pose and activity only serves to heighten the drama of Goodstein's iconlike focus.

Some Bowery artists do not work from direct perception. Barbara Grossman paints invented indoor scenes usually involving women reading books or sheet music, playing the piano, or gathered around a table. (See Plate 12.) Grossman is primarily concerned with formal issues. The figures and other elements she includes—small still-life arrangements, tables tipped up in broadest aspect, Matissian patterned walls and floors—are selected for their contribution to making each painting "real within its own logic." Deborah Kahn is one of

the Bowery's few abstract painters and another former student of Leland Bell. Kahn creates abstract forms with real, earthly presence. She describes each painting as a journey that "begins in confusion and ends with what is knowable."[67] As Kahn paints, images emerge that are often suggestive of a figure, as in *Torso*. (See Plate 13.) Kahn works toward a clarity, negotiating the line between what the eye sees and what the mind knows, to give shape to what one of her peers calls "unseen but knowable" forms.

Bell, Goodstein, Grossman, and Kahn each have shown at the Bowery for more than twenty years. None of their shows has been reviewed by the *New York Times*, which is considered the newspaper of record for contemporary American art. At age fifty-seven, and after showing his work in New York for twenty-seven years,[68] Lewis received his first mention in the *Times* in 1998 in the form of a lukewarm two-paragraph review.[69] That show of Lewis's sold out, with a few canvases going to collectors and many purchased with the pooled resources of students and peers. But showing just once every three years, and with most of the work at the Bowery priced around $2,000, a sellout show does not earn enough to make a living for the individual painter. At the Bowery even very large works by painters who have been honing their skills for decades sell for under $5,000. Nearly all Bowery artists must teach, many full time, and into middle age. More time spent teaching leaves less time for painting. Lewis worries, "I don't have time actually to fulfill the project of painting as I see it in its complexity because nobody is buying paintings and giving me enough money so that I can do it."

At least as destructive as a shortage of time and money is the intellectual and emotional impact of working without acknowledgment. Particularly among the generation of the Bowery's founders, a deep frustration is evident. They won-

PLATE 1. Leon Polk Smith, *Correspondence Violet-Red*, 1967, acrylic on canvas, 90" x 50".

PLATE 2. Linda Stark, *Peppermint Rotation Diptych*, 1993, oil on canvas, 8" x 9". Courtesy of Jack Shainman Gallery, New York.

PLATE 3. Megan Marlatt, *Burgers on the Grill*, 1993, oil on burnt canvas, 10" x 10". Courtesy of the artist.

PLATE 4. Rebecca Howland, *Weeds of New York: Thistle and Sweet Pea*, 1995–1996, oil on canvas, 65" x 36". Courtesy of the artist.

PLATE 5. Nancy Chunn, *September 26, 1996*, 1996, ink and pastel on newspaper, 21-1/2" x 13-3/4". Courtesy of Ronald Feldman Fine Arts, New York. Photograph by John Back.

PLATE 6. Malinda Beeman, detail of *Tree Wall (Winter)*, 1996, lithographs, carved wood, ceramics, silkscreen, installation. Courtesy of the artist.

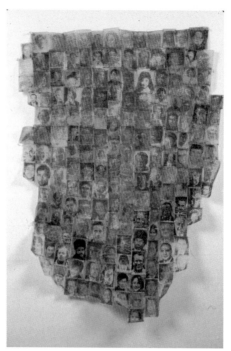

PLATE 7. Lisa Corrine Davis, *Essential Traits #8*, 1997, Xerox transfer, ink, and colored pencil on vellum, 18" x 26". Courtesy of the artist.

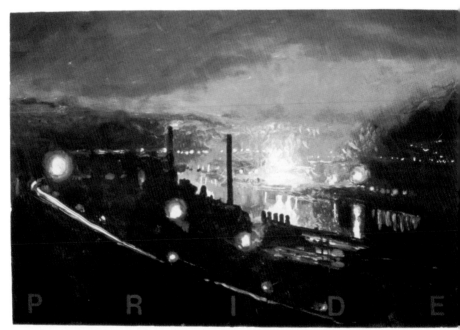

PLATE 8. Lawrence Gipe, *Pride*, 1991, monotype with silkscreen, 31-1/2" x 47". Courtesy of Pelavin Editions/Cheryl Pelavin Fine Art, New York.

PLATE 9. Kenneth Aptekar, *Heavy Equipment*, 1992, oil on wood, sandblasted glass, bolts, 30" x 60". Courtesy of Steinbaum Krauss Gallery, New York.

PLATE 10. Stanley Lewis, *DC Backyard*, 1997, oil on canvas, 20" x 20". Collection of John Van Rens, New York.

PLATE 11. Barbara Goodstein, *Woman Washing*, 1983, plaster on stained board, 14" x 11" x 3/4". Courtesy of the artist.

PLATE 12. Barbara Grossman, *The Black Table II*, 1997–1998, oil on linen, 60" x 48". Courtesy of the artist.

PLATE 13. Deborah Kahn, *Torso*, 1997, oil on canvas, 26″ x 24″. Courtesy of the artist.

PLATE 14. Andrew Forge, *Mezzogiorno, Roma*, 1995, watercolor and gouache on paper, 16″ x 12″. Private collection.

PLATE 15. Ruth Miller, *Pond*, 1998, oil on linen, 9" x 12". Private collection.

PLATE 16. Nicholas Carone, untitled, 1986, oil on canvas, 29-1/2" x 19-1/2". Collection of Gordon Chandler, Carrollton, Georgia.

der whether there is an audience for their work and, if not, how they will keep going. Lewis acknowledges "a kind of bitterness in [thinking] you have another thirty years to go keeping up your energy and economically not being free." Even having a show, which often marks either the launching or culmination of a longtime project, can feel like an unremarkable event. Goodstein finds that "if you have a show and it's not written about, it's sort of like you didn't have it." Eventually the pressure becomes both intellectual and social, as painters' family and friends increasingly wonder why they keep doing what they do. Goodstein says the lack of acknowledgment produces a prevailing sense of "desperation and total bitterness." Most of the painters agree that "you have to bury that stuff," as Lewis puts it, in order to prevent it from influencing the task at hand. It's a lesson they may have learned from watching Leland Bell. When motivated by frustration, Bell's naturally compulsive style of working could consume him. Temma Bell remembers watching her father "spend a whole winter putting bananas in and out of a painting." Matthiasdottir sometimes hid Bell's paintings both to save them from ruin and to force the painter to move on.

The frustration is sometimes reflected on the Bowery's walls. It's mostly a matter of presentation: messy wall labels, ill-fitting homemade frames, works hung in a cramped, careless manner. Some artists use cheap store-bought canvases or paint in oil directly onto paper, with little thought for archival concerns. One artist remembers watching as another "hammered a very large nail into the center of a painting to hold it together." Although it sometimes appears tattered and torn, the actual substance of these painters' work has escaped largely unaffected.

One Bowery member refers to his peers as belonging to a "lost generation" of American painters. Indeed, the designation applies to more than just one generation of painters.

Many of the artists discussed above descend from an exceptional and little-known group of teachers, stretching far beyond the influence of Leland Bell, who have kept the faith both in their classrooms and in their studios. Andrew Forge was dean of the Yale School of Art and a member of its faculty from 1975 to 1994. For decades Yale's was considered the best painting program in America. Forge's paintings are composed entirely of dots and short dashes that he calls "sticks." Each work is inspired by an aspect of the visible world—seasons, street scenes, landscapes—which is implied but never depicted. (See Plate 14.) Forge's process acknowledges the speed of improvisation, but his dense, woven compositions demand a slow read. It's a combination—of simple elemental forms, a jittery rhythm, and a narrative undercurrent—which bears far more similarity to late Mondrian (particularly *Broadway Boogie Woogie*) than to the pointillist Georges Seurat, with whom Forge is often compared.

The Studio School has been a home to many important teachers, including Forge's wife, Ruth Miller, who has taught there for more than twenty-five years. Miller is a still life and landscape painter. On small canvases, most just over a foot square, she concentrates her attention on nature's simple side—two cypresses marking the crest of a hill, or the shadowy floor beneath a tree's lowest boughs. (See Plate 15.) Her selections, which could be mistaken for details from Cézanne landscapes, have the studied intensity of portraiture. Nicholas Carone, who studied at the Hofmann School, was a founding faculty member of the Studio School where he taught for more than twenty years. Today Carone runs his own art school in Italy. As a late abstract expressionist, Carone played an important role in emphasizing figuration throughout and after that movement's close. In the eighties and early nineties he painted a series of portraits that would hold up in comparison with any in the history of the genre. (See Plate 16.)

They depict imagined people, many haunted or forlorn, with all the psychological acuity of Rembrandt and the painterly execution of Manet. Forge and Carone are both more than seventy years old. Neither they nor Carone has been the subject of a major museum show; no book exists that compiles any one of these artists' work; and only one (Miller, who shows at the Bowery) is currently represented by a New York gallery.

The abundance of time that both this generation and the mid-career, Bowery-age painters have spent teaching has helped to produce successive generations of artists dedicated to the project of painting. Today there is a large and active group of twenty- and thirty-something artists making work which—though not always made of paint—still reflects painting principles. Many of these artists are products of the handful of art programs—including those at American University, Boston University, Dartmouth College, Indiana University, and the Studio School—where drawing, painting, and art history still comprise the basic curriculum. These programs graduate students with the knowledge, discipline, and skills that will inform a lifetime of aesthetic exploration. Teachers at these schools feel compelled to be frank with their students about what one calls the "injustice side" of being a painter. Like their teachers, these young artists are trying to carve out sustaining careers in an environment that has become even more forbidding with the passing of a generation.

Today more than ever the most sought after, "cutting-edge" art schools resemble talent agencies. With no set curriculum and little or no skills training, students spend the bulk of their time learning how to launch their careers. All forms of ambition are encouraged. And learning how to discuss one's work is considered more important than knowing how to make it. Credit is given for almost anything. A student at UCLA's art school (considered one of the hottest pro-

grams in the nation) has stalked Ronald McDonald with a videocamera.[70] At the trendy Art Center College of Design in Los Angeles, one student's two-year output consisted of two pornography magazine layouts. Another student converted her studio into an extreme sports facility.[71] At these schools gallery owners attend faculty critiques of students' work. Collectors and curators come, even from abroad, to browse through students' studios. UCLA faculty member Charles Ray admits with some dismay that his students "often feel if they don't have a gallery or a show by the time they graduate, then they're losers."[72] Meanwhile the most recent generation of painters is following the model established by their mentors. They are joining co-ops geared toward younger artists and assembling ad hoc group shows wherever they can find a space. Like their predecessors, they consider themselves radicals. After all, they are making the only kind of art most art schools and commercial galleries are afraid to touch.

Many painters say they feel like monks, working diligently at their own tasks, shut out of a world to which they no longer relate. Kahn cites George Orwell's essay, "Inside the Whale," and argues that artists have had "to retreat inside themselves to make work because the world has gone too crazy." "Sometimes," Kahn says, "I think I'm inside the whale."[73] Abstract painter Alan Cote agrees. He works every day in his studio, the top floor of an old tugboat factory on the Hudson, which is occupied by the massive presences of his bright two-canvas paintings. Few of these works have ever been exhibited. Cote feels that painting is "in a time of quietude, a time when the people who really want to do it are going to do it."[74]

Every now and then an event occurs which shines light on this solemn enterprise. On March 19, 1997, the Studio School was preparing for one of its weekly public lectures. Abstract expressionist painter Willem de Kooning had died

earlier that day and, even though not enough time had elapsed for the obituary to make it into the newspapers, everyone at the Studio School already knew. That evening's lecturer decided to forgo his speech. Instead he offered his reflections on de Kooning and invited members of the audience to add their thoughts. The room was packed with twenty-something painters. Their teachers rose to speak, one after another. Charles Cajori told a story about having lunch at an automat with de Kooning decades earlier. As they ate, he recalled, he noticed that de Kooning was using only one hand. The other was "gripped tight around a large bundle."[75] When he asked about the package, de Kooning explained that it was paint bought with the proceeds from an art prize he had just won. It was color paint, the first he had been able to afford in a long time. Here de Kooning was, Cajori observed, eating ten-cent food he had just bought out of a machine and clutching paint to his chest for dear life.

Painting has a momentum all its own. Although there are conditions that can discourage and stifle its growth, nothing stops it. Like many of her peers, Bowery founder Barbara Grossman does not like talking about her frustration. In the end, "painting has to save painting," she says, so why worry over it? Indeed, the paintings will get made, but unless they are acknowledged today, history will be their only audience.

4

LEVELING THE
MUSEUM

In a 1995 letter to the editor of the *Wall Street Journal,* the controller of a Houston construction company told the following story:

> Our bricklayers were repairing the stone flooring at Houston's world-class Museum of Fine Art's outdoor sculpture garden. To protect a bronze bas relief piece hanging near our work, our crew had positioned a velvet rope in front and draped some burlap over the work, securing it with silver duct tape. During the morning, the wind pulled one corner of the cover loose, exposing about 30% of the piece.
>
> While eating lunch about 30 feet away and out of sight, our crew overheard a discussion between four art patrons who had finally wandered over to our area. For about half an hour they discussed the deep symbolism and implications of the artist having covered his work in burlap and why he allowed the public only partial access to what was there.
>
> They waxed long and hard about the appropriate-

ness of the texture of the burlap in relation to the medium used. And what the use of the velvet rope meant in juxtaposition to the base materials of the burlap and duct tape. And the cosmic significance of using degradable materials to try to hide the true inner beauty.[1]

This humorous situation reveals how greatly the museum-patron relationship is based on trust. Visitors expect history museums to know the facts and science museums to understand the math, but they demand even more from art museums. Although most viewers respond differently to Vermeer's intimate pausing interiors than they do to the fleeting images of everyday life, few believe they will ever grasp the elusive quality that defines art against everything else. So they vest art museums with the authority to parse the history of art and to present for society's edification the best examples of man's aesthetic efforts. When museums become confused, so do visitors.

In recent years art museums have begun to resemble other kinds of institutions. Some have blurred their mission with that of trendy galleries, showing work fresh from the artist's studio before history has had a chance to determine its significance. Many museums are beginning to mimic entertainment arenas, converting much of their exhibition space into slick halls designed to excite the masses with blockbuster shows that promote artists like movie stars. And most museums now front-load the visitor's experience with so many opportunities to sip cappuccino and to purchase water-lily-patterned neckties that their foyers might be mistaken for premium shopping malls. Many of the distinctions that have separated museumgoing from less elevated activities for more than a century have been erased.

The underlying source of these and countless other changes has been a quiet revolution in the philosophy of mu-

seums. For more than two decades art museums have been undergoing an active period of revision, rearranging everything from pictures on the wall to bricks and mortar—all part of an attempt to shed their elitist image and appear as more egalitarian institutions. Gallant neoclassical entrances built long ago have been condemned as intimidating and closed. Instead today's visitors are greeted by museums with barely more curb appeal than a megamall. Once inside, museumgoers rarely find what was long the norm—a permanent collection laid out as a tour of civilizations, presented plainly to facilitate the process of looking. Instead visitors are confronted with an overnarrated version of the history of art, often installed less in the service of visitor needs than in accordance with the dictates of contemporary multicultural priorities. Ironically the actual results of these changes have been anything but pluralistic. What was once a democratic institution has evolved into a highly prescriptive one, more dedicated to influencing visitors' worldviews than to providing the opportunity to learn through looking.

Not all museums have pursued a revisionist program. Among the prominent exceptions are New York's Metropolitan Museum of Art and the Art Institute of Chicago (though they too are partial to blockbuster promotions). Most of the institutions that have resisted the revisionist trend are headed by long-tenured directors whose own training was oriented toward connoisseurship and the direct examination of art objects. Since that approach to art history is no longer being offered in most graduate programs, this generation of museum directors is likely to be the last of its kind. Even today most art museums are headed by directors for whom revisionist ideas are the norm. In order to appreciate the impact of this new way of thinking, it is important to understand the genealogy of American museums.

While European "salons" provided luxurious environ-

ments for viewing pictures, visiting America's earliest museums felt more like going to a circus, with curiosities shown alongside art objects. The first museum to display paintings in America—in Philadelphia at the end of the eighteenth century—also showed stuffed birds, mammoth bones, fossils, and "a mounted five-legged, double-tailed cow giving milk to a two-headed calf."[2] As the American art museum evolved, and art was distanced from oddity, the museum's practical roots survived in its dedication to the goal of education. As democratic versions of their predecessors across the Atlantic, American museums sought to use art to educate a wide audience. Museologist Laurence Vail Coleman has described the spirit of this new institution:

> The term collection fairly well defines a European museum. One could define the American museum as an institution which uses its collections for a specific end: to raise the general public's level of culture and knowledge; it does not serve the interests of a particular class or group.[3]

The Boston Museum of Fine Arts' founding documents called on it to be "a popular institution, in the widest sense of the term."[4] The articles of incorporation for the Cleveland Museum of Art directed it to "provide instruction and maintain courses of lectures upon art" that would serve "the best interest of mechanics, manufacturers and artisans."[5] America's art museums were always intended to be useful places.

Part of the instruction that museums were expected to provide was moral. In 1869, at the first meeting convened to discuss the founding of the Metropolitan Museum of Art, the publisher William Cullen Bryant suggested that the "wholesome, ennobling, instructive" nature of art would keep New Yorkers from succumbing to "the temptations to vice."[6] In 1876 Boston's mayor said that with the opening of the Mu-

seum of Fine Arts "all classes of people will derive benefit and pleasure from barely looking upon objects that appeal to the sense of the beautiful."[7] According to former Smithsonian secretary S. Dillon Ripley, museum founders shared "a strong, a zealous missionary desire to uplift, to create cultural equality as one of the fundamental outgrowths of our new democracy."[8] These founders were convinced of the civilizing effect of a place of high seriousness in which aesthetic greatness was presented for the community's consumption. Not entirely unlike their revisionist successors, America's museum founders believed in the moral influence of art. But these founders were content to let art speak for itself, and to allow museumgoers to think for themselves. And they built institutions dedicated to this serious but simple exercise.

In striking contrast to museum founders, those who have worked to revise art museums show little interest in the quality of visitors' actual experience with objects. In a 1990 study of the survey questionnaires that museums routinely give to their visitors, University of Chicago historian Neil Harris found that most museums reflect an "apparent indifference [to] the objective museum visit itself." This stands in striking contrast to early museums, which made every effort to offer the broadest possible access and to provide services that would heighten the experience of art. According to Harris, early American museums invested mostly in "inexpensive admissions, long opening hours, good location, useful labels, explanatory catalogs." These museums were founded on the build-it-and-they-will-come assumption that "the public eventually would make use of [their] treasures" as long as museums opened their doors. Harris found that today's museums are primarily concerned with impacting visitor "attitude, volition, perception, awareness, and opinion." Revisionist museums concentrate less on exposing museumgoers to great art than on using art to influence visitor opinion. It's a goal

at which they often fail, says Harris: "However thorough the preparations, intentions often seem frustrated by the failure of visitors to respond the way curators expect and by the retention of attitudes that some might think had long since disappeared."[9] Try as they might, revisionist museums apparently are unsuccessful at convincing visitors to see museums as sources of social insight.

Early expressions of this new activist mission appear in the publications of the American Association of Museums, a membership organization for museum administrators. A 1984 AAM report titled *Museums for a New Century* called on museums to address global and local concerns previously considered outside their purview, explaining that "the fervent idealism of the 1960s prompted museums even further toward social consciousness." Among the issues the AAM report takes up are "dramatic assaults on the ecosystem," overpopulation, and the "alarming imbalance" in the distribution of wealth worldwide.[10] The report's authors—including the directors of the Children's Museum of Indianapolis, the Museum of Modern Art, and the Missouri Botanical Garden—offered few recommendations that addressed such broad and emphatically stated concerns. Eight years later the AAM issued another report, *Excellence and Equity*, which again discussed geopolitical issues, including the impact of "multinational corporations," how "rapid economic development poses clear environmental dangers," and how "imbalances of wealth and poverty threaten political stability."[11] But this time, in addition to airing its concerns, the AAM also found a part for museums to play in changing the world.

In *Excellence and Equity* the AAM argued that museums should "no longer confine themselves simply to preservation, scholarship, and exhibition" but should instead become relevant by embracing the new goal of promoting "heightened cultural sensitivity." In order to accomplish this

task, the AAM called on museums to "shed the limiting cultural biases and ethnocentrism of the past" by changing their methods and their missions. "Diversity" would become museums' new mantra, *Excellence and Equity* explained: "As we approach the end of the twentieth century, national boundaries are shifting. Diversity—cultural, intellectual, environmental, social, economic, ethnic, national, educational, and generational—is seeking full expression." This newfound diversity called not only for a revision of museums but for a redefinition of the nature and purpose of art itself. "A 'quiet revolution' in the philosophy of interpretation is under way," explained the AAM. "Objects are no longer viewed solely as things in themselves, but as things with complex contexts and associated value-laden significance."[12] In the revisionist museum it would not be enough for art merely to be art. It also would be a tool for social change.

This view of art and of the purpose of museums is a by-product of the new museology, a subfield of art history which emerged in the early 1990s. Proponents of the new museology take issue with the traditional museum's premise that great art is for everyone or, more fundamentally, that when people look at art—no matter who they are or where they come from—they see the same thing. This notion is a corollary to the centuries-old definition of art as a man-made object imbued with a quality that allows it to transcend its original context and to retain meaning across time. New museologists define art differently. Columbia professor and *Nation* art critic Arthur Danto, one of the new museology's foremost theorists, explains: "As recently as twenty years ago there was a certain consensus in moral philosophy and in the philosophy of art that ethical and aesthetic values were universal . . . the task of good art was to embody principles of beauty valid for all human beings." But a "recent turn in ethics and in art marks the disintegration of this consensus," says Danto.[13]

Columbia art historian Keith Moxey agrees: "It is time to recognize that art history, a discipline whose fundamental premise is that aesthetic value is a universal human response, belongs to the past."[14] According to the new museology, even the greatest art cannot escape its time or the biases that viewers bring to it. Those who are awed by the Sistine Ceiling or the Parthenon are not responding to the power of these monuments, say revisionists, but flocking to well-known sites for the purpose of acting out culturally dictated reactions. That neither viewers, artists, nor art itself can rise above circumstance is a notion popular not only in academia, but among museum leaders as well. According to Stephen Weil, a former deputy director of the Smithsonian's Hirshhorn Museum, "That the greatest of artists have the capacity to transcend the temporal—to infuse their work with something of the eternal—is no longer a widely accepted notion."[15] But if artistic greatness is an illusion and we do not go to museums to see masterpieces, what is the purpose of the museum?

According to the revisionist model, the traditional art museum will best serve the public if it is remade into what Danto calls a "museum of interest and identity." New museologists theorize that people's responses to art are determined by their cultural identity—largely defined by their race, class, and sex—and that museumgoers are seeking out art that affirms and promotes the interests of that identity. Visiting a museum is not an intellectual act but a political one, as Danto defines it: "To experience art is, from the very start, to have an interest—not personal or individual, but the interest which has as its object the furtherance of the group to which one belongs. The art is there for the sake of that interest." According to this theory, a waitress goes to a museum to see works that illustrate the experiences of women or of marginalized laborers. Black visitors are interested only

in art from Africa or by African-Americans—and so on, with as many permutations as race, class, and gender-based diversity allows. Visitors have no use for art with which they share no cultural identification. Danto admits that this redefinition of museumgoing has dictated a striking shift in the mission of museums: "The change was from the presentation of objective data for the sake of knowledge to the creation of subjective opportunities for communion with the history of the viewer's own group."[16]

Originally art museums catered to a single audience: the visitor seeking to experience excellence. That mission presupposes an agreed-upon set of standards for judging artistic quality. According to Neil Harris, early museumgoers believed "that standards of taste and scholarship had objective reality and that museums could express them in three-dimensional form."[17] People went to museums expecting to see great art, and it was the job of museums to supply it. Museums relied on the practice of connoisseurship—the close examination of art objects through the consideration of the characteristics that compose form, including color, line, subject, space, and composition—to make determinations of artistic quality. Stylistic and cultural differences aside, all art objects were assumed to be striving for aesthetic excellence.

The revisionist museum's identity-based art experience debunks the idea of excellence, standards—even quality. After all, if our response to art is driven not by what we see but by who we are, how can there be a single benchmark by which to compare art objects? Art historian and former Whitney Museum curator Benjamin H. D. Buchloh condemns the notion of quality as "the central tool which bourgeois hegemonic culture (that is, white, male, Western culture) has traditionally used to exclude or marginalize all other cultural practices."[18] To claim that one painting is better than another, one period of artmaking more successful than another,

or one civilization more aesthetically advanced than another is viewed by revisionists not as a scholarly judgment but as an act of prejudice. Indeed, according to Harris, even the practice of "classification has come to be seen as an act of domination."[19]

It is not a priority of the revisionist museum that the art it displays be good. Danto asserts that "the primary concern of art is not that it be beautiful; beauty is at best secondary."[20] Far more significant, according to the new museology, is an artwork's ability to provide a therapeutic, group-affirming experience. Here revisionists lean heavily on the efforts many art historians have made in recent years to level the hierarchies of masters, mediums, and movements. Michael Ann Holly, chairman of the art history department at the University of Rochester, describes her program: "We do film, we do Rembrandt. . . . We don't talk about a masterpiece, about a canon, about genius."[21] Alan Wallach, an art historian at the College of William and Mary, calls on museums to follow the lead of art history departments and "break out of the masterpiece-treasure-genius-paradise syndrome."[22] Museum heads appear to be listening. The Smithsonian's Weil condemns the traditional museum's favoring of painting over the work of "potters, goldsmiths, tailors, carpenters, sandal-makers, or jewelers." Weil attributes painting's elevated status to "historical happenstance," suggesting that it is only coincidence that the idea of art came into use (or, as Weil puts it, was "fabricated") in Italy during the High Renaissance.[23]

But when standards become relative, everything becomes art, and politics (or any other nonart priority) is left free to guide the mission of museums. One museum administrator explains it this way: "The emphasis has shifted away from the traditional interpretive goals that focus on the transmission of facts and concepts to what is more popularly being

called the creation of meaning." Gary Vikan, director of Baltimore's Walters Art Gallery, explains that the goal of the revisionist museum is to "legitimize subjectivity and relativity which then inevitably casts a shadow of doubt over the museum's 'authority voice.'"[24] It is more than a bit of smoke and mirrors for revisionists to claim that their goal is to mute the museum's voice and to allow visitors to assign their own meanings to art. Revisionist museums direct the visitor's experience more deliberately than museums ever did in the past, giving visitors cues even before they enter the building.

Like their eighteenth-century European forebears, most American museums were built in the Greco-Roman style in order to convey the tie of both the institution and its collection to the heritage of Western civilization. The classical architecture also helped museums project an image of permanence and safekeeping—not unlike banks of the period, which were also often classically designed. But this appearance had a practical use in addition to a symbolic value. Early museum entrances were built to help visitors make the transition from the orientation of everyday activity to that of artistic contemplation. As a crucial element in that transition, most museums required visitors to climb a grand staircase—first to reach the museum's entrance, then sometimes again inside. The physical work expended in the task of scaling the stairs was a metaphor for the effort required to reach a state of knowledge, of which the museum was a treasure house. Revisionists condemn these entrances as elitist. Today few museums use their original entrances and even fewer require visitors to ascend a staircase. Even Paris's Louvre—on which so many other survey art museums were based—is now entered through the basement. Most museum entrances have been relocated to something akin to a side or back door, often off the parking lot. Visitors now enter these museums no differently than they might a mall or market. The change not

Left: Cleveland Museum of Art, original entrance, opened 1916. Photograph by Howard Agriesti. *Right:* Cleveland Museum of Art, north entrance, Marcel Breuer Wing, opened 1971.

only shuns museums' European roots but also confirms what the new museology posits, that the experiences one has inside a museum are not elevated above, but are merely an extension of, the transactions of daily life.

Until 1971 visitors entered the Cleveland Museum of Art through its massive, neo-classical entrance, overlooking an Olmsted-designed park. The museum's founders considered "an adequate approach" to be the first criterion for determining a building site for the museum.[25] An 1892 editorial in the *Cleveland Leader* called the museum-to-be "a magnificent temple of art," explaining that "a feast of the beautiful is better enjoyed when it is a little apart from the associations and surroundings of business life."[26] Early visitors to the Cleveland museum entered the building by climbing a monumental staircase and passing through an arcade of ionic columns. Had costs not derailed an early plan, visitors would have been greeted in the neo-classical portico by marble sculptures of Michelangelo and Titian.

Cleveland's original entrance is now closed. Visitors are ushered through the museum's new front door, consisting of a fortresslike concrete canopy attached to a granite-box addition to the original building. Visitors traverse a driveway, but no stairway, to approach the museum. Similarly, visitors

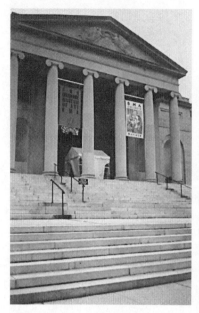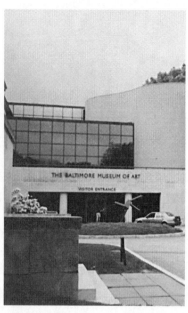

Left: Baltimore Museum of Art, original entrance, opened 1929. *Right:* Baltimore Museum of Art, new visitor entrance, opened 1982.

to the Baltimore Museum of Art walk along a parking lot—in the path of cars—to an entrance so unobtrusive that the museum was forced to install a "visitor entrance" sign to direct stray museumgoers. After opening a lightweight door, they pass through a small, low-ceilinged alcove and into a largely art-free foyer. Visitors to these museums undergo no physical or perceptual transformation—no sense of readying for an experience of high seriousness.

Before 1982, visitors entered Baltimore's museum by scaling twenty-seven steps, proceeding through a row of ionic columns that support a classical pediment, and passing through a set of massive doors. But Arnold Lehman, who served as the museum's director for eighteen years, calls the old entrance "imposing in a somewhat negative way [which said] something about elitism."[27] He believes that a classical

façade speaks "to only a small fraction of the community" and makes others "uncomfortable." The original entrance is now used only for special events—such as fund-raisers—attended by the sort of people Lehman characterizes as "not bashful about asking for champagne." But Lehman admits that other visitors have expressed an appreciation of the museum's classical architecture. He reports that he once overheard a group of inner-city kids who had just entered the museum's grand hall comment on "how beautiful it is and what an absolute change in experience it is from their daily lives." Still, Lehman seems not to realize that these kids and his champagne crowd are having a shared response to the elevating nature of the museum's original architecture.

At Boston's Museum of Fine Arts the 1981 addition of a new wing caused a significant shift in how the visitor encounters the history of art. New museologist Carol Duncan contrasts the old and new orientations:

> In the old Museum of Fine Arts, everything was organized around the central theme of Civilization. Behind the monumental classical entry façade, the entire sequence of world civilizations followed one upon the other: Greece, Rome, and Egypt . . . with the Renaissance centrally placed. This arrangement is still intact today, but the [new addition] seriously disrupted the order in which it unfolds. Because the new wing has in practice become the museum's main entrance, the classical galleries, the old museum's opening statement, now occupy the most remote reaches of the building.

Visitors to Boston's museum today find that "the museum's opening statement now consists of a large gallery of modern art, three new restaurants, a space for special exhibitions, and a large gift-and-book store." In many ways this museum

has become a revisionist ideal, since "it is now possible to visit the museum," Duncan gleefully points out, "and never once be reminded of the heritage of Civilization."[28]

Similarly, visitors to the Seattle Art Museum are greeted with little that places a priority on art. A large foyer leads to a gift shop, cash machine, coat-check room, and auditorium. The mezzanine level is a café. Seattle's museumgoer could hardly be blamed for forgetting that the purpose of visiting a museum is to look at art, since the museum displays objects in only a third the amount of space accorded to art in the traditional museum.[29] Art seekers must ascend a full three floors before they can view sections of the museum's permanent collection. The third floor houses the Native American, Chinese, Japanese, Korean, Andean, and Oceanic art collections and, in the museum's largest permanent exhibition space, the African art collection. Visitors must proceed further, to the top floor, to catch a glimpse of European or American art. Seattle's de-emphasis of Western art is not unique.

Most museums have reorganized their collections in ways that subvert what the new museology calls the "master narrative," or the traditional museum's presentation of the history of art as a chronological tour of civilizations from ancient Egypt and Greece to the present. In many museums this change has been achieved by jumbling the order in which the permanent collection is presented and relocating a selection of non-Western art to the front of the museum. Upon entering the Baltimore museum, visitors are greeted with a museum shop and restaurant. Those seeking to begin a review of the museum's collection are presented with a single starting point: a gallery of African, Native American, Oceanic, and pre-Columbian art located immediately off the lobby. Before Baltimore's new entrance opened, visitors passing through the classical façade proceeded first through the Amer-

ican painting collection and into the European galleries. Visitors to Cleveland's museum have two choices upon entering the museum. They can go down a passageway leading past two museum stores, along a cafeteria, and into the museum's Asian and Native American art galleries. Or they can proceed up a stairwell and start their tour of art history with selections of contemporary art and the South Pacific and Africa collections. Revisionist museums make a point of tipping the scales of history in favor of non-Western art.

In the 1990s even historically traditional museums became self-conscious about how they exhibited Western versus non-Western objects. Perhaps the most vivid example was the National Gallery of Art's 1991 blockbuster, "Circa 1492," a massive show which surveyed artmaking around the world at the time of Christopher Columbus's voyage. A press release described the objects in the show from Africa, Islam, and Japan as "masterpieces." Works from China were "splendors." The "splendor" of the Aztec Empire was also touted, along with the "important textiles" of the Incas, "celebrated" work from Brazil, and the "finest works in gold" from Colombia and Costa Rica. Meanwhile, the aesthetic quality of Western objects was downplayed. These works were not being shown for their aesthetic merits, explained the museum, but rather to illustrate Europeans' odd view of the rest of the world. According to the press release, "Circa 1492" would portray "Europe and its fascination with the exotic" by revealing "how far the realities of Far East culture exceeded the Europeans' dreams."[30] One critic accused "Circa 1492" of going "beyond appreciation to a kind of complete cultural relativism that refused to make any judgment about the greater historical significance of the West."[31] Indeed, instead of placing a priority on any particular art, the show was an exercise in excess, with more than six hundred objects displayed. To the National Gallery's credit, the quality of all the objects was

impeccably high. The show even included Leonardo da Vinci's
Portrait of a Lady with an Ermine, which was on loan from
a museum in Kraków, Poland, and making its first appear-
ance in the United States. Still, as visitors pressed into the
gallery where the Leonardo hung, it was hard not to notice
that museum politics now disallowed showing a work by such
an admired artist without bringing in hundreds of other ob-
jects for balance.

While the National Gallery and other more traditional
museums padded exhibitions to make them more acceptable
to revisionists, other museums pursued more aggressive strate-
gies. When the Dallas Museum of Art expanded in 1993, its
collection was reorganized as "museums" within the museum.
Dallas's Museum of Europe is home to European paintings
and sculpture from antiquity through 1945. In the Museum
of the Americas, colonial through twentieth-century Ameri-
can art is displayed not in the context of the European tra-
dition but as somehow derivative of Meso-American work.
This arrangement spurred the *New York Times* chief art critic
to observe: "This is a novel and multicultural idea, putting
ancient Peruvian textiles, Olmec sculptures and Yupik Eskimo
masks on the same footing as paintings by Frederic Edwin
Church and Georgia O'Keeffe." As the *Times* points out, the
artistic traditions these artists represent have nothing in com-
mon, aside from the coincidence that they all "worked in the
same hemisphere."[32] The purpose of the juxtaposition clearly
is not to illuminate art or history (since the viewer can only
be confused), but to make a jolting political statement about
how museums in the past have defined American art.

Another method museums have adopted for confronting
the traditional museum's "master narrative" is to pit con-
temporary art against objects in the museum's permanent
collection. Often this is accomplished by allowing a con-
temporary artist to arrange an exhibition that juxtaposes his

work with works in the museum's collection. In some instances a museum will give an artist free reign of its contents, as the Maryland Historical Society did in 1992 when it put its collection at the disposal of installation artist Fred Wilson. Wilson used the Historical Society's art and artifacts to stage "Mining the Museum," an exhibition which a curator claims was intended to "undermine our assumptions and expectations of museums, art and history."[33] The installation took up an entire floor of the museum and consisted of a string of confrontational arrangements, most of which can be described as race-based one-liners. In one display Wilson laid a Ku Klux Klan hood inside a stroller. In another he grouped antique chairs before a whipping post.

In 1993 the Seattle Art Museum invited Wilson to incorporate his comments throughout its permanent collection. The suggested starting point for the installation was a hallway on the museum's fourth floor where Wilson spot-lit a water fountain, fire extinguisher, and fire alarm to mock the way museums sometimes highlight art objects. Wilson's commentary took many forms: he placed a Rolex watch inside a case filled with gold African objects, piped African music into modern art galleries, and shoved seven sculptures and five paintings into a corner of an early modern gallery (in imitation of how the Seattle museum displays African and Native American art). The catalog describes Wilson's installation as "a combination of a treasure hunt, a series of elaborate and witty riddles, and a multileveled probe into cultural and racial bias." One curator credits Wilson with introducing "a prismatic reality less burdened with prejudice, privilege, and oversimplification" than the original installation.[34] Some museumgoers were less impressed with Wilson's arrangements and complained that they interfered with their ability to see the art on display. "Please remember the art-loving public" wrote one discouraged visitor.[35]

Although most new museologists claim that their goal is to recast the museum in a way that is more inclusive and audience-centered than the traditional museum, these same revisionists show a remarkable lack of interest in actual public opinion. Baltimore's museum offers a case in point. A neon sculpture by conceptual artist Bruce Nauman sits high atop Baltimore's new visitor entrance and is visible even from quite a distance. The sculpture intermittently flashes the words SILENCE VIOLENCE VIOLINS in the same area where, on traditional museums, the names of great artists are carved into a cornice. Former Baltimore museum director Arnold Lehman recalls that when the piece was originally installed, neighbors wrote to the museum and to the newspaper complaining that it was an eyesore. Citizens argued that neon had no place on the museum's façade, and they threatened to take their case to the zoning commission. When asked why, in the age of the visitor-centered museum, these residents' opinions had been disregarded, Lehman asserted: "We've always believed that the museum has to take a leadership role rather than being reactive to the community." Indeed, it was during Lehman's tenure that *Baltimore Sun* art critic John Dorsey claimed "the museum gained a reputation with many visitors as aloof and arrogant."[36]

The high revisionism of the eighties and early nineties continues today, though its influence has been obscured recently by museums' revived romance with blockbusters. In 1999 more than 800,000 people visited the Los Angeles County Museum of Art to see an exhibition of paintings by Vincent van Gogh. Blockbuster exhibitions at major museums routinely attract half a million visitors, averaging more than 5,000 museumgoers daily. Revisionists dislike these shows not only because they reinforce a narrative of art history that is based on individual genius, but because blockbuster attendance figures undermine the claim that great art is incapable of speak-

ing to everyone. New museologist Carol Duncan blasts the "institution of the giant retrospective," expressing disgust at how "a voracious demand for Great Artists, living or dead, is obligingly supplied" by museums.[37]

There are good reasons to criticize today's blockbusters. Often they defy a basic rule of special exhibitions: that a show must be of sufficient scholarly significance to justify the cost and risk of transporting and exhibiting the works in it. The progenitor of the blockbuster idea—the Metropolitan Museum's "Treasures of Tutankhamen" show, which toured America in the late seventies—gave scholars and the public alike their first opportunity to examine artifacts uncovered in 1922 when archaeologists discovered the nearly undisturbed tomb of a young Egyptian king. The Tut excavation is considered one of the most significant archaeological events of the twentieth century. And when 55 objects from the tomb were exhibited at the Met for 17 weeks in 1979, the show drew more than a million visitors at the rate of 10,600 a day.[38]

Unlike Tut, today's blockbusters are often little more than crowd-pleasers. If the shows were a barometer of art historical significance, French impressionist Claude Monet—whose paintings have been the subject of one or more blockbusters each year for the last five years—could claim unrivaled status as history's most significant artist. In addition to lacking scholarly heft, many blockbusters suffer from a crisis of quantity versus quality, with most shows displaying far more works than a thorough exhibition requires. The overhyped atmosphere these massive shows create shares many characteristics with a rock concert, with ticket scalping and hopeful fans waiting out at all hours of the day and night. Inside the exhibition, crowds can get so thick that some galleries easily could be mistaken for mosh pits. At the exit visitors find posters, T-shirts, and other mementos emblazoned with the art star's name—all positioned where weary art fans will find

them hard to resist. From start to finish, blockbusters are designed to inspire shopping and socializing but often fail to provide an environment that is conducive to the close examination of art objects.

It is a testament to how thoroughly museums have remade the art experience that institutions whose goals have virtually nothing in common with museums have followed their example in tapping into the star-power of great artists. One of the attractions nestled among the acres of craps tables and slot machines at Las Vegas's Bellagio Hotel is a small gallery that shows mostly French impressionist and abstract expressionist works. The casino advertises the art stars on its marquee in the same way that similar signs boast the names of headliners like Wayne Newton or Siegfried and Roy: "Now Appearing: VAN GOGH, MONET, CÉZANNE, AND PICASSO." The license plates on Bellagio limousines are emblazoned with the same names. Not far away a real estate development in suburban Las Vegas sells homes from the mid-$400,000s, each of which is named for an artist. The "Monet" is a rambling ranch with a three-car garage; the "Michelangelo" includes a library and a hobby room.[39]

If, in the public's mind, the names of great artists now conjure the same kinds of associations as Cadillac and Gucci, it is because the idea of art has been diminished. Originally American museums sought to provide a forum where people could commune with individual objects and work at the task of understanding art. Museums no longer encourage their visitors to strive for such lofty goals. Blockbusters sell a version of museumgoing that amounts to little more than glancing at art and buying souvenirs. For those who do look longer, revisionist museums portray the great story of art as a heroless tale of cultural production in which art esteems to no loftier goal than to be an instrument for personal uplift or a pawn in contemporary political argument.

5

HARVARD'S FOGG

Harvard University's art collection of more than 150,000 objects is housed in two buildings with quite different personalities.[1] The older of the pair is the red brick, Georgian-style Fogg Art Museum, founded in 1891.[2] The Fogg displays the core of Harvard's collection of Western art from the Middle Ages to the present. Among its holdings are works by Botticelli, Titian, Cézanne, Picasso, and Mondrian. The museum's galleries encircle a courtyard of travertine marble arcades which replicate details from the sixteenth-century Church of the Madonna di San Biagio in Montepulciano, Italy. Only the bustle of English-speaking visitors prevents someone standing at the Fogg's center from knowing he is not in Italy.

Facing the Fogg's north side is the Arthur M. Sackler Museum, which opened in 1985. The Sackler contains galleries for Harvard's ancient and non-Western art collections, but much of the building is taken up by classrooms and offices for the university's art history department. The Sackler is a postmodern structure which combines minimalist surfaces with eccentric details and critical allusions to past architecture. The museum's peaked entrance references the

ancient Lion Gate at Mycenae. But the Sackler's version re-
places the muscular lions that guard the original doorway
with two monumental cylinders bedecked with bright green
vents. This flourish is just one of the Sackler's many details
which, to one architecture critic, suggest "Miami Vice."[3]

Atop each cylinder, above the vents, sprout steel rods.
These are the only remnants of a plan to build a bridge con-
necting the Sackler with the Fogg. The link was not scrapped
by the university but by Cambridge's city council, which
thought it might be an eyesore. Indeed it would have been
awkward (and not just architecturally), because the distance
between Harvard's art history faculty and its art collection is
far greater than the 150 feet that separate the buildings that
house them. As one curator remarked at an event marking
the Sackler's opening: "As far as art history goes at Harvard,
the things in the museum might as well be 1,000 miles away."[4]
According to reports from across Harvard's art community—
from current and former faculty and students—the art his-
tory faculty at the university with the best art collection in
the world finds little use for it today. Students come and go
and, in the words of one Fogg curator, "they never even know
we're here."[5]

This fissure between the Fogg and Harvard's faculty is
almost entirely attributable to trends in the discipline of art
history at large. Over the last thirty years many humanities
scholars have turned away from the close study of literature
and art and toward theoretically based approaches that place
scholars at some remove from their primary sources. Art his-
tory was somewhat of a latecomer to this trend. The disci-
pline's original methodologies—including connoisseurship,
the study of iconography, and the craft of artistic biography—
staved off the incursion of theory for some time. But art his-
tory's unique concern with artists and with art's formal
properties waned throughout the 1980s. Today most art his-

tory deals more with events in society than with art objects, which have been relegated to the role of illustration. Harvard's department is a stark example of this shift, in part because it sits on a treasure house of art of the kind, quality, and quantity that draws blockbuster crowds to public museums. Yet at Harvard it does not provoke most professors or students even to walk across the street.

This has not always been the case. For more than a hundred years the Fogg and its collection were at the core of art study at Harvard. When Harvard offered an art history course in 1874 it was the first in any American or English university. The course was taught by Charles Eliot Norton, who originally held the title "Lecturer on the History of the Fine Arts as Connected to Literature." The job was given to Norton by his cousin, Charles Eliot, then Harvard's president. Norton was an Anglophile and a great friend and admirer of the English art critic John Ruskin, who believed deeply in the moral purpose of art. Norton had similar ideas about the intermingling of art and life, and the ability of the human imagination to chart a moral course. "The imagination is the source not only of the poetic faculty," Norton argued, "but of the sentiments by which man is ennobled and civilized." And, to Norton's mind, no people needed civilizing more than did his fellow Americans, for whom "the concern for beauty . . . hardly exists among us, and forms no part of our character as a nation."[6]

The aspirations that Norton grafted onto art illuminated his lectures, and he attracted students in droves. Agnes Mongan, who later became director of the Fogg, remembers Norton's class being a packed house: "[Norton] gave his lectures in Sanders Theater at twelve o'clock. Roughly twelve hundred students came to every lecture. There were no slides. There were no photographs."[7] According to friend and writer Henry James, Norton saw his students as "fellow-citizens in

Fogg Art Museum, Harvard University. Courtesy of Harvard
Photo Services.

the making," and he took it as his duty to "convert [these]
young products of the unmitigated American order into ma-
terial for men of the world."[8] One of those students was an
undergraduate named Bernard Berenson, who went on to lay
much of the groundwork for the study of Italian Renaissance
painting. Norton introduced Berenson to Isabella Stewart
Gardner, launching one of the most productive relationships
in the history of American art collecting.

Norton inspired so many of his students into collecting
that their generous gifts to Harvard became the teacher's
legacy. As an undergraduate, Edward Waldo Forbes, who was
the grandson of Ralph Waldo Emerson, had taken Norton's
courses in classical and medieval art. Forbes graduated in
1895 and four years later began donating works to the Fogg,
including:

A Florentine tabernacolo, an Adoration of the Magi, of
the school of Ferrara, a portrait of a Procurator of St.

Arthur M. Sackler Museum, Harvard University.
Courtesy of Harvard Photo Services.

Mark, the beautiful ancient copy of the Meleager of Sco-
pas (in some respects the best of the extant copies of
that work by the famous Greek sculptor), a Greek head
of Aphrodite, and the front of a Roman sarcophagus with
a relief representing a battle of Greeks and Amazons.[9]

In 1909 Forbes became the Fogg's director, beginning a thirty-
six-year tenure during which he made two decisions that af-
fected art teaching at Harvard for generations. The first was
to rebuild the Fogg Museum, which had opened only in 1895.
Forbes deemed the first Fogg insufficient for teaching pur-
poses, and became famous for faulting the building for "hav-

ing a lecture hall in which you could not hear, a gallery in which you could not see, workrooms in which you could not work, and a roof that leaked like a sieve."[10] A new, state-of-the-art Fogg was completed in 1927. In addition to sufficient space to hang the entire collection, the new Fogg had an art conservation laboratory (the world's second) and a fine arts library. It was with the transfer of Harvard's art book collection from Widener Library to the Fogg that what came to be called the "troika" was complete.

The troika referred to the trio of institutions that comprised the Fogg learning experience: the art history department, the museum, and the fine arts library. Fogg faculty and students dubbed these the troika in order to emphasize the department of fine arts' seamless relationship with the Fogg and its library. So central was the Fogg to art study that graduate students were said to be studying "at the Fogg," not at Harvard per se. The Fogg was a teaching museum and a laboratory for the department, and its holdings were a working collection. New objects were acquired not just with an eye to quality but to usefulness for teaching.

In 1915 Forbes made a second important decision—to lure Paul J. Sachs away from his family's banking business (and the opportunity to head Goldman Sachs) and into service as the Fogg's assistant director. Sachs had graduated from Harvard in 1900, worked in banking, and then served as a colonel in the Red Cross during World War I, aiding wounded French and American soldiers on the western front.[11] In and amongst these experiences Sachs had traveled the world collecting art, with an emphasis on prints and drawings.

At Harvard Sachs's name became virtually synonymous with two courses he taught for decades. He gave the university's first class in modern painting, which students affectionately dubbed, "A Seminar with Paul Sachs." According

to one account, "[Sachs] told his students fascinating anec-
dotes of people whom he had known, who had modeled for
or known Monet, Manet, Degas; stories of dealers, of Vol-
lard in Paris, hanging like a great hawk in the doorway of
his shop."[12] Over dinner at Sachs's house in 1928 three Fogg
students—Lincoln Kirstein, John Walker, and Edward War-
burg—founded the Harvard Society for Contemporary Art. In
a rented second-floor space on Harvard Square the Society
showed contemporary art, providing the first ongoing forum
in America for modern artists, including Pablo Picasso and
Alexander Calder. Sachs and his brother Arthur both served
as Society trustees.[13] The Society was a precursor to the Mu-
seum of Modern Art, of which Sachs was also one of the
first trustees.

Even more influential on Harvard, on museums, and on
art history at large was Sachs's course on "Museum Work
and Museum Problems," known as "the museum course."
The course's creation myth credits the former secretary of
the Metropolitan Museum of Art, Henry Kent, as its pro-
genitor. Kent set up the Met's original system for handling,
cataloging, and tracking art objects, much of which remains
in place today. He knew that America's budding public art
museums needed people to run them who knew the meth-
ods and ethics of museum work. While returning to New
York from Boston by train, he wrote the curriculum outline
for a museum course on the back of an envelope. Kent sent
his notes to Sachs, who began teaching the class in 1922.

The museum course's unique demands inspired Sachs
to develop a new method of teaching which "centered on the
close observation of the object; and the careful recording of
that observation."[14] The technique owes much to Berenson,
whose work on the classification of Italian paintings relied
on close examination and comparison. After the inception of
the museum course, Harvard students at all levels learned

about art by handling and examining real objects, an approach that came to be known as the "Fogg method."

In Sachs's classroom the Fogg method took various forms. Sometimes Sachs would take his students to a museum, ask them to choose the best work in a gallery, and make them defend their decision. Usually the museum course met at Sachs's home, Shady Hill, which had been Norton's home before him. Shady Hill was stocked with art, occupying every wall, bookcase, and tabletop. Sachs brought students into the long drawing room where he sat facing them and then handed over an object. Students passed the work around as Sachs asked: "What does it say to you? Is it a work of art? What do you think of the material? Is it worth paying attention to?" Agnes Mongan recalls the experience: "There you would sit with some incredibly rare object in your own two hands, looking at it closely. It would stir you deeply." Mongan remembers being faced with objects of all kinds: "a small bronze Assyrian animal, a Persian miniature; in another case, a trecento ivory, occasionally a small Khmer bronze head."[15] Sachs wanted his students to become expert in the immediate analysis of any object's aesthetic characteristics, unbounded by period or style or medium. The goal of the museum course was for students to achieve an almost innate understanding of art objects, to become fluent in the language of art.

Most graduate students who studied with Sachs also enrolled in a studio course Forbes taught on the "Methods and Process of Italian Painting." In what came to be called the "egg and plaster course," Forbes's students learned about the potential of various mediums by working with them: preparing fresco plaster, making gesso, applying gold leaf.[16] According to one former student:

> Each member of the Forbes class had to do a fresco using trecento techniques. We also had to make a silverpoint drawing, paint a small tempera panel, make a

painting using the techniques of the Venetians, and one using a nineteenth-century technique. This was so we would all recognize immediately the technical characteristics of such works of art.[17]

Norton's students had been taught to see art as a vessel of morality. Sachs and Forbes were moving their students away from moral analysis and toward a more objective, scientific means of assessing art. They were training connoisseurs, many of whom went on to use their skills in practice.

In the 25 years that Sachs taught his museum course he had 341 students—188 men and 153 women.[18] Among the group were James Rorimer, who went on to direct the Metropolitan Museum of Art, and John Walker, who headed the National Gallery of Art. Other museum course alumni led the Frick Collection in New York, Connecticut's Wadsworth Atheneum, the Cleveland Museum of Art, and Boston's Museum of Fine Arts. Because of Sachs's own recommendation, his former student Alfred H. Barr, Jr., became the founding director of the Museum of Modern Art. A 1989 count found that 42 former Sachs students had become museum directors and 45 had served as curators.[19]

Even after Sachs and Forbes both retired in 1945, the flow of Fogg graduates streaming into museum careers scarcely ebbed. John Walker's directorship at the National Gallery was followed by that of Fogg students J. Carter Brown and Earl A. Powell. The current directors of New York City's three most influential museums are also Harvard alumni: the Metropolitan Museum's Philippe de Montebello; Museum of Modern Art director Glenn D. Lowry; and Maxwell Anderson, head of the Whitney Museum of American Art. These students never studied with Sachs or Forbes but with the next generation of Harvard professors who succeeded them and built on the Fogg method.

In the 1930s the Fogg's ranks benefited from the addi-

tion of many scholars who were refugees of Nazi Germany. The department's first emigré scholar was Wilhelm Koehler, an expert in Carolingian art. George Hanfmann, who studied ancient art, joined the department in 1935 and stayed for forty-seven years. Hanfmann had left Germany in 1934 while he was finishing his doctorate at the University of Berlin, after he was attacked by Nazi gangs. He curated the Fogg's ancient art collection and spent twenty years directing Harvard's archaeological digs at Sardis in present-day Turkey. Hanfmann's arrival at Harvard was followed in 1937 by that of Jakob Rosenberg, a specialist in seventeenth-century Dutch painting. Rosenberg was a connoisseur, trained in exacting stylistic analysis by his mentor, the Swiss art historian Heinrich Wölfflin. Rosenberg was one of the first Rembrandt scholars to cast doubt on many of the works attributed to the master. Another Wölfflin student, Chinese art specialist Max Loehr, also eventually joined the department.[20] These new faculty members had more extensive academic training than did their Fogg predecessors. Their arrival signaled a professionalization of Harvard's department.

Of this new wave of professors, Jakob Rosenberg had the greatest impact. His former student John Rosenfield, who went on to teach at Harvard for more than thirty years, recalls taking a course with Rosenberg on quality in art: "Day after day we had quizzes on quality. We'd be shown two drawings and would have to determine which had more unity, which had more vitality, and [we'd] try to verbalize differences in quality."[21] Marjorie Cohn, currently the Fogg's curator of prints, remembers a class when she chose the lesser work: "I can remember being mortified because I picked the Van Dyck rather than the Rubens. He made it perfectly clear why the Rubens was the better one."[22] Rosenberg taught his students that connoisseurship was not a gift that some people had and others lacked, but a process that anyone could

learn. In the words of one colleague, Rosenberg "helped de-
mystify connoisseurship" by demonstrating that it required "a
bit of intuition buttressed by a sharp and perceptive eye, a
vast storehouse of historical and technical knowledge, close
first-hand familiarity with almost innumerable works of art,
a formidable visual memory, and incessant practice."[23]

Indeed, Fogg graduates were expected to possess a knowl-
edge of art history that was both broad and deep. John
Coolidge, who studied at Harvard in the 1930s and taught
there for almost forty years, remembers a typical question
from the oral general examination required of all graduate
students: "Mr. So-and-so, will you tell us who were the popes
between Martin V and Innocent X?" The student's recitation
of more than three centuries of popes was corrected on the
spot, and then he was asked: "Now, Mr. So-and-so, who made
their portraits?"[24] In preparation for the exam, students "read
oceanically," says Fogg graduate Paul Barolsky.[25] In the sec-
ond part of the test a student was presented with a room of
objects—"bronzes, paintings, drawings, furniture, majolica,"
remembers Barolsky. Often many of the items were drawn
from private collections to ensure that students had not seen
them previously. Maxwell Anderson remembers: "Objects were
brought up from Manhattan collectors to beat me to the
punch."[26] Students were given four hours to date, identify,
and evaluate each object.

The Fogg tradition of connoisseurial observation matched
with encyclopedic knowledge continued into the 1960s, even
as the department started bringing on more scholars who
were not "Harvard men." Aside from the emigré scholars, the
department's early faculty had been largely comprised of gen-
tleman scholars with undergraduate Harvard degrees. Now,
as graduate departments had become established across the
country and many universities were turning out talented art
historians, Harvard diversified its ranks.

Coolidge, who studied architectural history and joined the department in 1947, had earned his undergraduate degree at Harvard but had gone on to New York University's Institute of Fine Arts for his Ph.D. In 1954 Seymour Slive was hired to replace the retiring Rosenberg. Slive is a scholar of Dutch art who was educated at the University of Chicago. John Rosenfield, whose specialty is Japanese art and whose Ph.D. is from the Fogg, taught at UCLA before returning to Harvard in 1960. A year later James Ackerman joined the faculty. Like Coolidge, Ackerman had studied architectural history at the Institute of Fine Arts. These and other additions to the faculty expanded the department's expertise while also muddling its almost perfect Harvard pedigree.

Still, the grand don of the department throughout the sixties and seventies was a Harvard man through and through. All of Sydney J. Freedberg's degrees were from Harvard and, except for military service and a brief tenure at Wellesley College, the Fogg was his home for fifty years.[27] Freedberg was the consummate connoisseur, specializing in Italian Renaissance art but with an eye that could read anything. His own Harvard training had been inspired by the example of Bernard Berenson, at whose side Freedberg had begun studying when he was twenty-three.

Although Berenson and Freedberg were born fifty years apart, their lives shared many parallels. Both were Jewish and grew up poor in Boston.[28] Berenson's father was a peddler, Freedberg's a tailor. As boys, both attended Boston Latin School, America's oldest public school, famous for educating Boston's brightest children. Both spent their undergraduate years at Harvard, where Berenson studied mostly literature and Freedberg went on to earn his fine arts Ph.D. Berenson served as an army intelligence officer in Paris during World War I. Freedberg spent World War II with army intelligence, on assignment with the British navy, and was awarded the

Order of the British Empire. Both spent their careers making signal contributions to the field of Italian Renaissance art history. Berenson and Freedberg were two men on the same path, a generation apart.

Freedberg learned from Berenson not only the skills and determination of impeccable scholarship but the art of carving a personal grace from a bootstrap Jewish childhood. Berenson was spurred by social bias and professional necessity to adopt the cadences of gentile high society. Freedberg's situation was not compulsory like Berenson's, but his conversion was no less dramatic. Everyone who knew him recalls Freedberg's stately manner and the entirely manufactured accent that punctuated it—part Boston Brahmin, part English. Renowned for his sartorial elegance, according to one account Freedberg easily "could be mistaken for James Bond's boss."[29] Freedberg was, in the words of a colleague, "a self-created masterpiece."[30]

Freedberg's mentoring took place at Berenson's Italian villa, I Tatti, which sits on a hilltop outside Florence and, at the time, housed an unrivaled collection of art, photographs, and books dedicated to the study of Italian art. It was at I Tatti that Freedberg chose to study the Renaissance and learned from Berenson the art of connoisseurship. Due in part to his student's influence, Berenson eventually gave to Harvard both the villa and his archive.

When Berenson came to the field of early Italian Renaissance art at the end of the nineteenth century, many important works were still either unidentified or misattributed. His own project began with developing methods for distinguishing an individual artist's hand. Berenson built on the work of Italian physician Giovanni Morelli, who had pioneered a technique that relied on identifying aspects of paintings that artists tended to execute in a rote manner. Morelli found that when painting portraits, for example, artists often

would render hands or ears in the same manner, inadvertently providing a telltale signature. Berenson vastly expanded on Morelli's method, developing a new paradigm for attribution based on what he called "artistic personality."

Unlike Morelli, Berenson believed that a work of art was more the product of an artist's mind than of his hand. Hence the unique character of any painter's work (his artistic personality) was more consistently reflected in his overall aesthetic style than in the unconscious habits of his process. Berenson's analysis of artistic personality focused on two observable traits: the way in which an artist structured his works, and the consistent level of quality he achieved.[31] In any particular work a painter might choose to paint hands or ears differently than he had before, proving Morellian tests insufficient. But even the best artists created few works that significantly departed from his methods for organizing compositions, or that fell far outside his typical range of achievement. Berenson concluded that an accurate profile of a painter's artistic personality was the only dependable guide to identifying and evaluating his work.[32]

Berenson passed on to Freedberg not just his connoisseurial method but also its priorities, the highest of which was the centrality of the art object to art historical study. Freedberg would write on the topic even more eloquently than his teacher:

> Art history is based upon actual surviving presences from the past—tangible survivals: not mere indications of a form which we must reconstruct, as is the case in music, nor the verbal symbols of a thought or feeling, as in a poem, but the form itself, a physically present body that has endured through history. Contained in that form which we may touch and see is a communication—a

content that is the crystallization of the thought and feeling of a being in the past, made immediate and accessible to us.[33]

To Freedberg, centuries-old paintings were not dead documents but living evidence of how past individuals struggled to provide solutions to the challenges posed by their time. Art critic Clement Greenberg credited Freedberg's writing with conveying a sense of the *"working* life of art," a narrative that reads through the painter's eyes:

Leonardo, Michelangelo, Raphael and the others of their time and place, as they are followed from work to work, are shown as open cases, with their artistic personalities not yet set or solved: copying as well as discovering, acted upon as well as acting.[34]

Freedberg saw these painters as geniuses, but more fundamentally as individuals who had worked (like the artists before and after them) to achieve artistic greatness. Examining the results of those efforts was the core of Freedberg's method.

Like his mentor, Freedberg considered an artist's style to be the key to understanding his work. He concentrated less on the technical process by which a work was produced or on the person, place, or event it depicted since those aspects were more likely to reflect scientific limits and patron preference than artistic choice. Freedberg did not ignore factors outside the aesthetic. He considered surviving documents and historical accounts important resources that played a secondary role, as further confirmation of what a painting itself conveyed.

In some ways Freedberg surpassed his teacher, fulfilling the promise of connoisseurship that Berenson had only glanced. Berenson had been the visionary, organizing the Ital-

ian Renaissance field in broad strokes and identifying the tools best suited to assessing artistic accomplishment. Freedberg used those tools, honing their application and enhancing their effect. Freedberg's history of art was an epic tale of individual artistic personalities. But he also saw how isolated artistic efforts linked together to form a progressive evolution over time. Freedberg's mastery of both breadth and detail enabled him to forge a complete history of Renaissance painting that was greater than the sum of its parts.

Freedberg's nine books include two monographs of early mannerist painters, Andrea del Sarto and Parmigianino. But he was best known for two works in which he captured the Renaissance age, his two-volume 1961 *Painting of the High Renaissance in Rome and Florence* and then *Painting in Italy 1500–1600*, a contribution of more than 750 pages to the Pelican History of Art series, first published in 1971. *Painting in Italy* went into three editions and was translated into Spanish and Italian. It is a sweeping survey of the high and late Renaissance from Leonardo to Caravaggio and from Venice to Naples.

"There is no reason," Freedberg wrote, "why art history should not attain at times to the status of literature—or even poetry."[35] Almost everything that has been written about Freedberg remarks on his command of language. He described the *Mona Lisa* as directly as Leonardo painted her: "a synthesis of rare perfection between art and actuality: an image in which a breathing instant and a composure for all time are held in suspension."[36] Works with involved baroque effects received rolling interpretations, as in this description of *Venus, Cupid, Folly, and Time* by the sixteenth-century Florentine mannerist Agnolo Bronzino:

"Glacé surfaces of flesh emanate a contrary excitation; the postures of the protagonists are frank and yet evade; cold grace is manipulated into attitudes that convey, by the effect

of pattern, the fine-drawn tension of the actors' states of mind."[37]

One Fogg colleague observed that "Freedberg very seldom describes explicitly the methods he uses; they are like an elaborate intellectual scaffolding removed after a construction is finished."[38]

Freedberg's rhetorical skill did not translate into a cavalier attitude toward art. He was humbled by art, not standing astride artworks but before them. John Coolidge praised Freedberg's balanced approach: "His most personal gift is his capacity to analyze thoroughly, indeed exhaustively, an individual work of art without undue emphasis on one aspect against another and above all without destroying its vitality in the process of dissection."[39] A former student remembers sitting in class and realizing: "His descriptions were more real than the slide."[40] Another recalls her first Freedberg class: "He began to speak, with mesmerizing passion, about the 15th- and 16th-century Italian paintings of drapery-swathed saints and sweet Madonnas that flashed on the screen behind him. By the end of the class, he'd changed my life." This prospective physics major switched to art history the next day.[41]

Freedberg's classroom presence gave him a considerable profile among students. "People tended to follow him," says James Ackerman. "He had tremendous personal magnetism, and people naturally fell into his idiosyncratic mode."[42] One student remembers Freedberg as "the glamorous and fearsome star of the department." Again, this intimidating profile failed to materialize in reality, according to one student: "He was famous with undergraduates for eating them alive. Yet he also was a wonderfully patient teacher. He'd spend hours with the dumbest students."[43] Most graduate students simply held him in awe: "Freedberg kind of walked on water," says one.[44] Marjorie Cohn found Freedberg's seminars "scary

and wonderful." "He was so completely formed . . . as an intellect," says Cohn, "you all sat there at age twenty-one wondering if you could ever be as fully formed as Sydney."

His forbidding accent and starched mode of dress exaggerated Freedberg's considerable, if mythic, reputation for hostility toward nonformal approaches to art history. It was a reputation Freedberg took every opportunity to inflate. When anyone asked him what he thought of iconography, the study of symbol and subject matter in art, Freedberg's stock response was: "I'll study iconography after I go blind."[45] Colleagues even teased him. In the summer of 1961 Coolidge wrote Freedberg in Italy, asking for his help. Coolidge was organizing an index of sculptures that included images of David, and he wanted Freedberg to conduct a close examination of a few works while he was in Italy. To his request, Coolidge appended a plea: "Being even faintly iconographical, this suggestion will not appeal to you in the least, but I send it along nonetheless."[46] Freedberg complied with self-mocking reluctance. He was, in fact, his own keenest critic. "He was a cut-up," says one former student, who remembers Freedberg showing up at a Halloween party decked out as an Italian mafioso.[47] He always seemed anxious to tell anyone who asked about his peculiar accent that it was a byproduct of "pure affectation."

Although Freedberg was saddled with a reputation as a narrow Renaissance formalist, it was as much of an illusion as was his accent. His work was always informed by the latest scholarship, though, as a former student notes, Freedberg "carr[ied] this learning lightly," using only that which further illuminated the object.[48] Particularly in his later work Freedberg drew heavily on his knowledge of history, religion, politics, and iconography. In a review of *Painting in Italy,* Freedberg's Fogg colleague Henri Zerner observed: "There is no question that Freedberg acknowledges the value of other

approaches and that he uses them when he wishes to do so with distinction."[49]

Freedberg's artistic interests also ranged far beyond the Renaissance. When still a budding young professor in the late 1940s, he reviewed contemporary art for *ArtNews* magazine. In a regular column titled "This Month in New England," Freedberg critiqued the diverse lot of local talent that comprised the "Boston School," including primitive painters, abstract expressionists, geometric abstractionists, and neo-romantic portraitists. He was just as tough on contemporary artists as he was on their Renaissance forebears, and he gave academic artists a particularly hard time. Of a series of landscapes by local favorite Charles Hopkinson, Freedberg wrote: "These watercolors are forthright and technically adroit, perhaps both in excess, for the technical ease at times verges on seeming carelessness, and the forthrightness tends to tourist-painter obviousness."[50] The only virtue Freedberg found in an exhibition of earnest but naive works by a Salem painter was that it "makes us feel the frustration of a single mediocrity."[51]

The terms Freedberg served as department chair in the early sixties and seventies coincided with what Ackerman remembers as the Fogg's "golden age."[52] The new blood flowing into the department created an exhilarating environment. Even though much of the faculty was now young and working in a wide array of approaches, the atmosphere was collegial. Ackerman attributes the harmony to the fact that "there was no doctrine," no one way of doing art history that was required of all.[53] "This place has been remarkably gifted at maintaining an aura of collegiality," observes one longtime faculty member, speaking of the sixties and seventies. "[Harvard] is a very privileged world and there's enough for everyone. I was not aware of interpersonal conflicts at all." That situation would soon change.

In 1974 a young professor of modern art, Michael Fried, came up for tenure. Fried had been considered a rising star at Harvard since his days as a graduate student in the sixties when he co-curated an abstract painting show at the Fogg featuring Kenneth Noland, Jules Olitski, and Morris Louis. Fried was a formalist, a kind of Sydney Freedberg of modern art for whom looking at art was central to the interpretive task. Like Freedberg, Fried also inspired a following. According to one student, "everybody who heard [Fried] became convinced of the value of taking art seriously and personally, as he so obviously did."[54] Freedberg strongly supported Fried's tenure candidacy, but some members of the faculty had reservations. "Michael would say outrageous things like 'I'm going to teach the history of European art and leave Marcel Duchamp out of it,'" says one. Fried was an outspoken advocate of Greenberg-inspired formalism, which made him a "fiery partisan" to the mind of one colleague. But no one claimed that Fried's advocacy ever crossed an ethical line—he never tried to impose his opinions inappropriately on students or peers. So, somewhat begrudgingly, a majority of the department voted to support his tenure application. Instead of accepting a divided endorsement, Fried took an offer from Johns Hopkins University and left the same year. Ackerman regrets Fried's leaving, believing that "he would have been a very useful member of the department." To one professor, the Fried fight was "the great watershed in the history of the department."

1979 saw a reprise of these arguments. This time the candidate was Timothy J. Clark, a self-avowed Marxist who was teaching at UCLA and being considered for Fried's old post, with tenure.[55] Born in Bristol, England, Clark had emerged from his Cambridge University and Courtauld Institute training a dedicated social art historian who viewed art less as the unique product of an individual mind than as

the byproduct of the economic and political circumstances of the time in which it was produced. According to this way of thinking, art is no different than any other material artifact, its attributes merely a readout of pressures imprinted upon it by society at large.

Clark's view of the art historian's task differed considerably from that of many of his peers, including most professors who had taught at the Fogg. To Clark the goal of art history was not to assemble an accurate record of human creativity but to construct a history that represents the past in ways that are politically useful. Clark wanted not only to engage in this activist practice himself but to avoid a "deadly coexistence" with other methods by supplanting them with his own approach, as he indicated in 1974:

> I'm not interested in the social history of art as part of a cheerful diversification of the subject, taking its place alongside of the other varieties—formalist, Modernist, sub-Freudian, filmic, feminist, radical, all of them hot-foot in pursuit of "the new." For diversification, read disintegration.[56]

When Clark was being considered by Harvard, his only books were two spin-offs from his dissertation which dealt with art and politics during the brief term of the Second French Republic. In *Image of the People* he attempted a revision of realist painter Gustave Courbet, portraying him as a political radical trying to topple the bourgeois establishment and, as Clark writes, "to put an end to the connoisseur."[57] Clark's other title, *The Absolute Bourgeois,* dealt more broadly with art and politics in France from 1848 to 1851. When both books were published, in 1973, Clark was thirty years old.

Because these books made so forceful and clear-spoken an argument for a radicalized art history, they attracted considerable attention within the discipline and made Clark a

young star. But both works were also criticized for reasons that became consistent complaints about Clark's scholarship in later years. Many scholars accused Clark of handpicking paintings to fit his argument and ignoring others. His examination of Courbet's work was faulted for overlooking the artist's considerable output of genre paintings and landscapes during the period under review. Another criticism was that Clark, with little obvious rationale, oscillated between literal and metaphorical interpretations of the people, places, and objects in the carefully chosen group of paintings he discussed. Clark's flip-flopping interpretive strategy came under attack by critics of his 1985 book on Édouard Manet and his peers: "Whenever such 'literal' reading of an image proves unrewarding, becomes exhausted, or is simply indecipherable, the image can still be read metaphorically."[58] In practice this meant that Clark would read the blank stare that occupied the faces of most of Manet's female models sometimes as boredom, or class alienation, or even the distanced cynicism of a prostitute—depending on whichever interpretation best made the larger point he was striving to make about class relations in Paris from 1860 to 1880. "Clark seems to be using ideological keys that have to be forced into their locks," argued a reviewer in the *New York Review of Books*.[59]

Clark was suspected of advocating an art history of convenience, with methods that would bend to serve any argument. Even his admirers on the Harvard faculty harbored doubts about his work, though they were excited about the prospect of having so provocative a figure in the department. Ackerman supported Clark because he considered him to be "the most stimulating person in the field" while admitting that

> [Clark's] work has never had the rigor and precision that is usually a basis for our judgment. But, on the other

hand, that's partly related to the Marxist point of view, where a sociopolitical agenda might carry an argument farther than documentation sustained, and where the writer usually takes a *parti pris* and then undertakes to demonstrate it, which can lead to hiding of evidence or not even thinking to look for it contrary to the final result.[60]

Clark's primary competition for the job was Columbia University's Theodore Reff, who had edited the notebooks of Edgar Degas and written books on Cézanne and Manet. According to Ackerman, Reff was deemed "not exciting enough" for Harvard.[61]

Freedberg argued against Clark's candidacy from the start, which Ackerman says was uncharacteristic: "[Freedberg] had always, prior to that time, given ground very graciously in faculty arguments over new appointments. When he was outvoted, he accepted it."[62] But Freedberg was adamant in his belief that bringing Clark to Harvard would have a corrosive effect on the department and on the discipline at large. When Freedberg's opposition looked like it might threaten the appointment, Clark's supporters took the unusual step of meeting secretly with Harvard President Derek Bok who, in the words of one faculty member, "finally went along" with the idea of hiring Clark. At the decisional faculty meeting, Freedberg and a handful of others voted against the appointment. When it became clear that Clark had enough votes to win, the department chairman called for a courtesy vote of unanimous support, but Freedberg refused to go along. Clark joined the Harvard faculty in 1980.

"[Clark] came very much with a chip on his shoulder, feeling that he was in hostile territory," recalls Ackerman.[63] He immediately began making noise. "He reacted in a way that exacerbated the whole thing by really extreme radical-

ness in his initial courses," Ackerman says. The controversy around Clark helped make him a magnet for students. "Clark was a young buck who came onto the scene," says former student Robert Simon; "[he had] enormous amounts of students coming to lectures, he had acolytes."[64] One professor remembers Clark having sixteen students working for him at once. Diane Upright was teaching at Harvard at the time and recalls Clark as "a very charismatic figure, a very powerful teacher."[65]

Clark's arrival coincided with a shift in the department's leadership. In the late seventies and early eighties Islamicist Oleg Grabar served a lengthy term as department chairman. At the time Grabar was quite taken with new theoretical approaches that were sweeping the discipline. "[Grabar] once announced that he no longer wanted to be called an art historian," remembers one professor, but a "visual semiotician." Grabar and a small but growing coterie of like-minded professors advocated disassociating the department from the Fogg and the connoisseurial image embodied by its collection. "They wanted to do away with the Fogg Museum," recalls Irving Lavin, who sat on visiting committees to the department in the early eighties. "The faculty simply wanted to divorce itself from the museum."[66]

"Poisonous" is how curator Marjorie Cohn describes the relationship between the department and the Fogg in the early eighties: "The museum was more and more thought of as the second-class citizen, [the] last bastion of the ignorant and elitist connoisseurs." Upright often heard her faculty peers saying they would like to "put on ice or sell the contents of the Fogg Art Museum." According to Upright, these professors argued "that the works of art didn't have the value to them that they had previously and that everyone should just head for the library and forget the gallery." Another fac-

ulty member remembers: "There were people in the [department] who said 'I don't need objects. I need photographs, drawings, and diagrams.'" When Cohn attended a meeting of the art history faculty and protested "the increasing lack of use of the collection in teaching," a young professor responded by saying that "just because you have an ICBM missile doesn't mean you have to shoot it off." Cohn was shocked to hear a faculty member equating the Fogg's collection with a weapon, better kept locked away so it could not hurt anyone.

The Fogg emerged from this period intact, though some distance between it and the department was established. The annual visiting committee, which for decades had reviewed the department and the museum jointly, was split, with most scholarly members put on a departmental committee and museum donors sidelined to overseeing only the Fogg. This cutoff from the museum formalized a division that already was becoming evident in the work of graduate students. Upright recalls one who requested her guidance with a thesis. The student was writing about Picasso, so Upright asked how she had utilized the Fogg's sizable collection of his works. She was appalled at the student's blank response: "This student is working on something where the Fogg has spectacular works by Picasso from the period in question. And this student wasn't aware of it and had never looked at them."

As the museum and the department drifted further apart, the war between Freedberg and Clark heated up. "There emerged a struggle between T. J. Clark on the one hand and Sydney Freedberg on the other," says Rosalind Krauss, who earned her Ph.D. at the Fogg and served on the departmental visiting committee in 1982 and 1983. "This was a struggle that was playing itself out in every art history department . . . in the country."[67] The intense tone of the debate is evident

even in remarks Clark and Freedberg made some years later. Clark advocated a new art history and expressed frustration at the resistance he encountered:

> I think that art history has problems. It's an under-nourished and troubled discipline. Thank God there are some signs of renewal, but this renewal is not helped by the way things inevitably get converted into some kind of intellectual Star Wars.[68]

Meanwhile Freedberg maintained his drumbeat for keeping attention on objects:

> Many of the studies which approach art from a socio-logical or an economic point of view lavish far more effort and attention on the factors that surround the art than on the art itself, as if the setting, not the stone, were the important matter. If the primary matter of art history is, by definition, art, should not our main expenditure of effort be on it?[69]

The battle began consuming the department as faculty members took sides and graduate students followed. According to Robert Simon, "there was a sense that [Clark and Freedberg] were involved in a struggle over the soul of the discipline." Maxwell Anderson remembers how the mood inside Freedberg's own classroom reflected the change that was under way: "The room was crowded with undergraduates hungry to be in the presence of this great man, and leery, sort of jaded graduate students slouching in the back laconically."

Tensions came to a head in 1983 when the departmental visiting committee convened. Committee meetings normally consist of little more than a series of chats with faculty members and a good number of opportunities to socialize

with colleagues. "You're wined and dined and you report that things are going fine," says committee member Marvin Trachtenberg, a professor at New York University's Institute of Fine Arts.[70] Many members of that year's visiting committee were either long-standing friends of the department or scholars who had served as visitors for many years running. In addition to Columbia University's Rosalind Krauss, the committee included another Fogg Ph.D., Henry Millon, dean of the National Gallery of Art's Center for the Study of Visual Art, and Irving Lavin of the Institute for Advanced Study in Princeton, who was visiting for the third consecutive year.

The meeting was chaired by art collector and newspaperman Joseph Pulitzer, Jr. As a Harvard undergraduate in the 1930s, Pulitzer had studied with Sachs. Like his teacher, Pulitzer had inherited a business career but chose to pursue art with equal dedication. He credited Harvard with introducing him to modern art (his senior thesis was on Picasso) and training him in the methods of connoisseurship. He made his first art purchase during his senior year—a portrait by Italian modernist Amedeo Modigliani—and, along with his wife Emily, eventually assembled one of the most discriminating collections of modern art in the country. (When Pulitzer died in 1993 his pallbearers included artists Richard Serra and Ellsworth Kelly, along with Harvard president Neil Rudenstine.)

Pulitzer and the rest of the 1983 visiting committee had no reason to think their visit would be anything but routine. But as soon as the committee began they learned that a group of graduate students wanted to meet with them to discuss a problem in the department. The committee members were shocked when they heard what the students had to say. Lavin recalls: "They had a complaint that one of the professors

there would not allow people to study in his field unless they did the kind of art history that he wanted them to do." That professor was Clark.

The committee investigated and found that Clark was routinely violating the academic freedom of his students. Trachtenberg says the students reported that Clark was "telling students to avoid classes with other members of the faculty," namely Freedberg. One former graduate student said Clark put it to her like a rule: "If you were T. J. Clark's student, you couldn't study with Sydney Freedberg."[71] Lavin remembers students saying that they "were intimidated and . . . avoided Sydney for those reasons, political reasons." Clark's actions carried added impact, in part because he was the graduate student adviser at the time. But most of Clark's influence derived from his stature as a leading figure in the profession. To have attended Harvard in the eighties and not studied with Clark would have been considered a grave career mistake for any young art historian.

Freedberg's students were not the only ones that Clark turned away. Former students and colleagues report that he also refused to work with any student who wanted to study in his area of specialty but who did not want to adopt his approach to art history. Lavin recalls students testifying that "they were being told to leave Harvard if they didn't want to do 'X.'" According to Ackerman, Clark's attitude was "either you do it my way or I don't supervise you." He recalls a student who, after being cast out by Clark, ended up finishing her Ph.D. only after enlisting the help of three professors outside her field of study.[72]

Clark gave some students more trouble than others. "Clark had scarcely any women students," recalls Patricia Mainardi, who taught at Harvard in the mid-eighties. Mainardi's impression was that Clark "judged the women students and the students of color to be deficient in various

ways."[73] Simon, who studied with Clark, remembers that there were "a number of women who felt [Clark] paid a lot more attention to men than [to] women." Mainardi knew many women and minority students who specifically "came to Harvard to study with Clark. Because he was a Marxist they thought they were his constituency." One black male student who had hoped to work with Clark ended up leaving for Yale. Another black woman who wanted to study surrealism was told by Clark that she should work on African art instead. When she refused, no other professor would become her adviser, and she never finished her Ph.D.

Clark was formally reprimanded by the 1983 visiting committee, which filed a confidential report detailing his breaches of conduct. According to Lavin, the committee found Clark's mistreatment of students and fellow faculty to have been "systematic, deliberate, and objective."[74] Some members of the committee were nervous about filing the report. Lavin recalls Pulitzer expressing concern that they might be viewed by the university as a "runaway committee." After all, most visiting committees came and went quietly without rustling feathers. Pulitzer wanted to make sure they were not "rocking the boat unnecessarily," recalls the National Gallery's Henry Millon.[75] But the academics on the committee were resolute in their desire to condemn Clark's behavior. In part this is because their concern was grounded in more than just the evidence they had found at Harvard.

Even before coming to Harvard, Clark had earned a reputation for intolerance. At UCLA his faculty colleague had been another leading figure in Marxist art history, Otto Karl Werckmeister. In the mid-seventies, just as Clark and Werckmeister were becoming influential across the discipline, they channeled that influence into an effort to purge their own department of anyone who failed to toe the Marxist line. "What alarmed the committee [were] the reports from UCLA,"

recalls Trachtenberg, saying that "that department had been thoroughly politicized to the extent that they drove people out who didn't conform, whether they were students or faculty." Thomas Matthews, who taught at UCLA in the mid-seventies, testifies to the climate in the department: "Werckmeister and Clark were Marxists, and they shoved this down people's throats and everyone had to deal with it."[76] Another professor says Clark and Werckmeister had an "either-you're-for-us-or-against-us mentality." According to Ackerman, even guest speakers were given the treatment:

> Everyone knew that if he or she were to be asked to lecture at UCLA, they'd be pinned against the wall by the faculty, that this was its way of welcoming. As soon as the speakers stopped their talk, they'd be attacked violently from the left.[77]

Everyone in the profession knew that Clark had had a role in what happened at UCLA. "We didn't want this to happen at Harvard," recalls Trachtenberg. "We didn't want a department where one kind of approach became exclusive."

A former chairman of Harvard's department believes that he and his colleagues were naive when they hired Clark, unaware of how it would be to work with an avowed Marxist:

> This is a very liberal Ivy League environment. The problem of getting Marxists in your midst is that you're liberal toward them and they're not liberal toward you. And this we discovered. It's not a two-way street. The belief in diversity and the belief in being fair is not reciprocated.[78]

Indeed, by the time the visiting committee's report was submitted in 1983 the damage was already done. Freedberg took early retirement that year, leaving after thirty years of teaching. Former student J. Carter Brown, then director of the

National Gallery of Art, was glad yet "surprised" when Freed-
berg took him up on an offer to come to the Gallery and
serve as its chief curator, a post he held for five years.[79] Al-
though Freedberg never admitted publicly that Clark's be-
havior had played a role in his decision to leave Harvard,
there is little doubt that it did. As Lavin points out, "People
don't leave Harvard." Even retired fine arts professors hang
on to emeritus status, an office in the Fogg, and access to
the faculty club. Harvard's vast resources provide for a com-
fortable exit. Privately Freedberg acknowledged that he "would
have preferred to stay on and do battle." And he remained
angry for a long time. Almost a decade after leaving Harvard,
Freedberg wrote in a private letter: "T. J. [Clark]'s behavior
was totally in violation of every principle of academic de-
cency."[80]

Freedberg was not the only one who held a grudge. Ac-
cording to colleagues, Clark also remained bitter for a long
time about the committee's actions. Many say he never ac-
knowledged any misconduct and chose to interpret the rep-
rimand as an attack on his scholarship. Ackerman says that
"[Clark] felt very isolated and that he was cornered."[81] In
1988 Clark left Harvard for the University of California at
Berkeley.

The battle over Clark left a deep wedge in the depart-
ment between the portion of the faculty who favored theo-
retical approaches to art and those scholars who were oriented
toward objects. This "split became physical," as one faculty
member puts it, when the department moved out of its of-
fices in the Fogg and across the street to the new Sackler
Museum, even though that had not been the original plan.
The department-museum-library troika was no more. By that
time Harvard's profile in the profession was already so sig-
nificantly altered that a *Washington Post* article about the
Sackler Museum's dedication almost matter-of-factly an-

nounced: "Marxism, Semiotics, Structuralism, Radical Feminism and other ideologies have swept Harvard's fine arts department."[82]

A clear harbinger of this change was the modification of the undergraduate introduction to the history of art series, Fine Arts 13, a popular survey course which had been part of the curriculum for decades. Seymour Slive once said that the purpose of Fine Arts 13 was "to make undergraduates visually literate, to try to teach them how to see."[83] A good part of that education took place in front of actual objects. When the survey course was in session, the Fogg set aside a special gallery featuring works illustrative of each week's lesson. Teaching assistants took students over in small groups to examine the work. Because the Fogg's collection is so complete and of such high quality, it could offer a museum-quality exhibition almost every week. Ackerman recalls: "If one were lecturing on, say, neo-classicism in French painting, you had two Davids and about ten Ingres paintings, not to speak of drawings and prints."[84] In Fine Arts 13 students were not just exposed to objects, they were made to deal with them. As Coolidge explained:

> Right from freshman year, students are assigned problems dealing with originals. It may be something as simple and objective as contrasting a Crucifixion by Fra Angelico with a twentieth-century rendering of the same theme. It may be something as intricate and as subjective as analyzing the interiors of two local churches.[85]

As many as four hundred students regularly enrolled in Fine Arts 13. For years the course received rave reviews in the infamously frank, student-edited "Confidential Guide" to courses. The "all-stars of Fine Arts 13," as the 1978 edition put it, are "da Vinci, Rubens, Manet and their gifted colleagues."[86]

In 1988 the department broke Fine Arts 13 into six sep-
arate courses covering different areas and periods. Some
members of the faculty had been protesting the old course
for a long time, arguing that new theories cast skepticism on
the idea of a chronologically presented canon of great works.
In 1994 the survey was further dissolved. Out went the idea
of teaching art to undergraduates in any historically coher-
ent manner. Instead students were offered various courses
"organized by concepts deemed necessary for both under-
standing and critical analysis," according to the professors
who conceived the new structure. And because the notion of
a canon of great works is "a concept itself under interroga-
tion," argued the professors, the new courses would illustrate
the history of art with "film stills, photography, ceramics, fur-
niture, and advertising images."[87]

The focus of the survey also shifted away from experi-
encing objects and onto studying art theory. Students en-
rolled in the Fall 1994 version of the course heard lectures
on "The Positivist Dilemma and Original Context," "Ideolog-
ical Implication of 'the Real,'" and two days of talks titled
"Against 'Quality' and 'Value.'"[88] The reading list included an
essay on the role of "political domination and ideology" in
orientalist art, a period of academic artmaking which would
hardly seem worth mentioning in an omnibus survey of art.[89]
Students were also required to read "Women in Frames: The
Gaze, the Eye, the Profile in Renaissance Portraiture," an ar-
ticle that had first appeared in *History Workshop: A Journal
of Socialist and Feminist Historians*. The author of "Women
in Frames" explains that her article "investigates the gaze in
the display culture of Quattrocento Florence to explicate fur-
ther ways in which the profile, presenting an averted eye and
a face available to scrutiny, was suited to the representation
of an ordered, chaste and decorous piece of property."[90] The
capabilities of Harvard freshmen are difficult to overestimate,

but it seems unlikely that any undergraduate could appreciate such scholarship, especially a student who has enrolled in a course to learn how to tell a Michelangelo from a Leonardo. The new course required students to make just two trips to the Fogg.

As these and other changes were revising the most fundamental tenets of a Fogg education, a new addition to the faculty was challenging the very definition of what it meant to be an art historian. After two years of searching, the department filled Clark's slot. This time the faculty did not choose a maverick or a radical or even an art historian, in any traditional sense. Norman Bryson had trained and spent his early career at Cambridge's King's College, where he had studied English and written a dissertation in linguistics. By the mid-eighties, without a degree in the field, Bryson had transitioned into a career in art history by writing three controversial books which advocated for interpreting art through the prism of theories borrowed from literary criticism.[91] After a few years heading a comparative arts program at the University of Rochester, in 1990 Bryson was plucked by Harvard. The appointment shocked many in the profession who did not think that Harvard would hire someone working on the outer ramparts of theory who had no credentials in the field. "Nobody understands where that appointment came from," says Lavin. Even Bryson remembers asking at the time: "Are you really sure you want me to come?"[92] "He was trained in literature," remarks Ackerman, who was "really disappointed" that Bryson was hired.[93]

Bryson's method for interpreting art is grounded in the idea that a painting is primarily a vehicle for stimulating power shifts in society. To this way of thinking, the meaning of a work resides not in the painted product of the artist's intentions but in the interpreter's view of what the work could mean. In fact Bryson has argued that the contemporary art

historian may completely disconnect his interpretation from any responsible understanding of a work's original meaning. He calls for an art history driven by "pragmatics," in which interpretations are preferred on the basis of the desirability of their social consequences.[94]

Bryson considers perceptually based methods of interpretation, such as connoisseurship, naive. According to Bryson, "Power seizes, catches hold of, expropriates and deflects the channel of perception that runs from painter to viewer."[95] So someone looking at a painting can never be sure of what he really sees. Likewise an artist can never really know his own intent since the act of painting, indeed the very act of communicating, is so thoroughly bound up in power relationships. Bryson also rejects the social history of art epitomized by Clark's work. Social art history has its roots in Marx, who organized a society's activities into two categories, the base (or means of material production) and the superstructure (the courts, political parties, and other institutions). In this view the base drives all other aspects of society. Bryson's qualm with social art history is that it relegates artmaking to the superstructure, another of the myriad "secondary manifestations or epiphenomena of base action."[96] If art is seen as merely a byproduct of economic forces, it cannot participate in the dynamic political interplay that Bryson imagines.

Bryson's dismissal of these approaches is primarily a political calculation. He doesn't claim that connoisseurship or social art history are inaccurate ways of describing or understanding art, but that they are politically insufficient. Bryson accuses perceptually based approaches of "always render[ing] art trivial" and "at the margins of social concerns, in some eddy away from the flow of power." Marxist approaches are no better, positioning art "off the map, or at least relegated to the margin."[97] Instead Bryson advocates a

methodology that places art and its interpreters (art historians) at the epicenter of society, where they have the standing and the power to influence all things.

Critics of Bryson's work fault it less for its political expediency than for the lack of art historical knowledge it betrays. "As far as I can see, he looks at works of art as if they were written," says Ackerman.[98] Another Fogg professor says that Bryson "bases a lot of theory on terribly little knowledge of objects." Art historian Vivian Cameron, whose work focuses on the same period as Bryson's, says she knows many colleagues who think that Bryson "just doesn't see things."[99] "People question [Bryson's] grasp," says art historian Donna Hunter.[100] One of Bryson's Harvard colleagues jokes about an essay in which Bryson referred to Giotto painting canvases even though the fourteenth-century Renaissance master worked (on panel and in fresco) two hundred years before canvas came into common use.[101] According to Marjorie Cohn, Bryson never uses the Fogg Museum: "Every now and then one of his classes comes over, and I always find out afterwards it's because his [teaching assistant] arranged it."

Bryson's classroom lectures are heavily jargoned. In an undergraduate course on the history of modern art he dedicates an entire class to theorizing about the ways in which he believes that photography has aided in the monitoring and controlling of society. In an hour and a half lecture Bryson discusses three routes for this social control: "panopticism, bio-politics, and micro-management."[102] Throughout the talk dozens of slides are projected behind the lectern without Bryson ever calling students' attention to the characteristics of any particular work. Students are so busy scribbling arcane definitions and intricate theories into their notebooks that they rarely look up to see the art.

Indeed, in his own scholarship Bryson has been accused of failing to "look up" and examine the evidence. Peers point

to an error in his 1984 book *Tradition and Desire: From David to Delacroix*. The book's sixth chapter offers an analysis of a nineteenth-century cycle of ceiling paintings by French romantic painter Eugène Delacroix. The works are in the Deputies' Library at the Bourbon Palace in Paris. Bryson certainly writes as if he visited the library. He spends nearly a page describing the challenges facing a "pilgrim" to the site, among them the "hazards of access," "arduous conditions of viewing," and "appalling lighting."[103] Bryson expresses regret that the library's ceiling program is rarely reproduced in full, just favorite sections which "tend to be quoted out of context and divested of the complexity they possess." He further complains that previous students of Delacroix have documented the ceiling but "neglect[ed] the work of interpretation." In order to bring an end to the "critical neglect of the later Delacroix" and "to help redress the balance," Bryson puts forward his analysis, touting it as the first "comprehensive reading of the whole series of twenty-two paintings."

He begins by analyzing the scenes at each end of the cycle, depicting *Orpheus Civilizing the Greeks* and *Attila Destroying Italy and the Arts*. He then moves into a discussion of the twenty paintings that comprise the cycle's spine (groups of four paintings surrounding each of five domes), offering a diagram showing their location. "Let us suppose," writes Bryson, "a meticulous and schematically minded observer who works the series from end to end, in the manner of the ideal Sistine viewer. Nearest Attila he will find the four scenes which make up the dome of Science." But in fact the dome dedicated to Science resides not near Attila, where Bryson puts it, but at the opposite end of the cycle, near the painting of Orpheus. A visitor to the site would need only a cursory glance at the ceiling to see that the dome next to Attila is dedicated to Poetry, not Science.

Undaunted, Bryson proceeds into a discussion of the

four paintings comprising this misplaced Science dome, making much of their purported proximity to the Attila painting. He first discusses *Archimedes Killed by the Soldier*, which Bryson's diagram shows as bordering the Attila image, though in reality it does not. Bryson invests considerable importance in this painting's opposition to a painting of *Aristotle Describing the Animals Sent by Alexander*, which he claims appears across the dome from Archimedes. But in fact these images are situated not across from each other but side by side.

Bryson's diagram of the ceiling misplaces sixteen of the twenty-two paintings in the cycle. He then carries over these errors into his chapter-long analysis, proceeding dome by dome, discussing each cluster of works in reverse of its actual order of appearance, and most paintings in juxtaposition to paintings they do not juxtapose. Based on this almost wholly invalid presentation of the evidence, Bryson spins numerous theories and posits that the overall cycle is organized around the theme of revision, "in which one discourse positions another discourse contained within itself." Bryson projects his interpretation through the prism of textual theory:

> A notorious feature of irony is that the contained or quoted discourse tends to efface the points of origin— its own origin, the moment at which the citation or quotation begins, as a sub-set of the master-discourse; and the origin of the master-discourse itself, which irony has a capacity also to erase.

That Bryson's claims have no basis in fact presents no apparent obstacle to his analysis, which dabbles in Freud and a lengthy discussion of the "temporality of desire" before concluding with a warning to the viewer always to "see clearly what is before him." Art historian Lee Johnson, who has compiled a definitive six-volume catalog raisonné of Delacroix's

work, considers Bryson's interpretation of the Bourbon Library to be "utterly subjective" and "unworthy of serious consideration."[104] This kind of error buttresses the widespread suspicion that Bryson not only lacks a basic grounding in art history and art historical methods but that he is indifferent to these deficiencies. Some scholars have reason to wonder whether Bryson's recklessness extends into more fundamental principles of scholarly ethics.

Bryson has a reputation for plagiarism which stretches across his academic career. The most public incident took place in 1989 at a conference convened at the Louvre. Bryson had just finished giving a paper to a large audience comprising much of the international community of scholars of French art. Among his questioners was a young man who seemed nervous as he rose and spoke in French. Because the conference was open to the public, and questions had been uneven, some attendees suspected the fellow was a stray tourist. But others caught a few words. "He wanted Bryson to acknowledge that he had taken his ideas," remembers Donna Hunter. Robert Simon, who also gave a paper at the conference, recalled that the student apologized, saying that "he was sorry he had to do this but Bryson wasn't listening to him."

The questioner was Alexander Fyjis-Walker, formerly a student at London's Courtauld Institute. Bryson had served as one of two reviewers of Fyjis-Walker's master's thesis, which discussed iconography in the work of the early-nineteenth-century French romantic painter Antoine-Jean Gros. Now Fyjis-Walker was charging Bryson with stealing his work. Before the crowd of scholars he asked Bryson: "How can you explain the strange similarity between your work and mine?"[105] Simon recalls that an "electricity went through the air because [Fyjis-Walker] was really angry." As Bryson turned to the panel chair for a translation of the French, someone in

the back of the room shrieked, "This is scandalous!" A tense pause was broken when feminist art historian Linda Nochlin rose to ask: "Where would scholarship be if we couldn't use students' work?" Nochlin's comment drew an "agitated response" from the audience, recalls art historian Dorothy Johnson.[106] The session ended abruptly. In the confusion that ensued, Fyjis-Walker was approached by someone who had studied with Bryson at the University of Rochester, who told him that he "was not at all surprised" to hear Fyjis-Walker's charge.

The University of London investigated the charge. Bryson was found guilty of plagiarizing from Fyjis-Walker's thesis in an article he had published in the inaugural issue of an obscure journal, *History of the Human Sciences*.[107] Eventually Bryson published an apology acknowledging five passages in his article in which he had represented material from Fyjis-Walker's thesis as his own.[108] Many scholars expected that because this incident happened just before Bryson was to begin at Harvard, the university would withdraw its offer. But it did not. Throughout his tenure at Harvard, less public incidents continued to raise questions about Bryson's ethics.

In 1997 British art historian Ernst Gombrich complained to the *Times Literary Supplement* about an article in which Bryson had "insert[ed] a thirty-line summary" of Gombrich's own work. "Is it not usual in such cases to acknowledge one's source?" Gombrich asked in a letter to the editor.[109] The breach was even worse than Gombrich states. The disputed text is an article Bryson wrote on the early-seventeenth-century French painter Georges de la Tour, who is best known for his depiction of candlelight. Toward the beginning of the article Bryson segues into a lengthy discussion of the history of cast shadows in painting. But his observations borrow liberally (and sometimes literally) from an essay on shadows that Gombrich wrote in 1995. Bryson begins where Gombrich

does with a quote from Leonardo da Vinci advising against painting shadows too conspicuously. Da Vinci's statement represents "not only his own opinion but an almost universal prejudice among painters," writes Bryson.[110] This generalization—both in idea and in word—Bryson takes directly from Gombrich, who wrote that da Vinci "not only give[s] his own opinion but tells of a universal prejudice among painters."[111]

Next Bryson proceeds through three examples of shadow painting, relying on the very same works and discussing them in the same order as Gombrich. Bryson even uses Gombrich's exact words to describe one example. Of the Italian painter Fra Angelico's *Virgin and Child* fresco from San Marco, Gombrich remarks on the "immensely subtle cast shadows of the pilasters' capitals caused by grazing light."[112] Just tweaking Gombrich's words, Bryson observes that this "immensely subtle" section of the painting depicts "shadows cast by the pilasters' capitals as light grazes them."[113] Nowhere in his article does Bryson credit or even reference Gombrich's work.

In the fall of 1999 Bryson left Harvard and returned to London, taking up a post as head of the art theory program at the Slade School of Fine Art. During his nine-year tenure at Harvard Bryson was the unrivaled star of the department. When he walked through the Sackler's foyer, voices hushed and heads turned. Bryson and a handful of like-minded faculty members controlled the department's leadership for more than a decade, during which time Harvard lost its long-held number-one ranking among art history graduate programs.[114] "Dead at the center, strong on the margins," is how former Fogg professor Patricia Mainardi describes the program's fragmented profile today. One oft-cited criticism is that, with so many professors dedicated to pursuing theoretical issues, whole areas of art history have been neglected. "We have only a junior person in Baroque art," says Ackerman, "and nobody in the later Middle Ages" aside from someone who

specializes in northern Spanish art of the period. There are no longer debates inside the department about how much emphasis should be placed on teaching about objects since, as professor Ewa Lajer-Burcharth explains, "there is no one within the department who represents that nostalgia at this point."[115]

Indeed, courses concentrating on the examination of art objects have been all but banned from undergraduate and graduate course lists. Fogg curator Marjorie Cohn teaches a course on the history of prints in which a maximum of ten students work from originals. Some of the graduate students who have taken the course told her "that they were told by their advisers not to take [the] course" because it is "too old-fashioned." When Cohn and Fogg director James Cuno wanted to team-teach a larger course on printmaking, they resorted to offering it through the Department of Visual and Environmental Studies, Harvard's studio art department. According to one professor, the art history department gave Cohn and Cuno the distinct impression that "courses based on objects were unwelcome."

Like-minded graduate students are equally frustrated. Barry Wood came to Harvard in 1993 hoping to get an object-oriented education in Islamic art. During his first semester Wood signed up for a course on Mesopotamian art, expecting to learn the basics. Much to his surprise, "there was no art, just postmodernist anthropology. Every week I would wonder, 'When is the art coming? When am I going to learn about Mesopotamian art?'" Wood found that the few professors who taught classes he enjoyed had a bunker mentality, teaching as infrequently as possible and "remaining ensconced in their offices."[116] Wood left the program before finishing his doctorate.

Today Harvard's art history Ph.D.s have a somewhat infamous reputation for lacking any tangible knowledge of art

objects. Whitney Museum director Maxwell Anderson complains that graduate students at Harvard and elsewhere "are not rewarded today for being deeply steeped in the history of art. They are rewarded from the start on their ability to dance through the arcane vocabularies [within] the self-referential, self-congratulatory epic novel of postmodern art history." Rosalind Krauss is also concerned about a "deep illiteracy" she has witnessed in students for whom "the work of art is seen as contemptible." Krauss blames graduate programs for "produc[ing] this sort of alienated relationship to objects." Seymour Slive once said of the Fogg: "If we do our job well, no one leaves Harvard without knowing how to read a work of art."[117] Now it seems almost no one can leave Harvard knowing anything of the sort.

6

ESTABLISHMENT EXHIBITIONISM

One argument makes the rounds during every art war: the claim that it has always been the duty of avant-garde artists to shock the public and to challenge social norms. According to this theory, people find the most advanced art of their time offensive because great artists are uniquely gifted at sensing and articulating society's cultural frailties. This argument often receives the same reaction as a trump card. But does it accurately represent the avant-garde enterprise? Or is the equation of shock-value-equals-artistic-merit a sleight of hand put forth to justify the academic art of our time?

The history of art is indeed marked by the exploits of mavericks. After all, the beginning of the modern period is often dated to 1863, when a group of avant-garde painters, including Paul Cézanne and Édouard Manet, showed their work in the Salon de Refusés. The exhibition was a protest against the official French Salon whose jury had routinely rejected avant-garde art for years, favoring instead the romantic realism of the artists who reigned over Paris's art schools.[1] Two decades later these artists' successors took up

the cause. Painters Georges Seurat, Vincent van Gogh, Henri Toulouse-Lautrec, and two dozen of their peers formed the Société des Artistes Indépendants and showed their work in annual exhibitions meant to offer an alternative to the still pedantic Salon. Today defenders of the art that spawned the art wars often cite such examples of artistic rebelliousness as historical justification for contemporary disputes, suggesting that Andres Serrano and Chris Ofili are the Cézanne and van Gogh of our day—but the public is too blind to see it.

But even a brief survey of early modernist accomplishments suggests that the comparison does not flatter postmodernists. The early modernists sought to redefine artmaking on a fundamental level by challenging long-held ideas about space, color, even brushstrokes. Cézanne experimented with the depiction of space and nature at their structural levels. By exploring the expressive and symbolic value of color, rather than merely its literal application, van Gogh indicated a path toward abstraction. And through the methodical juxtaposition of dots of pure color, Georges Seurat posed basic questions about the relationship between process and form. Pursuing these bold goals led the early modernists into conflict with the art establishment, embodied in the Salon's jury which, according to the art historian John Rewald, "systematically endeavored to suppress all efforts which displayed the least disregard for its canons."[2] Because they threatened the status quo, the early modernists were marginalized. Van Gogh worked his entire life without recognition, as did Seurat, who died young without ever having a one-man show. Cézanne also worked in near obscurity until the last decade of his life, receiving his first solo show at age fifty-six. In mid-career Cézanne went for more than a decade without exhibiting a painting. His work was rejected at least thirteen times by the Salon jury; he succeeded just once, because of a loophole.

Jeff Koons, *Naked*, 1988, porcelain, 45-1/2" x 27" x 27". Private collection. Courtesy of Sonnabend Gallery, New York.

Compare this rejection the early modernists faced with the reception given to one of the most controversial art stars of the 1980s and early nineties, Jeff Koons. The postmodern period reached its shock-as-art climax in 1991 when Koons showed a series of sculptures and mural-sized photo-based paintings at Sonnabend Gallery in New York. The works depicted the thirty-six-year-old artist stark naked with his then-

William Bouguereau, *Nymphes et satyre*, 1873,
oil on canvas, 102-3/8" x 70-7/8". Courtesy of
Sterling and Francine Clark Art Institute,
Williamstown, Massachusetts.

wife, the Italian porn star and former member of parliament
Cicciolina, who wore spiked heels and stockings as the two,
in the words of one critic, "blissfully consort[ed] in an ac-
robatic variety of Kamasutra-like poses."[3] The viewer was
spared nothing. As performance artist Annie Sprinkle glee-
fully observed, "These canvases make no attempt to look like
anything other than enlarged photo blow-ups from a porn
mag."[4] Koons also depicted sexual scenarios in tinted sculp-

tures resembling the blown-glass collectibles found in tourist shops. He presented these works under the title "Made in Heaven" and expressed his hope that the images would conjure notions of spiritual purity in the minds of viewers: "When somebody sees my work, the only thing that they see is the Sacred Heart of Jesus."[5] As outrageous and patently offensive as this work was intended to be, Koons was not marginalized by the art establishment. He was rather vigorously embraced.

When early works from the "Made in Heaven" series debuted at the Venice Biennale in 1990, *Vogue* published an eight-page article titled "Koons Crazy," which was accompanied by photos of the happy couple shot by Karl Lagerfeld. Koons's previous show at Sonnabend had grossed $5 million; "Made in Heaven" nearly sold out.[6] The show's centerpiece— a nearly nine-foot-long plastic sculpture of the intertwined lovers surrounded by butterflies—was priced at $390,000. "Made in Heaven," which went on to venues in Cologne and London, was reviewed not only in the art press but in the *New Republic,* the *New Yorker,* and the *Washington Post.* In that same year Koons's work appeared in exhibitions in San Francisco, Antwerp, Berlin, Bologna, Portland, Lausanne, Salzburg, Indianapolis, Akron, Richmond, Philadelphia, Munich, and Trento, Italy.[7] The following year a retrospective of Koons's still budding career traveled to museums in California and the Midwest.

Koons's star has dimmed in recent years, but the commanding position he once held in the art world is reminiscent of the status accorded the painter William Bouguereau in late-nineteenth-century France. The coquettishly titillating nudes and sentimentalized saints that populated Bouguereau's canvases were the hit of the annual Salon, over which he wielded so much influence that Cézanne took to calling it "le Salon de Bouguereau." Bouguereau fits the traditional

definition of an academic artist—someone who enforces a stylistic status quo by catering to the lowest standards of public taste. An academic artist's success is measured by how thoroughly he can leverage his popularity to derive benefits from the art establishment—showing at the best galleries, being included in the most important museum shows, getting reviewed everywhere. Bouguereau received these privileges, and so has Koons.

But Koons, among others, has redefined what it means to be an academic artist. Koons's membership in the artistic elite draws not from his power to please the masses but from his success in cleverly offending them. It is Bouguereau's formula revised for the postmodern era. Koons works as Bouguereau did, with familiar and alluring subject matter and in an accessible style. Koons also works on a huge scale, designing works so unavoidably large that viewers do not look at them so much as they are engulfed by them. But it is the message Koons conveys with these trappings of popular appeal that differentiates him from Bouguereau. Bouguereau had a frank relationship with his audience: he gave them what they wanted and in return exacted influence. Koons lures the masses not to please them but to critique them and, in turn, to please art elites. As with most postmodernists, Koons's real subject is how foolish we all are. The goal is to embarrass us by showcasing our consumption, our modesty, our biases, our faith, our patriotism, even our preference for beauty. It is a formula that has monopolized gallery walls for more than two decades and only recently has shown the slightest signs of abating.

It is in the nature of the postmodern academic mindset to be intolerant—not to be content to coexist with other approaches but to discourage their existence and to drive them underground. In this book I have tried to show how this academicism came to monopolize the National Endow-

ment for the Arts, and to describe the toll this bias took on the project of painting. Art history proves the ultimate futility of the academic project. After all, there are few better-known names in the history of art than Cézanne and van Gogh. Bouguereau is a footnote. But such outcomes depend, to some extent, on how faithfully art historians and curators portray the past. And many of the institutions entrusted with the task of assembling the art historical record are today driven by concerns that undermine objectivity. Still, these efforts, not entirely unlike my own in this book, serve as little more than preliminary drafts.

Ultimately the history of art is constructed from the accumulated wisdom of individuals who have stood face-to-face with art objects and measured their worth. The process begins when a work is created and proceeds for centuries. Works that cannot withstand such scrutiny lose currency, if not in their own day then years later, when the space between a work and the viewer's eye is cleared of contemporary commotion. As the products of the postmodern period undergo this test, the calculated misperceptions and genuine follies of our time will be undone and the truth will emerge, long after the exhibitionists have left the stage.

APPENDIX A

Artists Considered by 1967 NEA Visual Arts Panels

EAST:
Lennart Anderson*
Carl Andre
Robert Beauchamp*
Ronald Bladen*
Nell Blaine
George Brecht
Ernest Briggs
(?) Burlein
Kenneth Campbell
Rollin Crampton*
Emilio Cruz
Nassos Daphnis*
Gene Davis*
Sidney Della Vanti
Walter Di Maria
Mark di Suvero*
Thomas Downing
Tom Doyle
John Ferren
Dan Flavin*
Miles Forst
Paul Frazier
Sam Gilliam*
Robert Goodnough*
Ron Gorchov
Stephen Greene*
Robert Grosvenor
Raoul Hague
Ralph Humphrey
Robert Huot*
Will Insley*
Donald Judd*
Alan Kaprow
Nick Kruschnick

MIDWEST:
Jerry Aidlin
Robert Barnes
William Barrett
Donald Baum
Charles Biederman*
David Black*
Aaron Bohrod
Cameron Booth
Byron Burford
Peter Busa
John Chamberlain
George Cohen*
John Colt
John Clague
John Paul Darriau
John De Wilde
William Dietsch
Dale Eldred*
Jean Follett*
Raymond Fried
Joe Goto*
Robert Grilley
Dwayne Hatchett
Fredrick Hollendonner
Patricia Hunsicker
Robert Israel
George Kokines
Ellen Lanyon
Edwin Mieczkowski*
Fred Munoz
Robert Nelson
Arthur Osyer
Charles Pollack*
Kerig Pope

WEST:
Jeremy Anderson
Billy Al Bengston*
Max Benjamin
Wallace Berman*
Kenneth Callahan
Vija Celmins
Richard Dahn
Michael Daley
Jay De Feo
Roy De Forest
Lynne Foulkes
Judy Gerrowitz
Robert Graham
Lloyd Hamrol
Julius Hatofski*
Guy Henderson
George Hermes
Robert Hudson
Bill Ivey*
Roger Jacobson
Jack Jefferson
Paul Jenkins
Robert Jones
Craig Kauffman
Lee Kelly
Leo Kenny
Gabe Kohn
Alvin Light*
Norman Ludin
Alden Mason
Charles Mattox
(?) McClarty
John McLaughlin*
Neil Meitzler*

EAST:
Gary Kuehn*
Loren MacIver
Robert Mangold*
Agnes Martin*
Knox Martin
George McNeil*
Howard Mehring
Robert Morris*
Walter Murch
Stephen Pace
Anthony Padovano
Ray Parker*
Phillip Pearlstein
Richard Pousette-Dart*
Paul Reed
Milton Resnick
Dan Rice
Phillip Roeber
James Rosati
Ralph Rosenborg*
Ludwig Sander*
Leon Polk Smith*
Tony Smith*
Theodore Stamos*
Richard Stankiewicz*
Hedda Stern
Myron Stout*
Tal Streeter
Richard Tum Suden
George Sugarman*
Sidney Tillim
Hugh Townley
Richard Tuttle
Tony Vevers*
Jerry Vander Weile
David Weinrib*
Bob Whitman
Neil Williams*
Phil Wofford
Jack Youngerman*
Adja Yunkers

MIDWEST:
Walter Quirt
Richard Randell*
Jerry Rudquist
Peter Saul
Jerry Savage
Ole Savonen
Alice Shattel
Julian Stanczak
Wallace Ting
Harold Tovisch
John Uduardy
Steven Urry*
H. C. Westermann*

WEST:
Gary Molitor*
Carl Morris
Hilda Morris
Clark Murray*
Ron Nagel
Bruce Nauman
Manuel Neri*
Edward
 Parczukowski
Kenneth Pawula
Eugene Pazzuto
Kenneth Price*
Ed Ruscha*
Ole Savonen
David Simpson
Michael Spafford
Wayne Stieglemeyer
Dan Talbert
Richard Van Buren
Julius Wasserstein
Homer Weiner
Bruce West*
Joe White
Phil Wilbern*
Emerson Woelffer

*Denotes grantee. The names of two grantees do not appear on these lists, William Geis and Alfred Leslie.

Names are spelled as they appear on memos reporting out each panel's work. An effort has been made to correct spelling errors.

APPENDIX B

NEA Budget Appropriations History

Year	Grant-Making Funds	Administrative Funds	Total Funds
1966	$ 2,534,308	$ 364,000	$ 2,898,308
1967	7,965,692	510,000	8,475,692
1968	7,174,291	600,000	7,774,291
1969	7,756,875	700,000	8,456,875
1970	8,250,000	805,000	9,055,000
1971	15,090,000	1,330,000	16,420,000
1972	29,750,000	1,730,000	31,480,000
1973	38,200,000	2,657,000	40,857,000
1974	60,775,000	3,250,000	64,025,000
1975	74,750,000	5,392,000	80,142,000
1976	115,937,000	6,819,000	122,756,000
1977	94,000,000	5,872,000	99,872,000
1978	114,600,000	9,250,000	123,850,000
1979	139,660,000	9,925,000	149,585,000
1980	142,400,000	12,210,000	154,610,000
1981	146,660,000	12,135,000	158,795,000
1982	132,130,000	11,326,000	143,456,000
1983	131,275,000	12,600,000	143,875,000
1984	149,000,000	13,223,000	162,223,000
1985	148,078,000	15,582,000	163,660,000
1986	143,999,732	14,822,508	158,822,240
1987	149,181,000	16,100,000	165,281,000
1988	150,591,000	17,140,000	167,731,000
1989	150,650,000	18,440,000	169,090,000
1990	151,405,000	19,850,000	171,255,000
1991	152,485,734	21,595,003	174,080,737
1992	153,106,244	22,848,436	175,954,680
1993	150,125,848	24,333,534	174,459,382
1994	145,662,000	24,566,000	170,228,000
1995	137,512,000	24,799,000	162,311,000
1996	80,734,000	18,736,000	99,470,000
1997	82,514,000	16,980,000	99,494,000
1998	81,020,000	16,980,000	98,000,000
1999	80,522,000	17,444,000	97,966,000
2000	79,552,547	18,075,053	97,627,600
	$3,455,047,271	$418,989,534	$3,874,036,805

APPENDIX C

1995 NEA Visual Arts Fellowship Grantees

IN PAINTING:

William G. Allan
San Rafael, CA

Matthew J. Antezzo
Brooklyn, NY

Kenneth R. Aptekar
New York, NY

Jack J. Balas
Berthoud, CO

Nancy L. Chunn
New York, NY

Chuck Forsman
Boulder, CO

Rebecca A. Howland
New York, NY

David A. Humphrey
New York, NY

Byron Y. Kim
Brooklyn, NY

Jerry Kwan
New York, NY

Mel D. Leipzig
Trenton, NJ

Zhi Lin
Springfield, MO

Megan Bronwen
Marlatt
Orange, VA

Bernard M. Martin
Richmond, VA

Manuel Jonas
Ocampo
Los Angeles, CA

Kay G. Rosen
Gary, IN

Ben Sakoguchi
Pasadena, CA

Tad Savinar
Portland, OR

Amy D. Sillman
Brooklyn, NY

Linda A. Stark
Los Angeles, CA

Mark C. Wethli
Brunswick, ME

IN OTHER GENRES:

Dennis P. Adams
New York, NY

Josely Carvalho
New York, NY

Maureen Connor
New York, NY

Lewis deSoto
Oakland, CA

Toni Dove
New York, NY

Douglas E. Hall
San Francisco, CA

Kathryn High
Brooklyn, NY

Ulysses S. Jenkins, Jr.
Inglewood, CA

Joel D. Katz
Brooklyn, NY

Frank Macmurtrie
San Francisco, CA

Inigo Manglano-
Ovalle
Chicago, IL

Daniel J. Martinez
Los Angeles, CA

Joey Morgan
Brooklyn, NY

Michael O'Reilly
Philadelphia, PA

William Pope.L
Lewiston, ME

Daniel M. Reeves
New York, NY

Margaret M. Stratton
Iowa City, IA

Peter L. Walsh
Baltimore, MD

IN WORKS ON PAPER:

Malinda M. Beeman
Snowmass Village,
CO

Meg A. Belichick
Brooklyn, NY

Donald E. Camp
Philadelphia, PA

Judy K. Chan
Long Beach, CA

Cecelia Condit
Milwaukee, WI

Dewey S. Crumpler
Berkeley, CA

Lisa Corinne Davis
New York, NY

Robert Dente
West Hartford, CT

Lawrence C. Gipe
New York, NY

Julie A. Heffernan
State College, PA

Adele M. Henderson
Buffalo, NY

Jenny Lavin
Brooklyn, NY

Matthew R. Lawrence
Lancaster, PA

Margaret R. Lazzari
Los Angeles, CA

Phyllis I. McGibbon
Wellesley, MA

Danny B. Tisdale
Harlem, NY

Annie West
New York, NY

Hongtu Zhang
New York, NY

Philip B.
Zimmermann
Barrytown, NY

NOTES

Quotations from interviews conducted by the author are cited only upon their first appearance in each chapter. Unless otherwise noted, subsequent quotes attributed to the same source are taken from the same interview.

CHAPTER ONE
The Endowment's Early Promise

1. "H. R. Gross," *Washington Post,* September 25, 1987, A24.

2. Gross quoted in Livingston Biddle, *Our Government and the Arts* (New York, 1988), 176.

3. Biddle, *Our Government,* 179.

4. Annual Report, National Council on the Arts, 1964–1965, 32, 35.

5. Ibid., 34.

6. Devon Meade, memorandum regarding Visual Arts Meeting, April 4, 1966, 1.

7. Interview with Paul Cummins, January 27, 1970, for the Archives of American Art, 19.

8. Geldzahler quoted in Cummins, 22.

9. Henry Geldzahler, talking points for meeting with Frank Hodsoll, undated.

10. Annual Report, National Endowment for the Arts, 1966, 68.

11. Ibid., 91.

12. Henry Geldzahler, memorandum regarding "Preamble to Challenge Grant in Support of Living Artists," undated.

13. Annual Report, National Endowment for the Arts, 1966, 69.

14. Calculated average age of thirty-three grantees.

15. Geldzahler quoted in John Pultz, "An 'Electric' Alliance? The Visual Arts Program of the National Endowment for the Arts, 1966–1973," May 13, 1985, unpublished. The quote originally appeared in a memorandum that Geldzahler wrote to NEA chairman Roger Stevens, January 1969.

16. Geldzahler quoted in Cummins, 52.

17. Richard Hunt, interview with the author, April 21, 1998.

18. Geldzahler memo to Roger Stevens, January 1969. In the process of conducting research at the NEA for "An 'Electric' Alliance," John Pultz took verbatim notes from a copy of this memorandum. The author thanks him for sharing those notes.

19. Barbara Rose, interview with the author, December 3, 1997.

20. Geldzahler quoted in Cummins, 50.

21. The Midwest panel was convened in the office of curator James Speyer at the Art Institute of Chicago. The West Coast panel met at the home of Walter Hopps, director of the Pasadena Art Museum.

22. Henry Geldzahler, Minutes of the September 11th Meeting of the East Coast Panel, 1966.

23. George Segal, interview with the author, February 9, 1998.

24. Henry Geldzahler, "60 Grants-in-Aid to Visual Artists," memorandum to Charles Mark, November 22, 1966, 2.

25. Robert Goodnough, interview with the author, March 4, 1999.

26. Alfred Leslie, interview with the author, March 12, 1998.

27. Thomas B. Hess, "Art, Government, and Dirty Books," *ArtNews*, May 1966, 25.

28. Thomas B. Hess, "All's Well That Ends Well," *ArtNews*, February 1967, 21.

29. Hilton Kramer, interview with the author, March 21, 2000.

30. Janet Keyshian, letter to Henry Geldzahler, undated.

31. Robert Mangold, interview with the author, November 27, 1997.

32. Edward Ruscha, interview with the author, April 2, 1998.

33. Roberta Smith, "Donald Judd, 65, Painter, Sculptor and Designer," *New York Times*, February 14, 1994, B8.

34. Parker quoted in William C. Agee, "The Simple Paintings/New Discoveries," in "Ray Parker Paintings, 1958–1965," a pamphlet published by the Washburn Gallery, April 1997, 1.

35. Greene quoted in George Melrod, "The Fame Game," *Art & Antiques*, Summer 1997, 76.

36. Kenneth Baker, "Sculpture: In Search of an Audience," *San Francisco Chronicle*, October, 6, 1991, 33.

37. "Neil Williams, Painter on Shaped Canvas, 53," *New York Times*, March 30, 1988, A24.

38. Irving Sandler, interview with the author, April 29, 1998.

39. Mark di Suvero, letter to Henry Geldzahler, March 26, 1965.

40. Di Suvero quoted in Annual Report, National Endowment for the Arts, 1970, 50.

41. Alfred Leslie quoted in Barbara Flynn, *Alfred Leslie: The Grisaille Paintings 1962–1967* (New York, 1991), 55.

42. Alfred Leslie, *100 Views Along the Road* (New York, 1988), 5.

43. Henry Geldzahler, memorandum to the National Council on the Arts, April 12, 1966.

44. Henry Geldzahler, memorandum to Devon Meade, September 9, 1966.

45. Henry Geldzahler, memorandum to the National Council on the Arts, undated.

46. Henry Geldzahler, draft article for *Art in America*, undated.

47. Biddle, *Our Government*, 278.

48. Thomas Willis, "Federal Allotments Provide Shot in the Arm for the Arts," *Chicago Tribune*, September 18, 1966, sec. 5, p. 13.

49. Schlesinger quoted in Gary O. Larson, *The Reluctant Patron: The United States Government and the Arts, 1943–1965* (Philadelphia, 1983), 181.

50. McWhorter quoted in Michael Straight, *Nancy Hanks: An Intimate Portrait* (Durham, N.C., 1988), 133.

51. Alice Goldfarb Marquis, *Art Lessons: Learning from the Rise and Fall of Public Arts Funding* (New York, 1995), 124.

52. Nixon quoted in Nancy Hanks, foreword to Annual Report, National Endowment for the Arts, 1969.

53. Wolfgang Saxon, "Nancy Hanks Dead at 55" *New York Times,* January 8, 1983, sec. 1, p. 17.

54. Nancy Hanks, foreword to Annual Report, National Endowment for the Arts, 1971, 1.

55. Jabbour quoted in Straight, *Nancy Hanks,* 278.

56. Brian O'Doherty, memorandum to Nancy Hanks, August 11, 1970.

57. Unsigned memorandum listing Visual Arts Programs planned for fiscal 1972, undated.

58. O'Doherty, memorandum to Nancy Hanks, August 11, 1970.

CHAPTER TWO

Bureaucratic Art

1. O'Doherty quoted in Associated Press, "Roy Lichtenstein," *St. Louis Post-Dispatch,* September 30, 1997, 5B; Paul Richard, "Frank Stella at 40," *Washington Post,* January 9, 1977, M1.

2. O'Doherty quoted in Jerry G. Bowles, "Brian O'Doherty Whispers in Ogham," *ArtNews,* September 1970, 34.

3. For this account of the event the author is indebted to Thomas McEvilley, "An Artist and His Aliases," *Art in America,* May 1999, 139.

4. Brian O'Doherty, *Inside the White Cube: The Ideology of the Gallery Space* (Santa Monica, Calif., 1976), 76.

5. Ibid., 38.

6. Ibid., 14.

7. Ibid., 76.

8. Hopps quoted in Jane Addams Allen, "Maze Runner Roams Art Labyrinth," *Washington Times,* April 4, 1986, B8.

9. O'Doherty, *Inside the White Cube,* 78.

10. Henry Geldzahler, memorandum to Roger Stevens, July 11, 1966.

11. Brian O'Doherty, "National Endowment for the Arts: The Visual Arts Program," *American Art Review,* July–August 1976, 70.

12. Annual Report, National Endowment for the Arts, 1976, 127.

13. Annual Report, National Endowment for the Arts, 1970, 50.

14. Annual Report, National Endowment for the Arts, 1971, 77.

15. These descriptions, which are quoted from the artists' applications, are taken from Michael Straight, memorandum to Nancy Hanks, June 18, 1974.

16. Straight, memorandum to Nancy Hanks, June 18, 1974.

17. Julie Moore, memorandum for the record, July 19, 1974, 2.

18. National Endowment for the Arts, Visual Arts Program Guidelines, Fiscal Year 1973, 2.

19. National Endowment for the Arts, Visual Arts Program Guidelines, Fiscal Year 1974, 4.

20. National Endowment for the Arts, Visual Arts Program Guidelines, Fiscal Year 1977, see p. 1 of application form.

21. Julie Moore, memorandum to Nancy Hanks, June/July 1974 (exact date unclear).

22. Straight, memorandum to Nancy Hanks, June 18, 1974.

23. Sherk application quoted in Straight, *Nancy Hanks*, 289.

24. James Melchert in Annual Report, National Endowment for the Arts (1979), 241–242.

25. James Melchert in Annual Report, National Endowment for the Arts (1980), 277.

26. Philip Pearlstein, "Censorship on Stylistic Grounds," *Art Journal*, Winter 1991, 70.

27. Tucker quoted in Celia McGee, "High Priestess of Trendiness," *New York Times*, January 17, 1993, sec. 2, p. 31.

28. Wilson quoted in Richard Bernstein, "Why the Cutting Edge Has Lost Its Bite," *New York Times*, September 30, 1990, sec. 2, p. 1.

29. Kenneth Herman, "Finley Attacks Her 'Victims' with Zeal of a Prophet," *Los Angeles Times*, September 15, 1989, sec. 6, p. 1.

30. See Jane Addams Allen, "Who's Winning the Culture Wars?" *Washington Post*, July 15, 1990, G1.

31. Michael O'Sullivan, "Finding Her Calling," *Washington Post*, February 19, 1998, B7.

32. Anemona Hartocollis, "Zero Identity," *Newsday*, December 12, 1991, sec. 2, p. 68.

33. Helen Frankenthaler, "Did We Spawn an Arts Monster?" *New York Times*, July 17, 1989, sec. A, p. 17.

34. William Bailey, transcript of the 126th meeting of the National Council on the Arts, November 3, 1995.

35. William Bailey, transcript of the 123rd meeting of the National Council on the Arts, February 3, 1995.

36. Ibid.

37. William Zimmer, "Landscape Returns to the Foreground," *New York Times*, October 13, 1996, sec. 13, p. 32.

38. David Diao, interview with the author, June 4, 1998.

39. Carter Ratcliff, *Sylvia Plimack Mangold: Paintings 1987–1989* (New York, 1989), np.

40. Sylvia Plimack Mangold, interview with the author, October 3, 1998.

41. Denzil Hurley, interview with the author, March 4, 1998.

42. Terrie Sultan, interview with the author, December 4, 1997.

43. David Pagel, "Stark Paints a Sumptuous, Labor-Intensive 'Rainbow,'" *Los Angeles Times*, October 26, 1995, F12.

44. Megan Marlatt, interview with the author, June 17, 1999.

45. Richard Huntington, "Letting Food Speak for Our State of Affairs," *Buffalo News*, October 11, 1994, 5.

46. Rebecca Howland, interview with the author, March 9, 1998.

47. Zhang quoted in Lillian Zhu, "Zhang Hongtu," *Asian Voices*, Spring 1994.

48. Malinda Beeman, interview with the author, June 24, 1999.

49. Lisa Corrine Davis, artist statement, undated.

50. Gipe quoted in David Humphrey, "Lawrence Gipe," *Bomb*, Winter 1994, 14, 16.

51. C.D., "Lawrence Gipe," *ArtNews*, September 1996, 134.

52. Ken Aptekar, interview with the author, February 20, 1998.

53. Maureen Connor, letter to the National Endowment for the Arts, grants office, April 23, 1997, 1.

54. Pope.L quoted in Martha Wilson, "William Pope.L," *Bomb*, Spring 1996, 51.

55. Ibid., 53.

56. Photo caption, *Maine Telegram,* August 3, 1997, sec. B.

57. In an interview with the author, February 19, 1998, Pope.L said that none of his 1995 NEA grant went to support *ATM Piece.* Pope.L claims that the grant is supporting his work on a novel which tells the story of a black girl growing up in the future.

58. William Pope.L, contribution to forum on "Creativity and Community," *M/E/A/N/I/N/G,* May 1994, 16.

59. Alice Thorson, "Woodcuts Are a Manic Protest Against Violence," *Kansas City Star,* April 28, 1995, 19.

60. Lori Gray, " 'Girl Germs' Exhibit Works to Keep It Clean," *Chicago Tribune,* February 3, 1995, 63.

61. Annie West, "IN-STALL-MENTS," *White Walls,* Fall 1990, 53, 58.

62. Daniel Martinez, interview with the author, February 23, 1998.

63. Martinez quoted in Max Benavidez, "Listening to the Militant Muse," *Los Angeles Times,* February 6, 1994, 4.

64. Josely Carvalho, Individual Grant Application Form, National Endowment for the Arts, January 20, 1995.

65. Josely Carvalho, final narrative on "Final Report Form for Grants to Individuals," National Endowment for the Arts, December 26, 1996.

66. Ulysses Jenkins, interview with the author, February 13, 1998.

67. Danny Tisdale, interview with the author, March 5, 1998.

68. Danny Tisdale, final narrative on "Final Report Form for Grants to Individuals," National Endowment for the Arts, July 1, 1996.

69. Danny Tisdale, "Danny Tisdale: An Artist for a Change, Contact with the Community," a poster reprinted in *M/E/A/N/I/N/G,* April 1996, 113.

70. Lisa Corinne Davis, final narrative on "Final Report Form for Grants to Individuals," National Endowment for the Arts, June 7, 1996.

71. Judy Chan, final narrative on "Final Report Form for Grants to Individuals," National Endowment for the Arts, December 15, 1996.

CHAPTER THREE
The Persistence of Painting

1. Stanley Lewis, interview with the author, December 5, 1997.
2. Barbara Rose, interview with the author, December 3, 1997.
3. Balthus quoted in David Bowie, "The Last Legendary Painter," *Modern Painters*, Autumn 1994, 19.
4. Edward Lucie-Smith, *Movements in Art Since 1945* (London, 1995), 104.
5. George Segal, interview with the author, February 9, 1998.
6. Lucie-Smith, *Movements in Art Since 1945*, 152.
7. Jed Perl, interview with the author, October 8, 1997.
8. Louisa Matthiasdottir quoted in Lawrence Campbell, "Louisa Matthiasdottir at Robert Schoelkopf," *Art in America*, October 1991, 154.
9. Mercedes Matter, "What's Wrong with U.S. Art Schools?" *ArtNews*, September 1963, 56–57.
10. Giacometti quoted in Mercedes Matter, "Drawing at the New York Studio School," *New York Times*, September 2, 1973, sec. 2, p. 15.
11. Graham Nickson started the "Drawing Marathon" when he became dean of the Studio School in 1988.
12. Martica Sawin, brochure essay for "The Hansa Gallery (1952–1959) Revisited," Zabriskie Gallery, September 16–November 8, 1997.
13. Porter quoted in Sawin, "The Hansa Gallery." Review appeared originally in *ArtNews*, January 1953, 55.
14. Gabriel Laderman, review of Louisa Matthiasdottir, *Art and Antiques*, Summer 1989, 37.
15. Fernand Léger, "Contemporary Achievements in Painting," in Charles Harrison and Paul Wood, eds., *Art in Theory: 1900–1990* (Oxford, 1992), 157.
16. Derain quoted in John Russell, "Gallery View Pondering the Path of Derain," *New York Times*, July 20, 1980, sec. 2, p. 23.
17. Jed Perl, *Paris Without End: On French Art Since World War I* (San Francisco, 1988), 26.
18. Hélion had served on the organizing committee of the ve-

hemently anti-figurative Association of Abstraction-Creátion painters group, which rejected any artist who "produce[d] works containing more or less obvious forms of living things or objects." Abstraction-Creátion, "Editorial Statements to Cahiers," No. 1 (1932), excerpted in Harrison and Wood, *Art in Theory: 1900–1990*, 358.

19. Hélion quoted in René Micha, *Hélion* (Naefels, Switzerland, 1979), 16. The quote is from an interview with Hélion published in *Attitudes* (1975), No. 21–23.

20. Hélion quoted in transcript of an interview conducted by Stanley Lewis, unpublished.

21. Ibid.

22. Nicholas Fox Weber, *Leland Bell* (New York, 1986), 39.

23. Bell quoted in Fox Weber, *Leland Bell*, 30.

24. Hélion quoted in Lewis, unpublished interview.

25. Hilton Kramer, "Painting in the Shadow of the Museum," *New York Times*, April 28, 1968, D33.

26. Hilton Kramer, "The Art of 'Painting' Is Alive and Well," *New York Times*, January 25, 1976, D1.

27. Kenneth Evett, "Academic Question," *New Republic*, February 15, 1975, 30.

28. Greenberg's quote appears in "Foreword to the 10th Anniversary Exhibition of the Betty Parsons Gallery" in John O'Brian, ed., *Clement Greenberg: The Collected Essays and Criticism*, Vol. 3 (Chicago, 1993), 256.

29. Jane Schoelkopf, interview with the author, November 7, 1997.

30. Robert Schoelkopf, letter to Peter Cahn, October 2, 1969; Robert Schoelkopf, letter to Mrs. John D. Rockefeller, III, February 12, 1970.

31. Jed Perl, "Successes," *New Criterion*, May 1990, 52.

32. Michael Kimmelman, review of Louisa Matthiasdottir, *New York Times*, March 3, 1989, C36.

33. John Hollander, "Leland Bell: Gesture and Trope," *Art in America*, July 1987, 113–114.

34. A retrospective of Matthiasdottir's work was arranged by the Salander-O'Reilly Gallery in 1996. The show, accompanied by

a small catalog, traveled to five university art galleries. Matthias-dottir died on February 26, 2000.

35. Barbara Grossman, interview with the author, December 10, 1997.

36. Barbara Grossman, interview with the author, September 10, 1998.

37. The group's original name was the Figurative Artists Group. It was changed to Alliance of Figurative Artists in the fall of 1970.

38. This description of the AFA's purpose is taken from former member Richard Miller's audiotaped recollections of the organization's early days. A transcript of Miller's comments is on file at the Archives of American Art in Washington, D.C. All subsequent quotes attributed to Miller are taken from this document.

39. Reference to "guts" and "heads" is from Philip Pearlstein, "Censorship on Stylistic Grounds," *Art Journal,* Winter 1991, 67. The tension between these two groups spawned a lawsuit in 1975 when Anthony Siani and Jack Silberman, two AFA members who were realists, accused Paul Georges of libel for depicting them as "violent criminals" in a 1974 painting entitled *Mugging the Muse.* A jury originally awarded Siani and Silberman $30,000 each, but the decision was overturned on appeal.

40. Pearlstein, "Censorship," 67–68.

41. Barbara Grossman, "The Bowery: 25 Years," and Sam Thurston, "Beginning the Gallery," essays in a pamphlet for "Bowery Gallery 25th Anniversary Exhibition," Bowery Gallery (December 2–28, 1994), 3, 7.

42. Green Mountain Gallery was a commercial gallery, though it was run in the same fashion as the co-ops.

43. Norman Turner, "The Bowery Gallery," in "Bowery Gallery 25th Anniversary Exhibition," 2.

44. Thurston, "Beginning," 3; Grossman, "The Bowery," 7.

45. Thurston, "Beginning," 6.

46. In the spring of 2001 the Bowery, Prince Street, and Blue Mountain galleries will be moving to 530 W. 25th Street. The First Street Gallery is located at 560 Broadway.

47. Thurston, "Beginning," 3.

48. Jed Perl, "The Art Nobody Knows," *New Republic,* October 19, 1992, 39.

49. Carone quoted in "American Abstract Expressionist: Nicholas Carone," videotape, Thomas Herskovic, producer and director, 1994.

50. Robert Hughes, "The Decline in the City of Mahogany," in *Nothing If Not Critical* (New York, 1990), 7.

51. Grossman, "The Bowery," 7.

52. Thurston, "Beginning," 6.

53. It is worth noting that Perl's wife, the abstract painter Deborah Rosenthal, shows at the Bowery Gallery.

54. See Jed Perl, "Seeing and Time," *New Republic*, August 3, 1998, 31.

55. Robert Hughes, interview with the author, May 30, 1997.

56. Jed Perl, *Gallery Going: Four Seasons in the Art World* (San Diego, 1991) 5. This is a reprint of an article that appeared originally in the *New Criterion*, October 1986, 67.

57. Salle quoted in Janet Malcolm, "41 Takes on David Salle," *New Yorker*, July 11, 1994, 61.

58. Stanley Lewis, interview with the author, December 5, 1997.

59. Bell quoted in Stanley Lewis, *Abstraction-Figuration Synthesis: An Essay on the Work of Eight Contemporary Artists*, unpublished manuscript, 9. Bell originally made this comment in a 1975 interview with Jamie Horowitz.

60. Lewis, *Abstraction-Figuration Synthesis*, 19. Lewis was describing the painter Charles Marks.

61. Jed Perl, "Half a Dozen Contemporaries," *New Criterion*, February 1990, 48.

62. David Wooddell, interview with the author, February 14, 1998.

63. Temma Bell, interview with the author, November 30, 1997.

64. Matthiasdottir quoted in Jerry Tallmer, "The Doctor's Daughter: Her Art Is in the Stillness," *New York Post*, January 9, 1982, 16.

65. Jed Perl, "Earth," *New Republic*, July 14, 1997, 30.

66. Barbara Goodstein, interview with the author, October 17, 1997.

67. Deborah Kahn, unpublished artist's statement, 1997.

68. Before joining the Bowery Gallery in 1987, Lewis showed at Green Mountain Gallery.

69. See Ken Johnson, "Stanley Lewis," *New York Times*, January 9, 1998, E39.

70. Dennis Cooper, "Too Cool for School," *Spin*, July 1997, 88.

71. Andrew Hultkrans, "Surf and Turf," *Artforum*, Summer 1998, 113.

72. Ray quoted in Hultkrans, "Surf and Turf," 146.

73. Deborah Kahn, interview with the author, December 5, 1997.

74. Alan Cote, interview with the author, November 29, 1997.

75. Charles Cajori, remarks at New York Studio School, March 19, 1997.

CHAPTER FOUR
Leveling the Museum

1. Kent Whitaker, letter to the editor, *Wall Street Journal*, July 25, 1995, A13.

2. Lawrence W. Levine, *Highbrow/Lowbrow* (Cambridge, Mass., 1988), 147.

3. Coleman quoted in Germain Bazin, *The Museum Age* (New York, 1967), 267.

4. Quoted in Levine, *Highbrow/Lowbrow*, 151.

5. Quoted in Evan H. Turner, "Prologue: To 1917," in Evan H. Turner, ed., *Object Lessons: Cleveland Creates an Art Museum* (Cleveland, 1991), 8.

6. Bryant quoted in Levine, *Highbrow/Lowbrow*, 201, and in Calvin Tomkins, *Merchants and Masterpieces* (New York, 1970), 30.

7. Quoted in Neil Harris, "A Historical Perspective on Museum Advocacy," in *Cultural Excursions* (Chicago, 1990), 85. This essay appeared originally in *Museum News*, November–December 1980, 60–86.

8. Dillon Ripley, *The Sacred Grove* (New York, 1969), 43.

9. Neil Harris, "Polling for Opinions," *Museum News*, September–October 1990, 46, 52–53.

10. *Museums for a New Century*, American Association of Museums (Washington, D.C., 1984), 19, 22–23.

11. *Excellence and Equity*, American Association of Museums (Washington, D.C., 1992), 10.

12. *Excellence and Equity*, 8, 10–12, 18.

13. Arthur C. Danto, "Postmodern Art & Concrete Selves," in *From the Inside Out* (New York, 1993), 11–12.

14. Moxey quoted in Scott Heller, "Visual Images Replace Text as Focal Point for Many Scholars," *Chronicle of Higher Education*, July 19, 1996, 8.

15. Stephen E. Weil, "On a New Foundation: The American Art Museum Reconceived," *A Cabinet of Curiosities* (Washington, D.C., 1995), 90.

16. Danto, "Postmodern Art," 17–18.

17. Neil Harris, "Museums: The Hidden Agenda," in *Cultural Excursions*, 138. This essay appeared originally in *Midwest Museum News*, Spring 1987, 17–21.

18. Benjamin H. D. Buchloh, "The Whole Earth Show: An Interview with Jean-Hubert Martin by Benjamin H. D. Buchloh," *Art in America*, May 1989, 158. The parentheses appear in the original.

19. Harris, *Cultural Excursions*, 140.

20. Danto, "Postmodern Art," 17.

21. Holly quoted in Heller, "Visual Images Replace Text," A8.

22. Alan Wallach, "Revisionism Has Transformed Art History, But Not Museums," *Chronicle of Higher Education*, January 22, 1992, B2.

23. Weil, *Cabinet of Curiosities*, 89.

24. Lisa C. Roberts and Gary Vikan, panel presentations to the annual meeting of the American Association of Museums, May 20, 1993. When Vikan made this statement he was the Walters' chief curator.

25. Walter C. Leedy, Jr., *Cleveland Builds an Art Museum: Patronage, Politics, and Architecture, 1884–1916* (Cleveland, 1991), 34.

26. Leedy, *Cleveland Builds an Art Museum*, 11. The editorial appeared in the December 25, 1892, issue of the *Cleveland Leader*.

27. Arnold Lehman, interview with the author, May 22, 1996.

In 1997 Lehman left Baltimore to become director of the Brooklyn Museum of Art.

28. Carol Duncan, "Art Museums and the Ritual of Citizenship," in Ivan Karp and Steven D. Lavine, eds., *Exhibiting Cultures* (Washington, D.C., 1991), 100–101.

29. This is the estimate of Robert Venturi, the architect of the Seattle Art Museum, as quoted in Roger Kimball, "Elitist Antielitism: Robert Venturi Does Seattle," *New Criterion,* April 1992, 7.

30. National Gallery of Art, press release and exhibition outline for "Circa 1492," May 23, 1991.

31. Richard Bernstein, *Dictatorship of Virtue* (New York, 1994), 47.

32. Michael Kimmelman, "Trying to Balance the Art and the Architecture," *New York Times,* October 26, 1993, C15.

33. Lisa Corrin, handout to accompany "Mining the Museum."

34. Patterson Sims, "Metamorphosing Art/Mixing the Museum," in *The Museum: Mixed Metaphors, Fred Wilson* (Seattle, 1993), 5, 9.

35. Quoted in Sims, "Metamorphosing Art/Mixing the Museum," 22.

36. John Dorsey, "Frames of Reference," *Baltimore Sun,* March 3, 1998, 1E.

37. Duncan, "Art Museums and the Ritual of Citizenship," 99.

38. "Treasures of Tutankhamen" appeared at the Metropolitan Museum of Art from December 15, 1978, to April 15, 1979.

39. The Bellagio Hotel was recently bought by MGM and much of the art collection sold. The real estate developer is www. christopherhomes.com.

CHAPTER FIVE
Harvard's Fogg

1. Harvard's third art museum, the Busch-Reisinger Museum, is an annex of the Fogg. Its collection is largely devoted to the art of German-speaking countries.

2. The current Fogg building was built in 1927. It replaced the original Fogg museum, constructed in 1895.

3. Paul Richard, "Harvard's Stunning New Face," *Washington Post*, October 19, 1985, G1.

4. Quoted in Richard, "Harvard's Stunning New Face."

5. Marjorie Cohn, interview with the author, October 24, 1997.

6. Charles Eliot Norton, "The Educational Value of the History of the Fine Arts," *Educational Review*, April 1895, 345–346.

7. Agnes Mongan, "Harvard and the Fogg," in Craig Hugh Smyth and Peter M. Lukehart, eds., *The Early Years of Art History in the United States* (Princeton, 1993), 47.

8. Henry James, "An American Art-Scholar: Charles Eliot Norton," *Burlington Magazine*, January 15, 1909, 202–203.

9. George H. Chase, "The Fine Arts," in Samuel Eliot Morison, ed., *The Development of Harvard University Since the Inauguration of President Eliot, 1869–1929* (Cambridge, Mass., 1930), 134.

10. Forbes quoted in Kenneth Baker, "The Fogg Art Museum, Harvard University," *Art Express*, November–December 1981, 17.

11. Mongan, "Harvard and the Fogg," 49.

12. Allene Talmey, "The Fogg Art Museum at Harvard," *Vogue*, July 15, 1947, 78. Frenchman Ambroise Vollard was the first art dealer to give an important show to Paul Cézanne and one-man shows to both Henri Matisse and Pablo Picasso.

13. For an excellent account of the Society's history, see Nicholas Fox Weber, *Patron Saints* (New Haven, 1992).

14. Sachs quoted in Sybil Gordon Kantor, "Harvard and the 'Fogg Method,'" in Smyth and Lukehart, *The Early Years of Art History in the United States*, 171.

15. Mongan, "Harvard and the Fogg," 50.

16. Kantor, "Harvard and the 'Fogg Method,'" 168.

17. Mongan, "Harvard and the Fogg," 50.

18. Harvard University Art Museums Archives, Paul J. Sachs files.

19. Kantor, "Harvard and the 'Fogg Method,'" 170, n. 49.

20. Loehr came to Harvard in 1960 after a lengthy stint at the University of Michigan.

21. John Rosenfield, interview with the author, October 22, 1997.

22. Marjorie Cohn, interview with the author, October 24, 1997.

23. Seymour Slive, "Jakob Rosenberg: Connoisseur, Scholar, Teacher," *Drawing*, September–October 1994, 54.

24. John Coolidge, "The Harvard Fine Arts Department," in Smyth and Lukehart, *The Early Years of Art History in the United States*, 52.

25. Paul Barolsky, interview with the author, October 28, 1997.

26. Maxwell Anderson, interview with the author, October 6, 1997. Anderson took the exam in 1979.

27. Freedberg earned his bachelor's degree from Harvard in 1936. He graduated *summa cum laude*, the first fine arts major to earn that designation in twenty years. He finished his Fogg Ph.D. in 1940. See Murray Schumach, "Sydney Freedberg, the Henry James of Art History," *ArtNews*, October 1974, 80.

28. Berenson was born in Lithuania in 1865 and emigrated to Boston with his parents in 1875. In 1885 he converted to the Episcopal church. In 1891 he converted again, to Catholicism.

29. Schumach, "Sydney Freedberg, the Henry James of Art History," 77.

30. Stuart Cary Welch, interview with the author, October 6, 1997.

31. For more on Berenson's concept of "artistic personality," see David Alan Brown, *Berenson and the Connoisseurship of Italian Painting* (Washington, D.C., 1979).

32. It was Freedberg's conclusion that Berenson's fascination with individual artistic personality was in part a reflection of Berenson's own intense, peculiar individuality. See S. J. Freedberg, "Berenson, Connoisseurship, and the History of Art," *New Criterion*, February 1989, 7–16.

33. S. J. Freedberg, "On Art History," *New Criterion*, September 1985, 18.

34. Clement Greenberg, "Review of *Andrea del Sarto*," in O'Brian, *Clement Greenberg: The Collected Essays and Criticism*, Vol. 4, 198. This book review originally appeared in *Arts Magazine*, November 1964.

35. Freedberg, "On Art History," 20.

36. S. J. Freedberg, *Painting in Italy 1500–1600* (New Haven, 1993), 28.

37. Ibid., 435.

38. Henri Zerner, "Mind Your Maniera," *New York Review of Books*, August 31, 1972, 25.

39. Harvard University Art Museums Archives, John Coolidge files, letter in Sydney Freedberg folder from John Coolidge to the American Council of Learned Societies, October 30, 1957.

40. Antonia Paepcke DuBrul, interview with the author, January 6, 1998.

41. Jo Ann Lewis, "A Renaissance Man's Artful Living," *Washington Post*, May 9, 1997, D1.

42. Ackerman quoted in "Art History Oral Documentation Project," interview by Joel Gardner (Los Angeles, 1994), 276.

43. Quoted in Paul Richard, "National Gallery Names Chief Curator," *Washington Post*, March 1, 1983, B1.

44. Gilbert Sewall, interview with the author, October 7, 1997.

45. Gilbert Sewall, interview with the author, October 10, 1997.

46. Harvard University Art Museums Archives, John Coolidge files, letter from John Coolidge to Sydney J. Freedberg, June 2, 1961.

47. Donna Hunter, interview with the author, February 3, 1998.

48. Paul Barolsky, "Sydney J. Freedberg and the Literature of Art," *Renaissance Studies*, December 1997, 476.

49. Zerner, "Mind Your Maniera," 28.

50. Sydney Freedberg, "This Month in New England," *Art-News*, October 1948, 54.

51. Sydney Freedberg, "This Month in New England," *ArtNews*, November 1948, 53.

52. Freedberg served as department chair from 1959 to 1963 and again in the early 1970s. James Ackerman, interview with the author, October 26, 1997.

53. Ackerman, "Art History Oral Documentation Project," 200.

54. Baker, "The Fogg Art Museum," 19.

55. T. J. Clark declined to be interviewed for this book. In a letter to the author (November 17, 1997) Clark expressed a "complete lack of interest in the subject" of his time at Harvard.

56. Clark quoted in Sara Day, "Art History's New Warrior Breed," *Art International*, Spring 1989, 84.

57. T. J. Clark, *Image of the People: Gustave Courbet and the Second French Republic, 1848–1851* (Greenwich, Conn., 1973), 161.

58. Richard Shiff, "Art History and the Nineteenth Century: Realism and Resistance," *Art Bulletin,* March 1988, 45.

59. Françoise Cachin, "The Impressionists on Trial," translated by Mimi Kramer, *New York Review of Books,* May 30, 1985, 24.

60. Ackerman, "Art History Oral Documentation Project," 248.

61. Ibid., 250.

62. Ibid., 194.

63. Ibid., 251.

64. Robert Simon, interview with the author, July 23, 1998.

65. Diane Upright, interview with the author, October 9, 1997.

66. Irving Lavin, interview with the author, October 29, 1997.

67. Rosalind Krauss, interview with the author, February 4, 1998.

68. Clark quoted in Grace Glueck, "Clashing Views Reshape Art History," *New York Times,* December 20, 1987, sec. 2, p. 1.

69. Freedberg, "On Art History," 20.

70. Marvin Trachtenberg, interview with the author, October 16, 1997.

71. Anonymous, interview with the author.

72. Ackerman, "Art History Oral Documentation Project," 253.

73. Patricia Mainardi, interview with the author, November 3, 1997.

74. Harvard still considers the 1983 visiting committee's deliberations and report to be confidential. Therefore, in their interviews, neither Trachtenberg nor Lavin revealed the names of any students or faculty who testified before the committee, or the name of the professor under investigation. Numerous off-the-record interviews conducted with other parties and oblique references to these incidents in the mainstream media confirm that Clark was the only professor under investigation by the committee, and that these charges could pertain only to him. See Glueck, "Clashing Views," and Day, "Art History's New Warrior Breed," 84–85.

75. Henry Millon, interview with the author, July 27, 1999.

76. Tom Matthews, interview with the author, September 23, 1999.

77. Ackerman, "Art History Oral Documentation Project," 249.

78. Anonymous, interview with the author.

79. J. Carter Brown, interview with the author, September 19, 1997.

80. Sydney Freedberg, letter to the author, October 2, 1992.

81. Ackerman, "Art History Oral Documentation Project," 257.

82. Richard, "Harvard's Stunning New Face," G1.

83. Slive quoted in Katherine Garrett, "A Whirlwind Tour of the Fogg Museum, Led by Its Most Knowledgeable Guide," *Harvard Magazine,* January–February 1978, 80.

84. Ackerman, "Art History Oral Documentation Project," 185.

85. John Coolidge, "Do You Know What You Like in Art?" *Harvard Alumni Bulletin,* January 10, 1953.

86. *The 53rd Annual Confidential Guide to Courses at Harvard–Radcliffe* (Cambridge, Mass., 1978), 75.

87. Irene J. Winter and Henri Zerner, "Art and Visual Culture," *Art Journal,* Fall 1995, 42.

88. Winter and Zerner, "Art and Visual Culture," 43.

89. Linda Nochlin, "The Imaginary Orient," in *The Politics of Vision: Essays on Nineteenth-Century Art and Society* (New York, 1989), 34.

90. Patricia Simons, "Women in Frames: The Gaze, the Eye, the Profile in Renaissance Portraiture," in Norma Broude and Mary Garrard, eds., *Expanding Discourse: Feminism and Art History* (New York, 1992), 41. This article originally appeared in *History Workshop: A Journal of Socialist and Feminist Historians,* Spring 1988, 4–30.

91. Norman Bryson, *Word and Image: French Painting of the Ancien Regime* (Cambridge, England, 1981); Norman Bryson, *Vision and Painting: The Logic of the Gaze* (New Haven, 1983); Norman Bryson, *Tradition and Desire: From David to Delacroix* (Cambridge, England, 1984).

92. Norman Bryson, interview with the author, October 23, 1997.

93. Ackerman, "Art History Oral Documentation Project," 261.

94. Norman Bryson, "Semiology and Visual Interpretation," in Norman Bryson, Michael Ann Holly, and Keith Moxey, eds., *Visual Theory: Painting and Interpretation* (New York, 1991), 73.

95. Ibid., 64.

96. Ibid., 67.

97. Ibid., 66, 68.

98. Ackerman, "Art History Oral Documentation Project," 261.

99. Vivian Cameron, interview with the author, January 6, 1998.

100. Donna Hunter, interview with the author, February 3, 1998.

101. Bryson, "Semiology and Visual Interpretation," 63.

102. "Introduction to Modern Art and Visual Culture, 1700–1990s" was co-taught by Norman Bryson and Ewa Lajer-Burcharth. This quote is taken from a lecture Bryson gave on October 23, 1997.

103. Bryson's comments on the Bourbon Library cycle are taken from Norman Bryson, "Desire in the Bourbon Library," in *Tradition and Desire: From David to Delacroix*, 176–212.

104. Lee Johnson, *The Paintings of Eugene Delacroix: A Critical Catalog*, Vol. V (Oxford, 1989), 37.

105. Alexander Fyjis-Walker, interview with the author, March 24, 2000.

106. Dorothy Johnson, interview with the author, November 12, 1997.

107. Norman Bryson, "Representing the Real: Gros' Paintings of Napoleon," *History of the Human Sciences*, May 1988, 75–104.

108. Norman Bryson, letter to the editor, *History of the Human Sciences*, May 1991, 171–172.

109. Ernst Gombrich, letter to the editor, *Times Literary Supplement*, January 3, 1997, 17.

110. Norman Bryson, "Bring Them Out of the Light," *Times Literary Supplement*, December 20, 1996, 18.

111. E. H. Gombrich, *Shadows* (London, 1995), 20.

112. Ibid., 23.

113. Bryson, "Bring Them Out of the Light," 18.

114. Jack Gourman, *The Gourman Report: A Ranking of Graduate and Professional Programs in American and International Universities*, 8th ed. (New York, 1997), 11.

115. Ewa Lajer-Burcharth, interview with the author, October 22, 1997.

116. Barry Wood, interview with the author, May 2, 1998.

117. Slive quoted in Garrett, "A Whirlwind Tour of the Fogg Museum," 80.

CHAPTER SIX

Establishment Exhibitionism

1. A few of Manet's works had appeared in the official Salon, but in 1863 his *Dejeuner sur l'herbe* was rejected.

2. John Rewald, *Post-Impressionism: From van Gogh to Gauguin* (New York, 1978), 30.

3. Judd Tully, "Jeff Koons's Raw Talent," *Washington Post*, December 15, 1991, G1.

4. Annie Sprinkle, "Hard-Core Heaven," *Arts Magazine*, March 1992, 46.

5. Jeff Koons quoted in *Jeff Koons*, exhibition catalog, Fronia W. Simpson, ed. (San Francisco, 1992), np.

6. Tully, "Jeff Koons's Raw Talent," Antonio Homem, interview with the author, June 8, 2000. Mr. Homem is director of Sonnabend Gallery.

7. This list is derived from Koons's exhibition history as it appears in Simpson, *Jeff Koons*, 126.

INDEX

(numbers in italics indicate illustrations)

A NOTE ON THE AUTHOR

Lynne Munson is a cultural critic and research fellow at the American Enterprise Institute in Washington, D.C. Her articles about art and culture have appeared in the *New York Times*, the *Wall Street Journal*, and *The Public Interest*. She was graduated from Northwestern University and then worked at the National Endowment for the Humanities, where she was special assistant to the chairman. She lives in Boston, Massachusetts.